And Still We RISE

Conversations

Race, Culture, and Visual

Carolyn L. Mazloomi

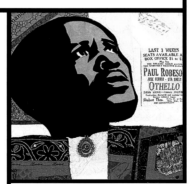

Schiffer Publishing Ltd

4880 Lower Valley Road • Atglen, PA 19310

Copyright © 2015 by Carolyn L. Mazloomi

Library of Congress Control Number: 2014958649

All rights reserved. No part of this work may be reproduced or used in any form or by any means—graphic, electronic, or mechanical, including photocopying or information storage and retrieval systems—without written permission from the publisher.

The scanning, uploading, and distribution of this book or any part thereof via the Internet or via any other means without the permission of the publisher is illegal and punishable by law. Please purchase only authorized editions and do not participate in or encourage the electronic piracy of copyrighted materials.
"Schiffer," "Schiffer Publishing, Ltd. & Design," and the "Design of pen and inkwell" are registered trademarks of Schiffer Publishing, Ltd.

Designed by Molly Shields
Cover designed by Brenda McCallum
Type set in Helvetica Condensed/Times New Roman

ISBN: 978-0-7643-4928-7
Printed in China

Published by Schiffer Publishing, Ltd.
4880 Lower Valley Road
Atglen, PA 19310
Phone: (610) 593-1777; Fax: (610) 593-2002
E-mail: Info@schifferbooks.com

For our complete selection of fine books on this and related subjects, please visit our website at www.schifferbooks.com. You may also write for a free catalog.

This book may be purchased from the publisher. Please try your bookstore first.

We are always looking for people to write books on new and related subjects. If you have an idea for a book, please contact us at proposals@schifferbooks.com.

Schiffer Publishing's titles are available at special discounts for bulk purchases for sales promotions or premiums. Special editions, including personalized covers, corporate imprints, and excerpts can be created in large quantities for special needs. For more information, contact the publisher.

Dedication

To Shamim...my dream, my wish, my prayer. You have brought more happiness than I ever dared hope for.

Contents

Foreword

And Still We Rise: Race, Culture and Visual Conversations excites themes of liberty, revolution, slavery, abolition, civil rights, voting, women's rights, entrepreneurship, innovation, space exploration, black citizenship, agency, resistance, protest, power, and freedom. The themes are all here, presented and made available in the exhibition of strong, sumptuous, vivid, and bold art quilts. In a roll call of the timeline of 400 years of the African-American experience, ninety-seven quilts commissioned by curator/quilter, Dr. Carolyn Mazloomi, support the recognition and rearrangement of our American memory.

Through this quilt show, we encounter agitation and comfort, unrest and peace, questions and answers, myth and truth, and exigencies of entrance and exit. One might ask how it is possible to cover such dynamic historical terrain in a display of quilted art works. It becomes possible through a timeline created to tell the story and the commissioning of artists to create quilts that narrate and demonstrate events, places, and people that inhabit that block of time.

As America celebrates the Sesquicentennial of the Civil War and the Emancipation Proclamation, this 150th anniversary reckons that there was a reason for the emergence of what Dr. Martin Luther King cites as the most important documents in American history—the Declaration of Independence and the Emancipation Proclamation. America's quest for freedom and liberty, expressed in these documents, underscores its historical advance, which began with the laws adopted by first colonists to establish their rights, rights that were once denied in England, and then continued through the ensuing tensions in the resultant democratic republic. As this democracy developed, we ask whose freedom and whose liberties were at stake as the land was acquired and a rising economy and wealth were established in the new nation; whose work and what denial of the freedom to those whose work made it possible? Despite the heralded liberty sought for some, it came at the cost of the enslavement of others. It is here that one realizes these documents were written during the eighteenth and nineteenth centuries, when daily life called for the nearly all-consuming expenditure of time spent in arduous tasks for survival, and that the time it took to discuss and write these documents was made available to the "Founding Fathers" through the free labor of Africans. The production of these documents, which protect American liberty and rights, set in motion a two hundred-year plus series of events that challenged these notions by those least addressed in their issue.

The challenge of the Africa-descended populations in America, then, to lay claim to American freedom and change, through the doctrine of "all born free and equal," is unprecedented in the history of the world, and that story is the focus of this quilt exhibition.

Monumental to the documentation of the quest for equality is a timeline mapping the people, places, events, achievements, and contributions that underscore triumph over unbelievable circumstances. A unique, first of its kind exhibition, *And Still We Rise: Race, Culture and Visual Conversations* is the brainchild of curator Carolyn Mazloomi. It chronicles this timeline, highlighting its cataclysmic moments and its heroes. The quilts in this exhibition were commissioned to tell an important and much-neglected story, an African-American and, yet at once, a truly American story in the magic of cloth. It serves as a visual document and presents a compelling narrative. Cloth is comforting. Cloth is a wrapping that all humans know. Cloth is non-threatening. In this format, we can engage in a much needed and warranted dialogue. Issues of slavery, oppression, racism, gender, and social justice pose difficult conversations and are the "tough stuff" of American history. The quilts in this show make available the critical content of African-Americans' experience and the lesser-known history of their place and role in the foundation of this country to the present day. These quilts contribute to the full orbit of American history and its whole story of resilience, survival, and triumph.

The quilters offer their own personal account of the events. The encounter with the images in the show is a visual feast of innovation, striking color, and historic reference that not only enlarges our spoken, written, and visual vocabularies, but, with the availability of a cloth journey, also allows the viewer to expand his/her own journey of visual literacy into that of cultural literacy. Through the genteel medium of cloth, we travel from story to story, through space and time, following the movements of an exceptional people who manage to soar above ordinarily crushing circumstances to claim victory, one moment, one decade, one era, one century at a time.

L'Merchie Frazier
Director of Education
Museum of African-American History
Boston, Massachusetts

Acknowledgments

I was inspired to create this exhibit by the fast approaching quadricentennial anniversary of the landing of the first enslaved Africans in America. The project has consumed almost four years of my life and was a formidable task.

No project of this magnitude can be brought to fruition without the help of others. I wish to thank the financial supporters of the exhibition, the National Endowment for the Arts, the Sara M. and Michelle Vance Waddell Fund of the Greater Cincinnati Fund, the Shirley Hartwell Foundation, Richard and Carol Beck, and Dr. Tracey Rico. There would be no exhibition had it not been for your unwavering support and encouragement to make the impossible possible.

Thanks to the wonderful artists, my textile griots, for visualizing our history and affirming our creative identity.

I am deeply indebted to my daughter-in law, Dr. Shamim Mazloomi, who acted as my research assistant. Special thanks to Peggie Hartwell, Carole Beck, and Dr. Myrah Brown Green for your encouragement, and for always believing I can do the impossible. To my dear friend and colleague, the late Gwen Magee, your spirit and courage will always surround all I do. To our photographers, Chas E. and Mary Martin, thanks for always making our quilts look great.

Thanks to Nasir, Nuri, and Faryan Mazloomi for inspiring me to record the history of my people through their art.

Finally, I give thanks to the ancestors, whose stories I will continue to tell and who walk this creative journey with me.

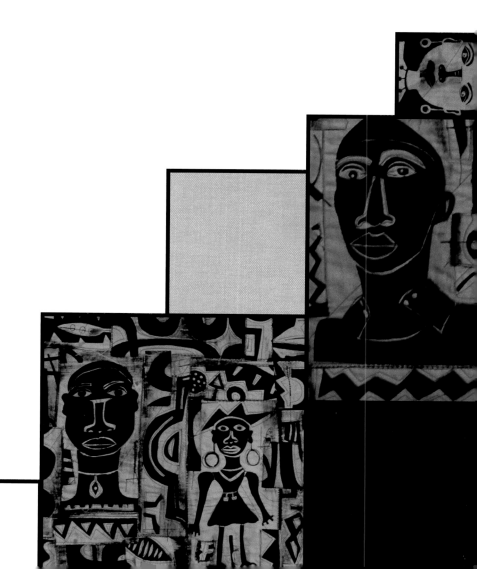

And Still We Rise:
Race, Culture, and Visual Conversations

Carolyn L. Mazloomi

The Genesis of the Exhibition

I ask myself, if we could quilt across the slave trade in Africa, across the Atlantic Ocean through the Middle Passage to the Americas, to early black citizens, inventors, and entrepreneurs—enslaved and free, to the Abolitionist Movement and the Civil War, to Reconstruction and Pan Africanism, to the Industrial Revolution and the Great Migration, to the New Negro and the Harlem Renaissance, to the WPA Movement, to Negritude, to the Civil Rights Movement, to the Black Power Era, and on to Black citizenry in contemporary America, what would the African-American experience in quilts look like? So begins *And Still We Rise: Race, Culture, and Visual Conversation.*

When contemporary artists are in sync with the social, political, and cultural currents of their communities, their artistic renderings become some of our most effective tools for fostering knowledge, dismantling mythical notions, and engaging the trust of others. The exhibition, *And Still We Rise: Race, Culture, and Visual Conversations*, constitutes an unprecedented commentary, dispelling the problem of restricted African-American artistic and historical agency by voicing, in cloth, an untold, chronological account of the struggles and triumphs of a marginalized people. When one faction of American society is excluded from the master narrative of our collective histories, the whole society loses. The loss of a more inclusive history leaves our entire nation needlessly vulnerable to repeating mistakes of the past.

The problem addressed by this monumental educational and artistic effort is two-fold. First, American history is not complete without the stories of African-American men and women, from our enslaved ancestors to our contemporary political leaders, and of our current societal challenges. It is widely known that America's mainstream educational curricula do not adequately include diverse American histories. Second, it is also common knowledge that average American citizens do not use reading material as the primary, preferred, or most effective mode of education. Today's contemporary learners, across varied age, ethnic, and social class groups, are pictorially and multi-media focused, particularly when it comes to acquiring knowledge about others. In light of this reality, the Women of Color Quilt Network offers the quilt exhibition, *And Still We Rise: Race, Culture and Visual Conversations,* as an inspiring solution to the problem of educating the general population about the ascendant influence of African-American culture on the American cultural landscape.

Educating our nation's citizens about important segments of our complex, authentic, national history is a critical priority for our vitality. But why quilts? Because quilting is one of America's most powerful art forms, with its widespread appeal and its association with comfort, warmth, and healing. Quilts and quilt making are important to America and to Black culture, in particular, because the art form was historically one of the few mediums accessible to marginalized groups to tell their own story, to provide warmth for their families, and to empower them with a voice. Through cloth, people can relate to history visually (story quilts), as opposed to reading about history, in ways that reach our hearts and teach us about our shared values. Choosing quilts as the visual medium for this exhibit accentuates the intersections of African-American contributions to American cultural production, while, at once, informing others about the art form and its role in African-American history. It is this often unknown and/or underappreciated, shared reality that must be voiced if we are ever to truly value the unique contributions diverse groups make to the fabric of our nation.

And Still We Rise: Race, Culture, and Visual Conversations explores the path of black history with a timeline of original quilts. The exhibit traces the course of Black history in America—from the first enslaved people brought over by Dutch traders in 1619, to brave souls marching for civil rights, to impact of African-American culture on the larger American culture, to the election of the first African-American president more than 400 years later, and to the death of Trayvon Martin. Unrivalled in breadth and scope, in one sweeping and important collection, *And Still We Rise: Race, Culture and Visual Conversations* provides an unparalleled account of the history of a people and events that have marked the evolution of African-Americans in America. These quilts take us to people, places, and events that many have never before encountered. There can be no discussion of the development of this nation and liberty without the enormous story of the *new* Africans and the evolution and demise of American slavery, with the pivotal ascension of the African-American as integral to all points of American history.

The quilts, as visual media, pose an alternative and non-threatening approach to topics of social issues, about people, places, and events that are embedded in the American memory as sensitive cultural parameters of race, class, and gender, labeled by James and Lois Horton as the "tough stuff of American history." The artworks prompt a dialog between artist/interpreter and the viewer, challenging existing notions and posing questions that serve to move the discussion of racial reconciliation forward into the next generation of problem solvers.

The exhibition brings to broad American audiences a collection of powerful artworks that not only excites, but also educates. For the African-American viewer, the exhibition is a validating expression of cultural genius. For viewers external to the culture, it is an awakening to the unknown and uncelebrated contributions of African-American artists to our Nation's history. For scholars of art and American studies, the exhibition is fertile soil for research inquiry and artistic critique of some of the finest material culture works emanating from contemporary American artistic masters.

The Daughters of Harriet Powers: African-American Women Quilt a Culture

Background

The European slave trade drew as many as ten million Africans in the largest forced migration in human history. Despite the assumptions of many white scholars, African culture survived the trauma of the Middle Passage and the humiliation and brutality of slavery, fueling a steady and powerful stream of artistic production in the Western Hemisphere. Tapping into a spiritual reserve of powerful rituals and memories, enslaved Africans created artistic forms that carried knowledge and values across generations. These arts included architecture, gold and silver smithing, basketry, furniture, ironwork, and needlework, such as embroidery, appliqué, piecing, and weaving. Although in Africa men made most textiles, in the Americas, work was divided according to Western patriarchal standards, and women took over the tradition. The bed quilt was unknown in Africa, but patchwork and quilted artifacts were made there. The Yoruba of Nigeria used patchwork in Egungun dance costumes, and the Hausa of Niger and Nigeria made pieced and quilted armor to protect horses and warriors during battle. Appliqué was the dominant needlework technique among the Fon of old Dahomey (now Benin), created for people of high rank for ceremonial purposes. Fon appliqué banners and flags recorded deeds of battle and historic events in the lives of kings. Black women and men drew upon these textile traditions as they made quilts in America.

No artistic form is more closely associated with African-Americans than quilt making, representing skill, aesthetic beauty, and utilitarian need. Moreover, for African-Americans, the quilt became a covert expression of resistance within the context of storytelling. In this way, African-American women found an outlet for their emotions, adversities, and triumphs. Under brutal conditions, quilters helped create strategies for survival as well as an interpretive window on the black experience in America. Although many slave quilters could not write, they left compelling cultural documents about the tragedy and humiliation that marked their lives. Denied freedom, but possessed of artistic genius, they gave voice to the voiceless, transcended suffering, reclaimed history, and transformed the future of their descendants. Van E.

Hillard summarizes this dynamic by writing, "As the Negro spiritual 'I Shall Not Be Moved' reflects a tree planted by the water, the quilt shall not be moved as a tradition of defiance and dialectical response to social and political circumstances." Hilliard adds, "The rhetoric of the quilt exposes systems of domination and illustrates the ways in which marginalized groups contest their experiences and express their meanings of the world. The quilt represents a ritualized practice of connection-making, unification and harmonizing."[1]

Although early scholarship placed African-American women outside mainstream American quilting traditions, implying that slave women lacked aesthetic talents and simply served as sewing assistants, in reality, they developed their own quilting art, drawing on the African past. Women who sewed for owners during the day used recycled bits of rags and old clothes to quilt for their families at night. Slaves forced to work in a European tradition found ingenious ways to include African cosmology and mythology in quilts for white mistresses. There are documented slave-made quilts, for example, featuring the symbol of Erzulie, Vodun goddess of love, cleverly disguised as flowers. Vodun is traceable to an African word for "spirit" and can be linked to Yoruba people who lived in eighteenth- and nineteenth-century Dahomey. The snake motif, Damballah, the West African god of fertility, also appears in Black-made quilts. The pattern is still popular among elderly African-American quilters in Mississippi and Alabama, most notably the famous quilters of Gee's Bend.

More than half of African-American quilts are narrative. In the tradition of the African griot, quilts tell stories of family leaders, moral and spiritual values, and social concerns. Such quilts, in both Africa and America, have been the primary vehicle for preserving family and political histories for generations.

Crafters of Genius: Three Former Slaves

Black women have always insisted upon being artists. They've insisted upon it since the first incorporated African designs into the making of quilts.
—Michele Wallace, 1989[2]

During slavery, there was little cultural or aesthetic value attached to quilting. Still, the need for self-validation led African-American craftspeople to prize technical mastery and creative brilliance. In some cases, masterful demonstration of skill brought the opportunity to free oneself and one's family. Former slaves Harriet Powers (1837–1911), Harriet Tubman (1820–1913), and Elizabeth Hobbs Keckley (1818–1907) all made and treasured quilts as artistic expression.

Lizzie Hobbs Keckley was a seamstress who used her extraordinary ability to purchase her freedom. Born a slave in Dinwiddie County, Virginia, she was sold at the age of fourteen and suffered greatly from the brutality of her various owners. At one time, her sewing skills supported her master and seventeen other people. Using her elaborately embroidered quilts as collateral, she borrowed $1,200 from white patrons in St. Louis to free herself and her son.

Prior to 1860, Keckley moved to Washington, DC, and made fine dresses for Mary Todd Lincoln and other prominent women, eventually becoming friend and traveling companion to Mrs. Lincoln. Around 1870, Keckley made her Liberty Medallion Quilt using scraps of silk from Mrs. Lincoln's gowns. Keckley spent her last years at Wilberforce University as a sewing instructor and director of Domestic Art.[3]

Perhaps the most celebrated African-American quilts are those of Harriet Powers. Although she could neither read nor write, Powers made two Bible quilts that are among the best known in American history. They reside in two of America's most prestigious museums—the National Museum of American History, Washington, DC, and the Museum of Fine Arts, Boston. Powers recorded local legend, biblical stories, and accounts of astrological occurrences in her work. The quilts show strong connections to the appliqué tradition of the Fon people of Dahomey in West Africa. Powers exhibited one of the quilts at the 1886 Cotton Fair, where it caught the attention of Jennie Smith, an academically trained artist and school administrator. Smith wanted to buy the work, but Powers refused to sell. There ensued four years of negotiation, ending in 1891, when Powers desperately needed money. Powers asked ten dollars, but eventually accepted five as the price of her work. Fortunately for posterity, Powers described in detail for Jennie Smith the meanings of each of the quilt's eleven panels. Powers visited Smith several times to see the quilt. In 1895, Smith exhibited the quilt at the Cotton States and International Exposition in Atlanta. A group of faculty wives of Atlanta University saw it and commissioned Powers to make another narrative work as a gift for the Reverend Charles Cuthbert Hall, president of Union Theological Seminary. These two quilts stand as critically important examples of African tradition, as well as African-American narrative quilting practices.[4]

Harriet Tubman was perhaps the most famous conductor on the Underground Railroad, making thirteen missions to rescue over seventy slaves. She helped John Brown recruit men for his raid on Harpers Ferry and was a Union spy during the Civil War. She is less known for her needlework, but her memoirs reveal that, in 1843, she made a patchwork quilt. Calling the quilt the most beautiful thing she ever owned, Tubman gave it to a white woman who aided her in her escape from Maryland.[5]

Keckley, Powers, and Tubman illustrate how African-American women used their needle skills to sustain their families and advance themselves and others toward freedom and independence.

This tradition continued in The Alabama Freedom Quilting Bee, the first quilt cooperative in the United States. The organization not only helped its members earn money from their quilting, but also served as a springboard for civil rights activism. The Bee began in 1966 in Wilcox County, one of two Alabama counties that did not have any registered Black voters. Members fought for voting rights and became involved in the historic demonstrations from Selma to Montgomery in 1965. Their work was sold in department stores, such as Bloomingdale's, Saks Fifth Avenue, and Lord and Taylor, bringing national attention to African-American quilts.[6]

Quilting a Legacy: A Place in History

In the past few decades, traveling museum exhibitions have brought African-American quilts to the public, stimulating broad interest and offering extraordinary opportunity for scholarly study. As a result, African-American-made quilts are now celebrated and highly collectible. The number of museum exhibitions featuring African-American quilts is still small compared to those of white quilt makers; however, the exhibitions that have been mounted have received critical attention from the art world. Most notably, *The Quilts of Gee's Bend,* an exhibit of brilliant, bold, and dynamic quilts created by women who live in the isolated African-American hamlet of Gee's Bend, Alabama, has captured the imagination of the public with an innovative and often minimalist approach to design. *New York Times* art critic Michael Kimmelman called the quilts "some of the most miraculous works of modern art America has produced." Alvia Wardlaw, co-curator of *The Quilts of Gee's Bend,* wrote, "The compositions of these quilts contrast dramatically with the ordered regularity associated with many styles of Euro-American quilt making. There's a brilliant, improvisational range of approaches to composition that is more often associated with the inventiveness and power of the leading twentieth-century abstract painters than it is with textile-making."[7]

Despite the powerful impression made by Gee's Bend quilts, it is important to emphasize that no single style dominates African-American quilts. African-American quilting can both reflect African heritage and embrace European styles. In the late 1970s, scholars attempting to codify African-American quilts identified certain aesthetic characteristics based on a small group of quilts distinct from traditional Euro-American patchwork quilts—vertical strip piecing, bright colors, asymmetry, symbolic forms, multiple patterns, improvisation, and African signs and symbols. Over the last decade this view has been debunked. African-Americans work in many styles, including some that reveal African heritage. As we conceptualize this diversity, we must keep in mind the dual cultural heritage of African-Americans. Each quilt must be considered on its own merits rather than placed in a framework of preconceived notions about African-American quilting.

Scholars must acknowledge the contributions of African-American women and their arts to American society. New categories of analyses and sources are needed to expand the scope of this research.[8] Although African-American quilts have recently received significant attention; they are still underrepresented in dialogue and preservation efforts. Moreover, there is critical need for scholars within the culture to become involved in this discourse. Roland Freeman and Cuesta Benberry were the first quilt scholars within the culture to write extensively about African-American quilt history, and Freeman was the first person to mount an exhibition of African-American quilts in this country.[9] Now a new cadre of historians continues the work of producing an accurate history of African-American quilts and exploring their intricate relationships to American history. Scholars Denise Campbell, Patricia Turner, Myrah Brown Green, and Kyra Hicks have all made recent contributions to the canon of African-American quilt studies.

Lost, Appropriated, and Recovered: The Threads of African-American Quilt History

Whose Story Is It?

If scholars agree on one fact about the history of African-American quilts and the artists who make them, it is this: the definitive "her-story" has yet to be told. As is frequently the case with other branches of African-American history, quilt narratives are complicated by social constructs formed by less than ideal relationships between colonizers and the colonized, masters and the enslaved, the over-privileged and the oppressed. Until the recent past, African-American quilters rarely had opportunities to chronicle our own histories, for this requires opportunities rarer still—the chance to speak from positions of power and agency.

In large part due to these social constructs, as African-American quilters, we sometimes feel compelled to tell the stories others want most to hear, rather than the stories most meaningful to us as quilters and creators of our own identities. In such cases, the authentic histories of our work are compromised and, as a society, we are relegated to hearing only that which we allow ourselves to hear. As a rule, however, the most powerful voices professing our histories have not been our own.

Many of the earliest accounts of American quiltmaking involving enslaved black people appear in stories primarily recorded by European-American families who had the means and foresight to document their own histories, sometimes including the needlework contributions of their slaves in personal journals, accompanying ephemera, or official inventories of their property. We also locate references to quiltmaking activities in the oral histories of black communities and in interviews with formerly enslaved African-Americans, most often documented by European-American ethnographers during the WPA Federal Writers Project.

Thus far, only a few contemporary pioneering African-American researchers have opened the door to historical self-agency for African-American quilters. Thanks to the research of scholars like quilt historian Cuesta Benberry and folklorist Gladys Fry, we are assured that the earliest historical references to and findings of African-American quilts were starting points leading to a vast treasure of African-American quilts.[10] Fry's work includes documentation of late eighteenth-century quilts believed to have been made by black seamstresses, but in some cases the provenance is unconfirmed.[11]

More recently, quilt historian Kyra Hicks has provided the most comprehensive chronicle of recorded African-American involvement in quiltmaking activities. Her timeline dates back to the first known early nineteenth-century efforts by the Oblate Sisters of Providence, black Catholic nuns, to teach sewing arts to young African-American girls, and the Female Anti-Slavery Society, formed by African-American women who sold quilts to raise funds for abolitionist causes.[12] Among other noteworthy documented works are the celebrated nineteenth-century Bible quilts by Harriet Powers and the "Mary Todd Lincoln Quilt,"

or "Liberty Medallion Quilt," as it is sometime referenced, by Elizabeth Hobbs Keckley. As the title of Benberry's seminal work suggests, the African-American presence in American quilts was always there, albeit virtually renounced or marginalized for decades in the predominant quilt discourse.

Artistic interests in quiltmaking traditions shifted as African-Americans progressed through periods of historical significance for the nation and for us as a people. The wanes and surges in quiltmaking activities affected African-American communities as these trends similarly impacted other communities. The ripple effects of these waves were often tied to economic conditions. As Blacks advanced socially and economically, sometimes involving moves to more urban communities, changes in quiltmaking practices reflected interests in and the availability of store-bought blankets for warmth and decoration. Ample documentation illustrates how African-Americans recorded, in both utilitarian and art quilts, our awareness and engagement of important political, social, and artistic movements.[13]

Interestingly, however, unlike thriving European-American neighborhoods, many African-American communities were not empowered with knowledge about the increasing worth of their quilts when the rise in valuing American homespun crafts returned. As a result, numerous poor or marginally educated African-American quilters gave away or sold their quilts for next to nothing, while buyers were well aware of the quilts' artistic significance and monetary value. Consequently, countless historically noteworthy quilt treasures were unwittingly siphoned from black families, furthering economic divides. Regrettably, this form of cultural and fiscal exploitation is an ongoing chapter in the history of African-American quilters.

Sifting the Colonized Narrative

Much has been written about historical linkages between African textiles and African-American quiltmaking in terms of aesthetics and assembly techniques. No one doubts that circles of African-Americans have always made quilts bearing obvious resemblances to decorative symbols and textile patterns found in the material culture of various African peoples. Certain researchers found these conspicuous elements of cultural continuity easier to trace than ones that forced us to think beyond the constraints of racial constructs—of black people as innately drawn to bold colors, asymmetry, improvisational preferences, and mystical symbolism, and of white people as intrinsically drawn to repetitive uniformity, symmetry, and rigid ordering. However, if we cast our net to capture the broadest historical linkages, we realize that the vast diversity of African nations where enslaved Africans were taken and brought to the Americas also gave rise to the vast diversity of aesthetic preferences found among African-American quilters.

This view of African-American quilt history rebuffs the predominant narrative that the "most authentic" forms of African-American quiltmaking are those which have been minimally influenced by European-American sensibilities. The flaw in the logic of this "most authentic" version of African-American quilt history is the assumption that European-Americans are the

originators of repetitive uniformity, symmetry, and rigid ordering in any aesthetic application. We have but to examine the infinite examples of aesthetic uniformity and symmetry in various forms of science, art, and architecture found in ancient and contemporary African nations to recognize alternative sources of influence and inspiration during the earliest metamorphosis of African-American cultural production and continuing into present-day genres.

The arrogance of oppressive colonization always includes a proclivity, on the part of an internalized colonizing mind, towards skewing perceptions of positive influences and negative impacts in directions that serve the purposes of those in power. And these skewed perceptions do not necessarily serve the ultimate interests of colonized societies or their displaced members. Be that as it may, we have neither logical reason nor decisive evidence to assume that, while early African-Americans were preserving the African aesthetic sensibilities of asymmetry and improvisation, they were not simultaneously preserving the African aesthetic sensibilities for symmetry and uniformity. One form of preservation was obvious to the colonized mind, the other remained undetected, a covert strategy enslaved blacks regularly used and oppressed blacks continue to deploy to resist and disrupt the harshness of their social relegation. We can stand solidly on evolving historical documentation that positions African-American quiltmaking as an ever-present influence on a rich American tradition of utilitarian and artistic cultural production across all genres.

Clearly more controversial than the history of African-American quiltmaking is its historiography; that is to say, the way in which the history has been crafted and by whom. Contention remains over universalized observations that bias historical narratives of African-American quilts and their creators. Art historian Lisa Farrington captures the consequence of historical voicing usurped or directed by those outside of the culture, and/or, more importantly, those who perpetuate an undercurrent of colonized perspectives in their narratives. Like Benberry, photojournalist Roland Freeman, art historian Raymond Dobard, and other black scholars have argued for far too long that the authentic history of African-American quilts reflects the same diversity in style, form, aesthetics, and technique, as the African-American people who make them. To promote a less representative quilt history at once distorts the history of the art, the culture, and the people.

So how does one bring authenticity to a rich history of asymmetry and improvisational mastery in quiltmaking without evoking stereotypical representations of African-American cultural production? Perhaps the answer can be more easily stated than applied—tell the whole story from a decolonized perspective, that is to say, a reflective point of view that speaks against the grain of universalized and racialized dogma. As the theme of this essay compels us to question—whose history is it, anyway? Is it African-American quilters' stories about themselves or is it someone else's story of how they perceive African-American quilts, quilters, and their culture? Is the history told by the exploited "other," who feels constrained to say what the paying public wants to hear, or is it told with the agency that accompanies the representational power of a self-defined identity?

These questions take us far beyond the scope of chronicling African-American quilt history and quiltmaking practices. Yet without posing them, and then challenging ourselves to thoughtfully answer them, we risk misinterpreting the history itself. Multiple histories about African-American quilts have already been written, to be sure. So, the more compelling work for us, as writers and readers of those histories, is to reflect on how we interpret and analyze them by posing difficult questions.

As an example, controversies surrounding historical accounts of quilts used as secret codes on the Underground Railroad continue to be hotly debated. Others have joined historians Jacqueline Tobin and Raymond Dobard in efforts to uncover evidence confirming oral history accounts of families who claim their ancestors were participants in crafting quilts used as maps or signaling devices to alert fugitive slaves and those aiding in their escape. Given the dearth of tangible evidence considered appropriate by traditional historical standards, the originators of these stories have been categorized by some as "exploited others" who feel compelled to tell a paying public what they want to hear. Differing interpretations determined that these oral history accounts are sufficient to be accepted more as history than folklore, when one considers the integrity of the "griot" role in African and African-American traditions and the sophisticated, undetected strategies enslaved Blacks were known to exercise to combat the institution of slavery. We have yet to conclude whether this new vein of history is really a novel twist on our long-standing historical preoccupation with the romance and intrigue of America's social order under slavery or a bona fide trail leading to the recovery of lost African-American quilt history.

A Narrative of Our Own

In recent years, we have witnessed an evolution of emerging narratives about African-Americans in general, and African-American quilts specifically, that give rise to decolonized voices— narratives that avoid re-inscribing stereotypic notions of black artistic sensibilities. Just as we can write about the motherly attributes of black women without conjuring up notions of mythical antebellum poor, but loyal and happy, "mammies," so too can we record the histories of African-American quilters without evoking similarly offensive stereotypes. African-American historians and ethnographers, such as Nell Irvin Painter, Lisa Farrington, Michael Harris, Patricia Turner, Kyra Hicks, and Denise Campbell, are among those contributing to a shift in the historical paradigm.

These African-American scholars are gaining credibility by voicing black heritage outside the constraints of the colonial perspective, shedding new light on old stories. While each writes to varying degrees about African-American quilts, their primary commonality is recovering the histories of black peoples in America by speaking with an oppositional gaze against appropriated representations of African-American culture.[14] Through historical lenses that follow the trajectories of earlier, similarly positioned authors, we see more comprehensive histories of African-American quilters, steeped in works of artistic, strategic resistance, that narrate the journeys of marginalized peoples in American society and throughout the world. These narratives speak of remarkable accomplishments, yet the stories are devoid of sanitized versions

of oppressive realities reflecting the daily lives of African-American quilters. The auto-ethnographic nature of their scholarship helps to guide us through complex interpretive nuances sometimes hidden from the gaze of other historians.

Nell Irvin Painter's 2006 landmark publication, *Creating Black Americans: African-American History and Its Meanings, 1619 to the Present,* is a first-rate example of a comprehensive view of the ways in which quilting continues to play a central role in the cultural production of black people.[15] From the earliest works of Harriet Powers and Elizabeth Keckley to contemporary pieces crafted by Viola Burley-Leake, Faith Ringgold, Kyra Hicks, Dindga McCannon, and others, we can trace the history of social issues important in the lives of African-Americans through the artistic and narrative contexts of their quilts. Similarly, Farrington and Harris draw from the themes of African-American quilts to connect social conditions that frequently shape the artistic freedoms available to or denied African-American artists.[16]

While, in some cases, these authors fall short of either challenging or embracing aspects of more controversial historical narratives, their expressions of the history are influential models for authors and readers who wish to test out decolonized historical perspectives on African-American quilts. Their representations are inclusive and do not resound as condescending or offensive, dogmatic rhetoric. Still, it would be prudent for us to critique our own gaze from time to time, for stereotypes are slippery by design, even as we combat their feigned fixed status. More importantly, these narratives illustrate how to record African-American quilt history, so that the history of an art form, central to the culture of its artists, distorts neither the people nor their work as quintessential representations of either.

From a complementary perspective, folklorist Patricia Turner's ethnographic work enters new realms of auto-ethnography for African-American quilters. Through Turner's research, sites of engagement in quiltmaking practices, never before considered in the documentation landscape of African-American quilt history, are making their way into the discourse.[17] Corresponding ethnographic research on newly recovered oral histories, conducted by cultural studies scholar and quilt historian Denise Campbell, calls into question the foundations of previously challenged theories of African-American quilt aesthetics. Campbell presents compelling evidence that some African-American quilters, on whom cultural continuity theories were based, may have allowed the researchers to believe what they wanted to believe about African-American quilt aesthetics because it was to the quilters' economic advantage to do so. She further challenges these theoretical precepts by applying theories of ethno-mathematics and "Afrogenics" to demonstrate more concretely how African-American quilt history permeates the dominant discourse even as it has been dismissed.[18]

Simultaneous with these scholarly endeavors are technological advances that provide new methods of accessing information about African-Americans heretofore believed lost or indiscernible. Cutting-edge developments in internet technology, forensic anthropology, and tracking the genealogy of DNA signal a new era of historical documentation for marginalized peoples and their cultural production. Yet recovering the past and capturing the contemporary history of African-American quilts and their

makers remains complicated by the contributing factors of: 1) the harsh conditions of enslavement, under which the first African-American quilts were made; 2) the general frailty of textiles as preserved material culture; and 3) entrenched oppressive colonial perspectives, through which prevailing histories about African-Americans continue to be voiced in the dominant discourse.

As the continuing saga of African-Americans in America unfolds, it will be important for all historians to reflect the complexities of quilt artists creating in the twenty-first century. Their emerging interests in techno-savvy popular culture mean the genres and inspirations of African-American fiber artists are similarly shifting. Even as this essay attempts to provide context for past and present African-American quilt historiographies, the landscape for the future is under construction. We must remain as diligent in recording our current and future quilt stories as we are in reclaiming the lost, appropriated, and recovered stories of the past.

1. Van E. Hillard, "Census, Consensus, and the Commodification of Form: The NAMES Quilt Project." *Quilt Culture: Tracing the Pattern*, ed. Cheryl B. Tornsey and Judy Elsley (Columbia: University of Missouri Press, 1994), 112-24.

2. Michele Wallace, *Black Macho and the Myth of the Superwoman* (London: Verson, 1989), 214.

3. Jennifer Fleischner, *Mrs. Lincoln and Mrs. Keckly: The Remarkable Story of the Friendship between a First Lady and a Former Slave* (New York: Broadway, 2003).

4. Gladys-Marie Fry, *Stitched from the Soul: Slave Quilts from the Ante-Bellum South* (New York: Dutton Studio Books and Museum of American Folk Art, 1990).

5. Ann Petry, *Harriet Tubman: Conductor on the Underground Railroad* (Amistad: New York, 2000).

6. Callahan, Nancy, *The Freedom Quilting Bee* (Fire Ant Books, Tuscaloosa, 1987), 31-44.

7. Interview, *PBS News Hour*, July 1, 2003.

8. Floris Barnett Cash, "Kinship and Quilting: An Examination of an African-American Tradition," *The Journal of Negro History* (1995), 80.

9. Roland L. *Freeman, Something to Keep You Warm—The Roland Freeman Collection of Black American Quilts from the Mississippi Heartland* (Jackson: Mississippi Dept. of Archives and History, 1981).

10. Cuesta Benberry, *Always There: The African-American Presence in American Quilts.* (Louisville: Kentucky Quilt Project, 1992), 21-29; Gladys-Marie Fry, *Stitched from the Soul: Slave Quilts from the Antebellum South* (Chapel Hill: University of North Carolina Press, 2002), 3-12.

11. Gladys-Marie Fry, *Stitched from the Soul: Quilts from the Antebellum South* (Chapel Hill: University of North Carolina Press, 2002), 31- 37.

12. Kyra Hicks, *Black Threads: An African-American Quilting Sourcebook* (Jefferson: McFarland & Company, Inc., 2003) 207.

13. Roland L. Freeman, *A Communion of the Spirits: African-American Quilters, Preservers, and Their Stories* (Nashville: Rutledge Hill Press, 1996); Carolyn Mazloomi, *Spirits of the Cloth: Contemporary African-American Quilts* (New York: Clarkson N. Potter Publishers, 1998); and Carolyn Mazloomi and Patricia C. Pongracz, *Threads of Faith: Recent Works from the Women of Color Quilters Network* (New York: Gallery of the American Bible Society, 2004).

14. Bell Hooks, *Black Looks: Race and Representation* (Boston: South End Press, 1992).

15. Nell Irvin Painter, *Creating Black Americans: African-American History and Its Meanings, 1619 to the Present* (Oxford: Oxford University Press, 2006).

16. Lisa E. Farrington, *Creating Their Own Image: The History of African-American Women Artists* (New York: Oxford University Press, 2005); Michael D. Harris, *Colored Pictures: Race and Visual Representation* (Chapel Hill: University of North Carolina Press, 2003).

17. Patricia Turner, "Inside Out and Outside In: Educational Trajectories in African-American Quiltmaking Practices," Panel Presentation, International Quilt Study Center Symposium, March, 2007.

18. Denise M. Campbell, *Quilting a Culture: Theories of Aesthetics, Representation, and Resistance in African-American Quiltmaking* (Ann Arbor, MI: UMI Publishing, 2006).

African-American Quiltmaking:
Communing with History

Aleia M. Brown

In his watershed article "The Black Arts Movement," Larry Neal defined the movement as black people establishing and celebrating the black aesthetic.[1] Early historiography of the movement advanced this idea of asserting agency, rather than relying on contemporary and future scholarship to shape such a vital part of African-American identity. The Black Arts Movement fiercely opposed how the American narrative consistently misrepresented or completely disregarded the African-American aesthetic and experience. While the movement heavily emphasized building the community and identity through the arts, it was not until much later that scholars began looking at how the movement positively affected people outside of the race. As exemplified in many mediums of black arts, quilting is also important to both African-American history and American history. Quilts by African-American artists occupy a space that documents African-American history while simultaneously residing in a space that highlights broader issues impacting all people.

For many reasons, quilts are significant pieces of material culture necessary in understanding the African-American aesthetic and experience. Their credence is evident in the idea that the artists who make them usually experience the subject or seriously commune with the history. Analyzing these pieces of material culture produces a richer narrative that involves nuances, tensions, and complexities that may not surface when using other sources alone. The tradition of African-American quiltmaking also counters the single-story narrative through the diverse subjects the artists tackle in their work. *And Still We Rise: Race, Culture, and Visual Conversations* presents a large body of work that varies in material, scale, subject, perspective, and tone. Contemporary quilt artist Ife Felix offers a bold and thoughtful portrait of the first African-American woman elected to congress in her work entitled *Shirley Chisholm: Unbought and Unbossed*. Her story quilt is one of several in the exhibition that hones in on a single person, substantiating the idea that individuals can work independently or collectively to make major contributions. Felix depicts the iconic moment when Chisholm became the first major party candidate for the President of the United States who was African-American and a woman. Against the red, white, and blue background and the scales of justice, Felix illustrates Chisholm's strength in paving the way for a more integrated political system. Not all the quilts highlight the iconic champions and pioneers of justice. Helen Murrell's *We Are All Warmed by the Same Sun* abstractly interprets the Tuskegee syphilis experiment

victims. Still another, *The Loving Quilt* by Barbara Ann McGraw, celebrates integration and acceptance through the Lovings' interracial marriage. These three quilts alone illustrate the different philosophies, values, and artistic statements that can exist within the larger body of work dedicated to the African-American experience. Indeed, African-Americans are multi-faceted people who contribute to society in different ways. Quilts show the collective African-American experience, while also reminding us of the unique memories of the individual. Both the collective and the individual narratives are essential to understanding people of African descent in America.

There are practical implications for preserving quilts dealing with the African-American experience. Culturally, they connect us to an identity that was difficult to retain with enslavement, Jim Crow, and other obstructions designed to strip African-Americans of their agency. The quilts give life to people, lands, events, and memories that the dominant American culture intended to fade. We are in the 21st century, but the quilts included in *And Still We Rise* provide us with a glimpse of people of African descent in America as early as 1619. Gee's Bend quilter Mary Lee Randolph echoed this idea of quilts holding the key to remembering and understanding the past. Though her quilts are often improvisational, they are mostly autobiographical, include materials that relate to her history, and infuse her sense of spirituality. Her family and community identify her as a memory keeper.[2] Her memories come through in her work, and she encourages others to share their memories through the communal act of quilt making and the artwork itself. Preserving quilts is more than preserving materials. It is also preserving personal memories and the history of a marginalized group of people. Most of all, it is preserving a conduit that encourages people to share their joys, trials, and triumphs for an audience to experience and learn from.

Evidently, quilts are an important piece of African-American history, but not including them in the larger American narrative would discount their power. Looking back, there are points where the larger culture expressed interest in African-American quilts. It is important to note that some of these attempts were genuine efforts to learn about African-American culture, while others came from more disingenuous and exploitative motives. During the Great Depression Era, between 1936 and 1938, the Federal Writers' Project of the Works Progress Association (WPA) interviewed formerly enslaved people. Although the WPA oral history effort proved faulty for a number of reasons, the interviewers still identified quilts as a point of interest, which

was reflected in their inquiries.[3] This is just one example of people outside of the race attempting to document African-American quilts. Lisa Farrington's *Creating Their Own Image: The History of African-American Women Artists* critiques these efforts and concludes that women of color are capable of expressing their own artistic vision, which also belongs within the framework of American history.

Beyond the aforementioned examples of the larger American culture exploring African-American quilts, there are some universal lessons that we all can learn from them. Their presence alone gives way to another, more inclusive narrative and facilitates a stronger appreciation for diversity. In addition to their cultural benefits, they strongly impact informal education. They also facilitate critical thinking and stimulate visual literacy. Analyzing patterns, narratives, materials, and social, political, and economic influences can lead to a memorable learning experience. What we know about our past greatly impacts the strength of our education, policies, culture, and relationships. Quilts are our portals to understanding the past to inform our present.

1. Larry Neal, "The Black Arts Movement," *The Drama Review* 3 (1968): 29-39.
2. William Arnett et al., eds., *Gee's Bend: the Women and Their Quilts* (Houston: Tinwood Books, 2002), 255-56.
3. The primary failure of the WPA oral history project was the oversight that formerly enslaved African-Americans would not necessarily trust, or feel comfortable with the white workers. The formerly enslaved were not always completely candid or forthcoming with their life details. Patricia Ann Turner writes more about this in *Crafted Lives: Stories and Studies of African-American Quilters.*

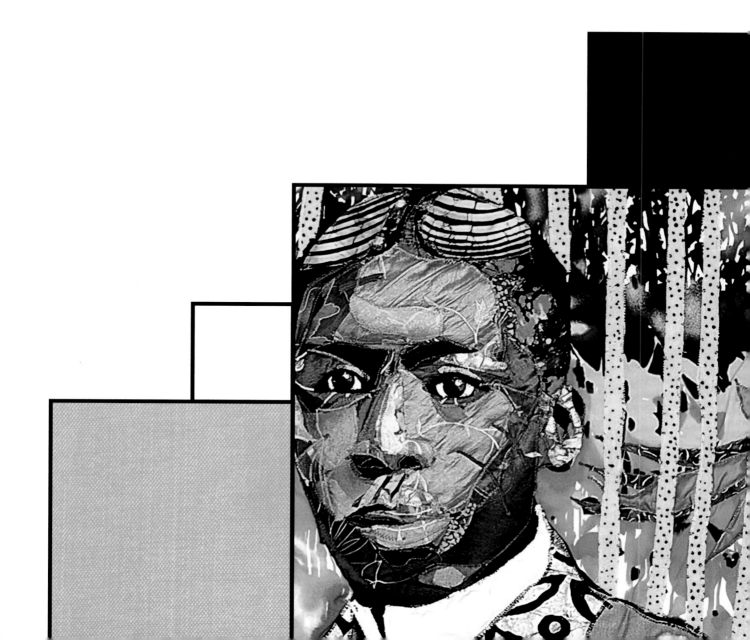

The Quilts

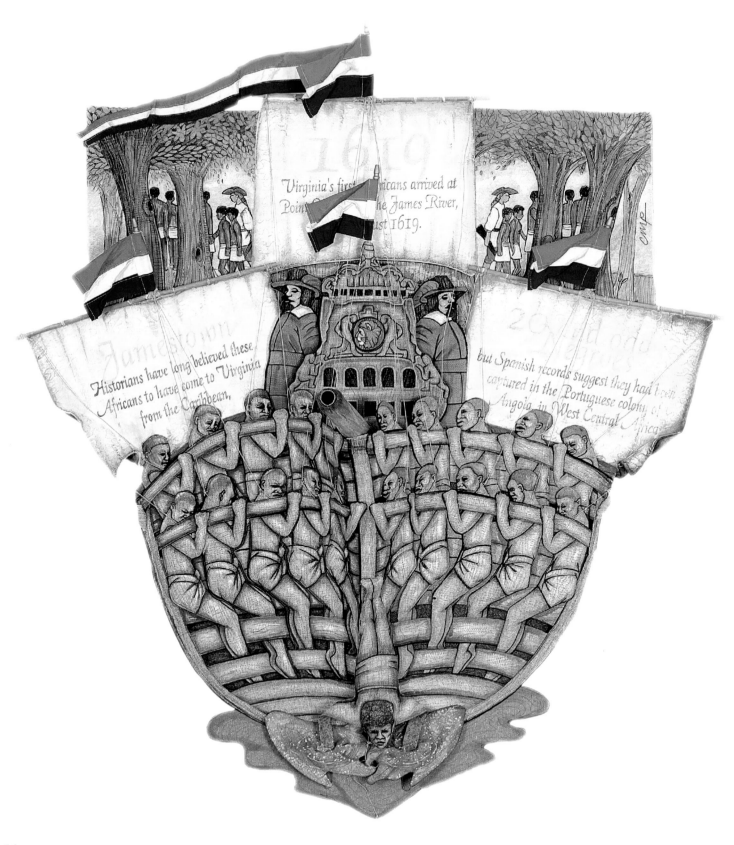

1619 | 20 and Odd

Carolyn Crump (Houston, Texas); 2012; 35 x 44 inches; cotton fabric, cotton thread, felt batting, cotton cord, zipper, acrylic, dye, colored pencils, wood, 3D paint, tulle, cotton batting; appliqué, fabric manipulation, hand painted, printed, machine quilted; photo by Chas. E. and Mary Martin.

Between 1618 and 1620, thousands of Africans were enslaved during two wars: one between King Alvaro III of Congo and his uncles and the other between the Portuguese leader Endes de Vascondes, accompanied by a band of marauding mercenary soldiers, and the Kingdom of Ndongo. In 1619, Africans were loaded aboard the Spanish ship *Sao Joao Bautista,* bound for Vera Cruz, Mexico. En route, it encountered the *White Lion,* which many believe was an English ship with a Dutch flag, and the *Treasurer,* an English ship. The *White Lion* and the *Treasurer* captured cargo from the *Sao Joao Bautista,* including nearly 60 Africans. The *White Lion* arrived at Point Comfort along the Virginia coast (present day Hampton) during the latter part of August 1619, carrying "20 and odd Negros." Two of the original Africans who came ashore, Antonio and Isabella, became servants on the plantation of Capt. William Tucker, who was the commander at Point Comfort. Governor George Yeardley and his Cape Merchant, Abraham Piersey, purchased some of the slaves. They were then transported to plantations along the James River in what would become Charles City. The *Treasurer* arrived three to four days after the *White Lion,* but was not allowed to trade its Africans, so they left Point Comfort for Bermuda, where the Africans were traded for corn. These became the first Africans to arrive in America on British occupied territory. There is no documentation that either ship ever traveled to Jamestown, Virginia, to unload Africans.

In 1623, Antonio and Isabella gave birth to William Tucker, the first African child born in America. The Tucker family and descendants from that child still reside in Hampton. William Tucker is buried there.

The intertwined bodies symbolize the closeness of each person in the hull of the ship. Many Africans died from the harsh conditions aboard slave ships during the voyage to the Americas. Given the opportunity, many jumped into the ocean to escape. The African at the end of the ship is trying to do just that.

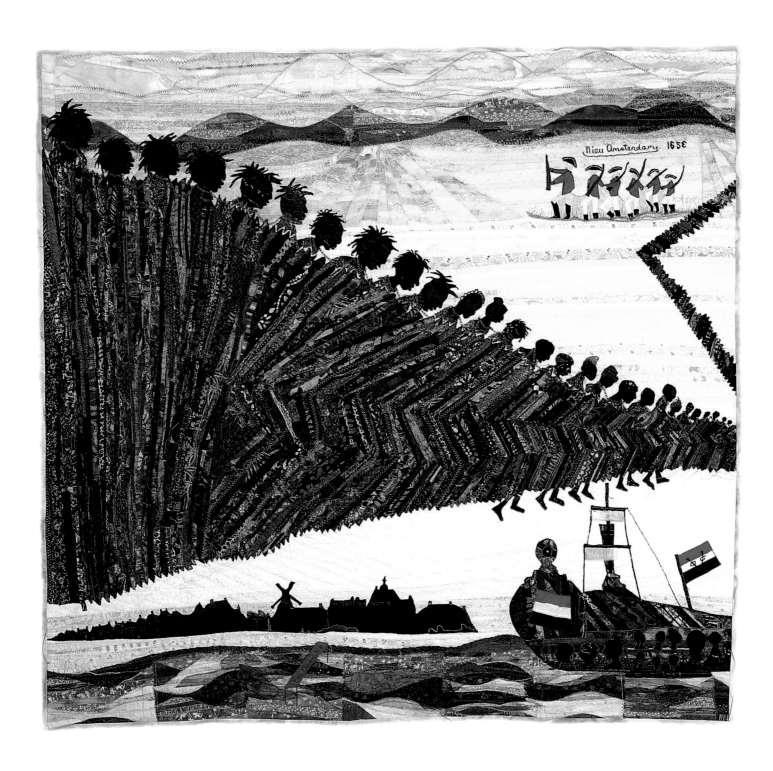

1653 | 240 Million African Slaves Ago

Valerie Poitier (Natick, Massachusetts); 2012; 50 x 50 inches; cotton, metal chain, beads, cotton batting; machine embroidery, appliqué and quilted; photo by Chas. E. and Mary Martin.

In the 1600s, a wall was built in the city of New Amsterdam (now New York City) to protect the Dutch colony from the indigenous people and British warships. Just thinking about it made me upset, shaky, and uneasy. In researching the theme of my quilt, I found the facts painful to ponder. The events of slavery, human trafficking, exporting and importing, degradation and deprivation, freedom for the white male, land-owning population, versus bondage and enslavement for me and mine. Me and mine? Yes, I carry the DNA of both African slaves and white landowners—male, I presume.

Acknowledging that those things existed made for a heart-wrenching exploration into the history. While my family does not have historical records claiming decedents from New Amsterdam, who is to say whether or not one of my ancestors walked across Pier 11 at that time (found on the lower left of the quilt). The pier is still in operation and thriving.

As the story of the quilt began to materialize in my sketches, I felt the need to tear fabric into strips. I felt as if I were outside the wall I was researching. Present-day Wall Street was named after this wall. As it turns out, financial transactions had begun taking place on the street inside the wall and later, even after it was dismantled, the name stuck and the financial district continued to grow. On the outside of the same wall are the recently discovered African burial grounds. More than likely, some of the graves are from those first thousand slaves brought to New Amsterdam.

Under the weight of what I learned, the strips creating the wall and the layers and layers of stitches took on that first bend, the slaves leaning into and morphing into each other. The bending at the knees of the bodies happened because of the weight of what I learned and remembered about the harsh realities of African-American history. The quilt needed a sunrise, a blue sky, and acknowledgment of survival. From one side of Manhattan and clear across the land to the North River, the slaves built that wall; they built the churches, tended the livestock, performed all manner of jobs.

The native, indigenous people were purposely excluded from the front of the quilt. On back of the quilt, I have listed those tribes of peoples recorded as inhabitants of the area before the West India Company (VOC) obtained the lands. When freedom was written about and demanded by British citizens years later, indigenous people were as left out of the recorded history and privileges of "We the People," just as we, the descendants of Africa, were left out.

There is one more significant silhouette: the town in black, built on the backs of those beholden to the VOC. These included not only were Africans brought here as property, but Europeans who came to work the land owned by one of the world's first intercontinental corporations. The slaves who built the wall belonged to the Dutch West India Company, as did everything else. Notice their flag on the slave ship.

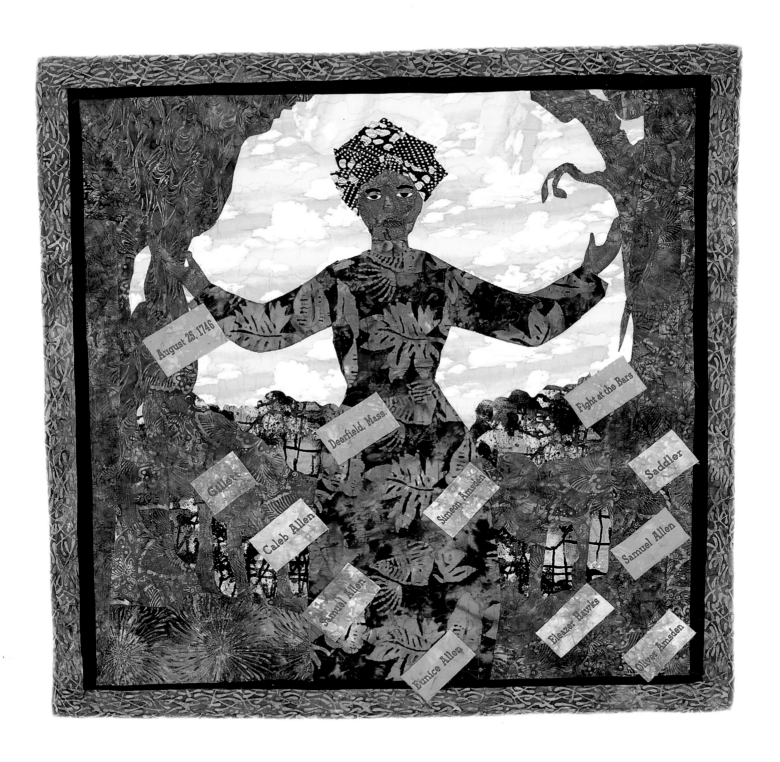

1746 | Lucy Terry Prince:
The Griot's Voice

Peggie L. Hartwell (Summerville, South Carolina); 2012; 50 x 50 inches; cotton fabric and batting, cotton and nylon thread; machined appliqué, machine embroidered; photo by Chas. E and Mary Martin.

Lucy Terry Prince—a daughter of Africa who was too young during her journey to remember the "Passage"—did not arrive in America with empty hands. Prince is known as the first African-American poet. Traveling with her was a "royal companion"—an ancient African tradition: a "griot voice"—which was her internal "keeper of the history." It allowed her to share the collective memories and stories of many precious people, places, and events. Lucy Terry embraced this gift and it, in return, gave her a tremendous voice and courage.

As a young girl in the Rhode Island colony, Lucy Terry (who was "owned" by a Puritan family), was baptized into the Christian faith on June 15, 1735, during the "Great Awakening." In the North, baptized slaves were most often treated like servants rather than slaves. This new relationship between herself and her Colonial family gave Lucy Terry more freedom to develop as a storyteller. In time, she grew as a person, and her "griot voice" became stronger.

In 1756, a successful, free "black man" named Abijah Prince purchased Lucy Terry's freedom, and they were married that same year. Six children were born to their union: Tatnai, Cesar, Drucilla, Durexa, Abijah R., and Festus. They moved to Guilford, Vermont, in 1864. Cesar fought in the Revolutionary War.

In 1785, threatened by a neighboring white family, the Princes appealed to the Governor of Vermont and his Council for protection. The Council defended the Princes, and in 1790, Lucy Terry Prince successfully negotiated a land case before the Supreme Count of Vermont. She argued against two prominent lawyers from the state (one of whom later became the Chief Justice of the Supreme Court of Vermont) and won her case.

Soon thereafter, Prince gave a three-hour address to the Williams College Board of Trustees, hoping to obtain admittance to the school for her son, Festus. Though successful in her presentation, her son was, in the end, not admitted.

Native Americans can find the most unforgettable of Price's words in the "Bars Fight," an oral ballad about an ambush by two white families on August 25, 1746. It was the only account of the event, and remained in "oral" form until it was written down and published in 1855. The names of victims of the fight are seen falling from Lucy Terry Prince's hand in this quilt.

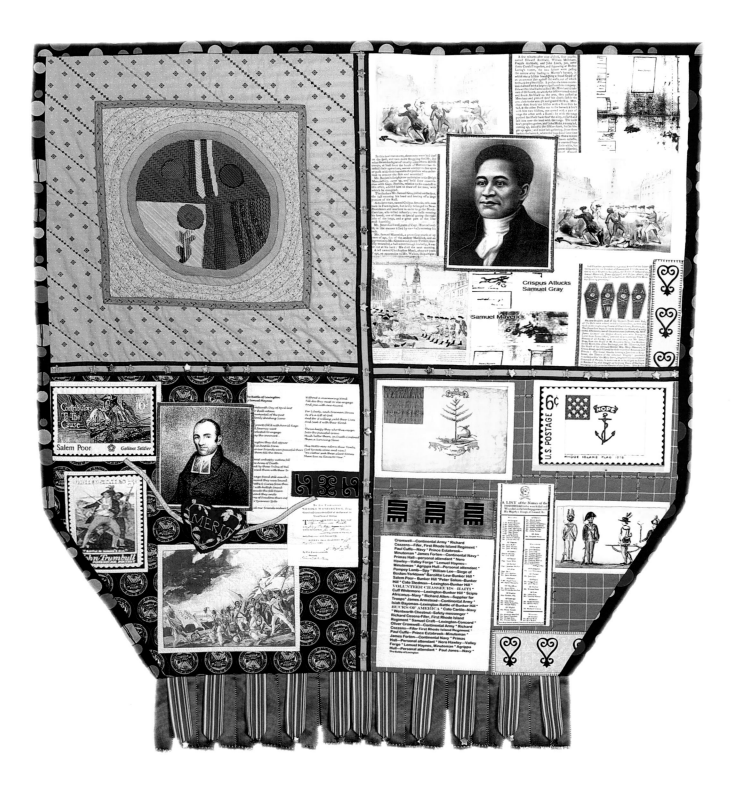

1770 | Crispus Attucks and Revolutionary Heroes

Jakki Dukes (Shaker Heights, Ohio); 2012; 50 x 50 inches; cotton, polyester, ribbon, plastic, buttons, cotton canvas, acrylic paint, wool, felt, metallic thread, ink-jet print image, cotton batting; needlepoint, embroidery, piecing, hand appliqué; photo by Chas. E and Mary Martin.

In choosing Crispus Attucks, I hoped to remind fellow Americans that black people have paid the price for freedom since the beginning of the nation. Additionally, I hoped to say "thank you" to the many whose contributions have been overlooked and, at times, suppressed. By creating this quilt, I honor freedom fighters. By going to the very beginning, there is no chance to overlook a deserving person, because all are included in this remembrance.

The entire quilt represents a medal, complete with ribbons and stars. It is shaped as a shield and decorated with historic images, symbols, and personal inspiration. Divided into four sections, each tells part of early history or pays homage. Star embellished ribbons separate the sections. At the bottom of the quilt is a fringe of medals symbolizing my belief that there should always be enough medals for those who sacrifice for the cause of freedom and justice.

In the upper right quadrant are images of the Boston Massacre, which is associated with the death of Chrispus Attucks of Massachusetts in 1770. There are sketches representing the encounter and a newspaper account of those who were injured around the same time. Attucks is considered the first to die in the quest for independence from England.

In the lower right quadrant are antique flags from Rhode Island and a flag from a special black troop during the Revolutionary period. There are lists of enlisted men and drawings of the uniforms.

In the lower left quadrant is an image of a black regiment, stamps honoring well known men, lyrics from the *Battle of Lexington* (written by a black man), and a reproduction of a medal for bravery commissioned by George Washington. They are stitched on fabric printed with motifs of the United States Army 1776.

The upper left quadrant contains a personal celebration of bravery. My brother designed the "Warrior Shield" in an art session at a hospice. I transferred the design to needlepoint canvas and stitched it while visiting him during his last days. I waited for a project that was significant enough to incorporate the symbols. Even my granddaughter, at age 3½, provided a few stitches, as she became fascinated by this project, thus making this quilt to honor our brave soldiers a bit of a family affair.

Most images were copied onto cotton fabric. The embroidered heart was copied from the medal for bravery. It is made of red felt and hand embroidered with metallic thread. The heart was appliquéd onto the prepared quilt. The ribbons are polyester, while the stars are buttons and the grey ribbons are completed with metal embellishments. The "Warrior Shield" is hand stitched on cotton canvas using cotton threads and metallic threads. The piece is machine quilted.

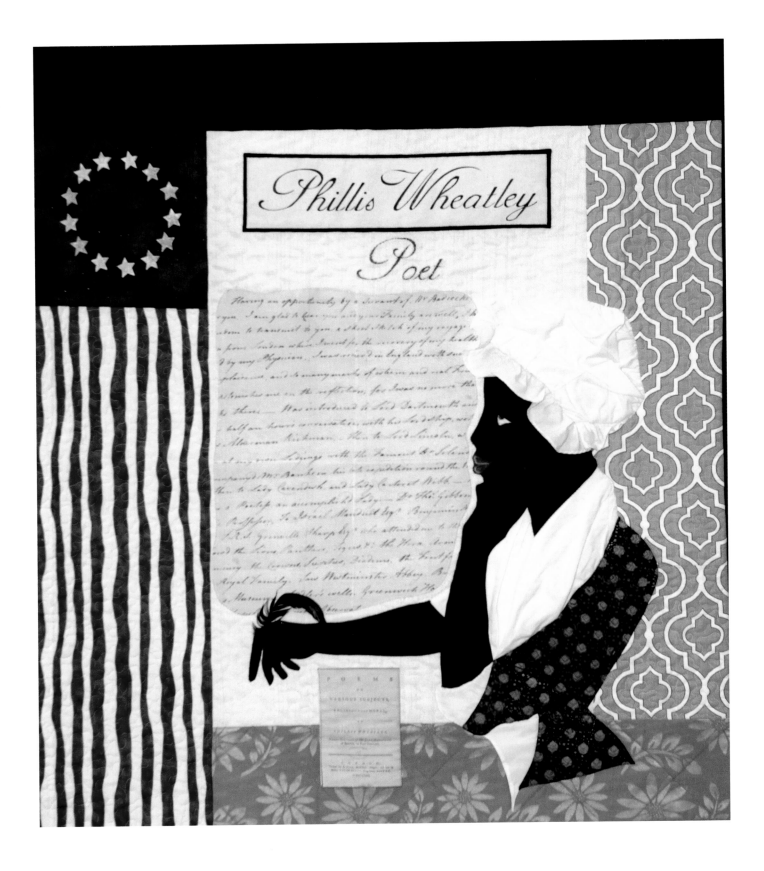

1773 | A Letter from Phillis

Carole Gary Staples (West Chester, Ohio); 2012; 51 x 36 inches; cotton fabrics and batting, embellishments; machine piecing, appliqué, and quilting, stenciling; photo by Chas. E. and Mary Martin.

A Letter from Phillis was inspired by the iconic image of Phillis Wheatley writing at her desk. The powerful image is universally recognized, appearing in a multitude of textbooks and even taking the form of three-dimensional sculpture. There is never a need to read the label to know who the woman on the illustration, poster, or sculpture is. As soon as you see Phillis Wheatley sitting at that desk with her bonnet on her head and pen in hand, you know who it is, which is evidence of the legacy she left behind. Being inspired by the beautiful letters and poems that she wrote, I thought it important to include images of her actual handwriting in this quilt as well as the image of her.

There are three important elements that epitomize Wheatley's poetry. First was her faith in God, which played a very important part in her life and her poetry. Secondly, her extensive education was very impressive, proving to the world that the color of one's skin does not indicate one's intellect. Last and most important was the legacy she created for all those who came after her. She serves as the bridge that connects the past to the future. Phillis Wheatley was a trailblazer. She was the bright, shining star that led all African-American authors into the literary world, especially black women writers.

Phillis Wheatley published her first poem at age 12; and her first volume of poetry, *Poems on Various Subjects, Religious and Moral*, was published in 1773. *Poems on Various Subjects* is a landmark achievement in American history. In publishing it, Wheatley became the first African-American and first U.S. slave to publish a book of poems, and was only the third American woman to do so.

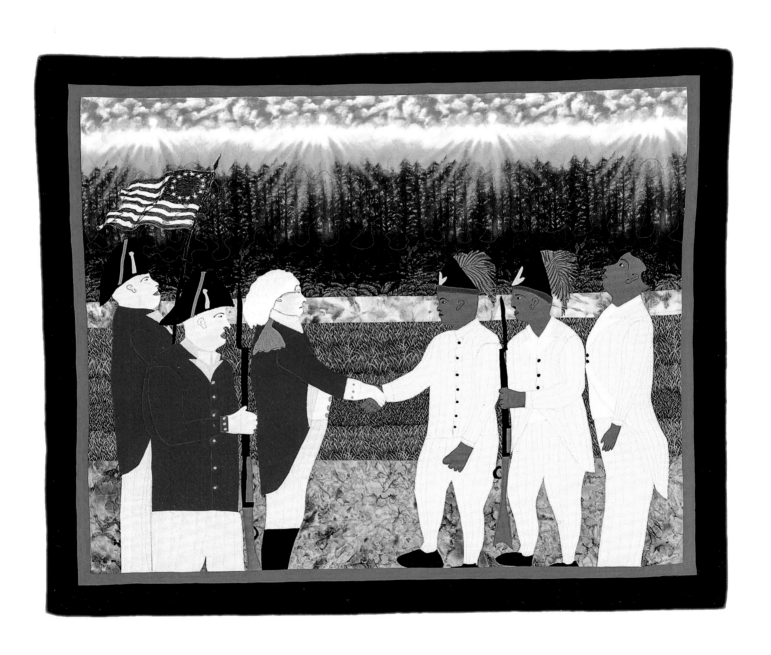

1775:
General George Washington and Black Soldiers

Connie Horne (Elk Grove, California); 2012; 50 x 50 inches; commercial cottons, fusible web and fabric paint, cotton batting; fusing, machine raw-edge appliqué and quilted; photo by Chas. E. and Mary Martin.

When making this quilt, I wanted to show the black soldiers meeting General George Washington to discuss joining forces. At this point, General Washington had reversed his previous decision to exclude black soldiers. Consequently, black soldiers participated in the War for Independence, serving on both the Patriot and British sides. This quilt shows my view of how their first meeting with Gen. Washington may have appeared.

From this time forward, future generations of black soldiers had distinguished records in the U.S. armed forces. Since the War for Independence, black soldiers have served in every U.S war to date, including service with distinction in the Civil War.

My husband's family has an extensive military background, including service by his father, four brothers, and numerous cousins.

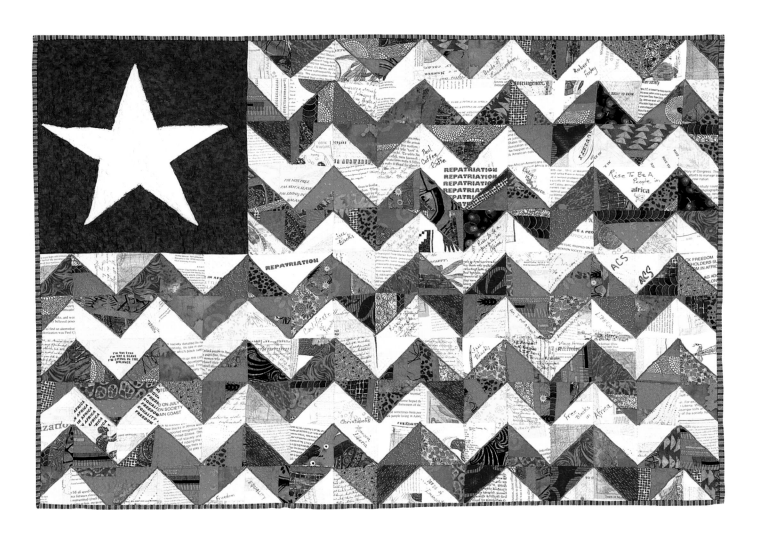

1816 | Repatriation:
The American Colonization Society

Arlene Kweli Jones (Bayswater, New York); 2012; 45 x 32 inches; commercial and digitally printed cotton fabrics, synthetic yarn, cotton batting; machine and paper pieced, machine and hand sewn, machine quilted by Sylvia Hernandez; photo by Chas. E and Mary Martin.

After the Revolutionary War and prior to the Civil War, there were blacks who were living in the balance: not enslaved and not truly free. Blacks who had achieved "freedom" during this time could not vote, own property, practice their religion, or receive a formal education. The American Colonization Society was formed in 1816 to advocate the return of free blacks to Africa, so they could achieve liberties not granted in the United States, though one must wonder if the real mission, in the minds of the southern delegates, was to rid the country of troublesome agitators who threatened the plantation system of slavery. I chose the Liberian flag to represent this period in our history, because Liberia was the country where the American Colonization Society sent freed blacks.

The Liberian flag is very similar to the flag of the United States. It contains red and white stripes and a white star in the blue canton. The blue on the canton represents the main land of Africa and the white star symbolizes the freedom the enslaved blacks were granted. The eleven stripes represent the eleven signers of the Liberian Declaration of Independence. The red and white stripes represent courage and moral excellence. Significant names, places, and dates are written within the white stripes.

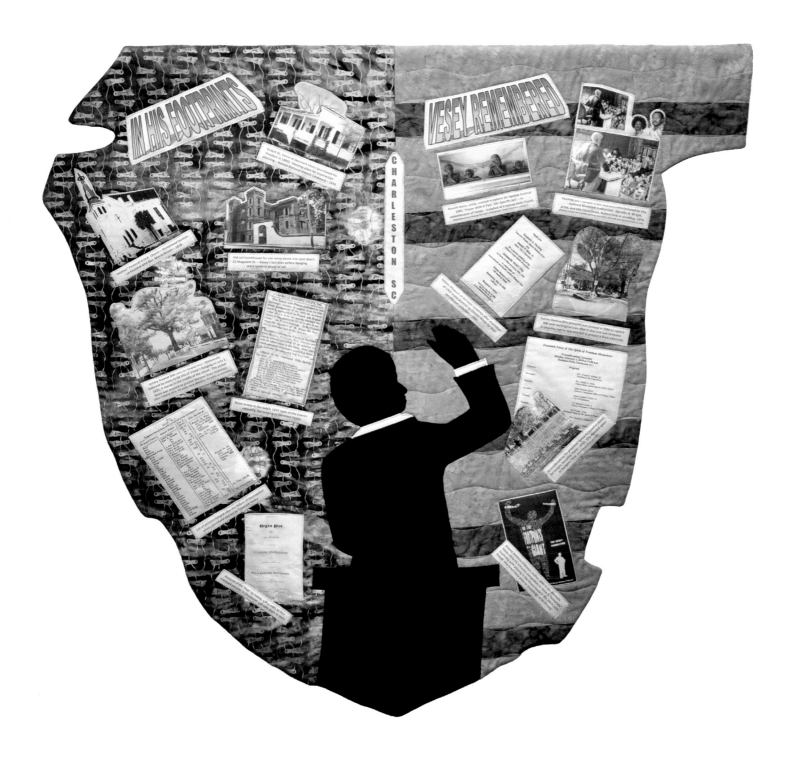

1822 | Remember Denmark Vesey

Marlene Seabrook (Charleston, South Carolina); 2012; 50 x 50 inches; batik fabric, Seta Color, photo transfers, cotton batting; machine appliqué and quilted; photo by Chas. E. and Mary Martin.

The quilt is designed in the shape of the Charleston, South Carolina, peninsula, where Denmark Vesey was enslaved, bought his freedom, planned an insurrection, and was hanged. I could not resist taking advantage of the extensive primary source material available—190 years after his death. The "Old Jail" where he spent his final night still stands. The artist provided the portrait and I literally walked in his footprints through the city taking photos.

Slave trader Captain Joseph Vesey bought Denmark (originally Telemaque) Vesey (1767–1822) as a teenager. While enslaved, Vesey was allowed to keep some of the money from his work as a carpenter. He bought his freedom for $600 in 1800 after winning $1500 in a lottery, and became a free black. He was literate, spoke three languages, and was a class leader at the independent African Methodist Episcopal Church, later named Emanuel Church. Vesey used this affiliation to recruit participants in the largest and best-organized slave conspiracy in U.S. history. He preached parts of the scriptures that he believed showed that slavery was contrary to God's laws. His goal was to free those who were enslaved and sail to Haiti, which had had a successful slave revolt. There were about four years of meeting secretly, recruiting, and gathering of funds and weapons. Vesey is said to have recruited a slave and free black network of nine thousand persons. Days before the attempt, a house slave—who was later rewarded with his freedom and a pension—told his master about the plot, who then informed the Mayor and the Governor. Arrests were made and trials followed. Denmark Vesey, his lieutenants Peter Poyas and Gullah Jack, and thirty-two others were hanged in July 1822.

Many antislavery activists regarded Vesey as a hero and, almost forty years after his death in 1822, the battle cry of African-American regiments in the Civil War, like the 54th Massachusetts, became *"Remember Denmark Vesey."*

Later, as forested land was cleared for the city's expansion, one tree was spared. It stood in the center of what would be one of Charleston's main thoroughfares and is purported to be the "hanging tree." I cannot verify that belief, but I do know that the street continued north around that protected tree. From the time of the executions, efforts were made to prevent "a revered spot" from being associated with those involved in the event. The locations of the graves of the thirty-five hanged remain unknown.

Responding to white panic after the plot failed, a municipal guard of 150 men was established. Half of the men were stationed to an arsenal in mid-Charleston called the Citadel. In 1842, the South Carolina legislature replaced the guardsmen with less expensive cadets from the newly established South Carolina Military Academy, which later became known as The Citadel.

To this day, Charlestonians think of Denmark Vesey as either a villain—hated as a ruthless man intent on the murder of white men, women, and children—or a hero—admired as a man who risked his personal freedom to secure civil rights for others.

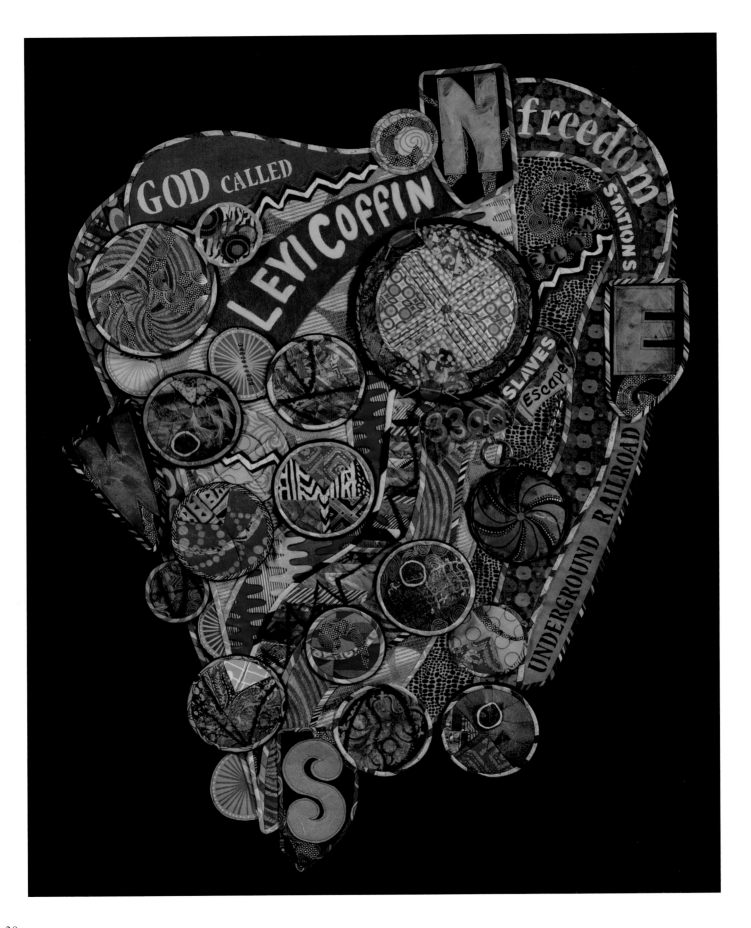

1826 | Levi Coffin:
President of the Underground Railroad

Cynthia Lockhart (Cincinnati, Ohio); 2012; 36 x 36 inches; mixed media and textiles including: felt, fibers, netting, lace, leather, metal chain, beading and felted balls, cotton batting, painted and stenciled graphics; appliqué, machine and hand stitched, acrylic painted accents, circular multi-layered accents representing the Underground Railroad Freedom Stations, bias accent seaming and strip layered accents; photo by Chas. E. and Mary Martin.

Levi Coffin established the Underground Railroad in Indiana in 1826. This artwork celebrates the accomplishments of Levi Coffin and the Underground Railroad Freedom Stations. The metaphoric, map-like shape of the art is the platform used to depict the twenty-one documented Freedom Stations. During the operation of the Underground Railroad, Freedom Stations spanned across the United States and Canada. I created individual circles of various sizes and unique configurations to represent the Freedom Stations. These circles are padded pockets that have secret layers. The circular, cell-like formations are connected by swirling pathways that link the symbolic secret system on the quilt. The largest of the circles featured on the quilt is a landmark for the Levi Coffin House, which was located in Newport, Indiana. It is referenced with hand painted text, graphics, appliqué, quilt points, and chains.

Levi Coffin was a legendary figure in the Underground Railroad movement. He was known as "The President of the Underground Railroad," because of his significant efforts as a conductor and an advocate for the cause—his house was called "Grand Central Station." Coffin was a Quaker abolitionist and was called by God to this monumental undertaking. He was credited with having never lost a single slave who traveled through his Freedom Station.

One of the more significant slaves who reached freedom through Levi Coffin's House was "Eliza," whose story was depicted in the bestselling book "Uncle Tom's Cabin." Levi Coffin was credited with helping over 3,300 Slaves in their flight to freedom, from his Newport home and in Cincinnati, Ohio, where he and his family relocated in 1847.

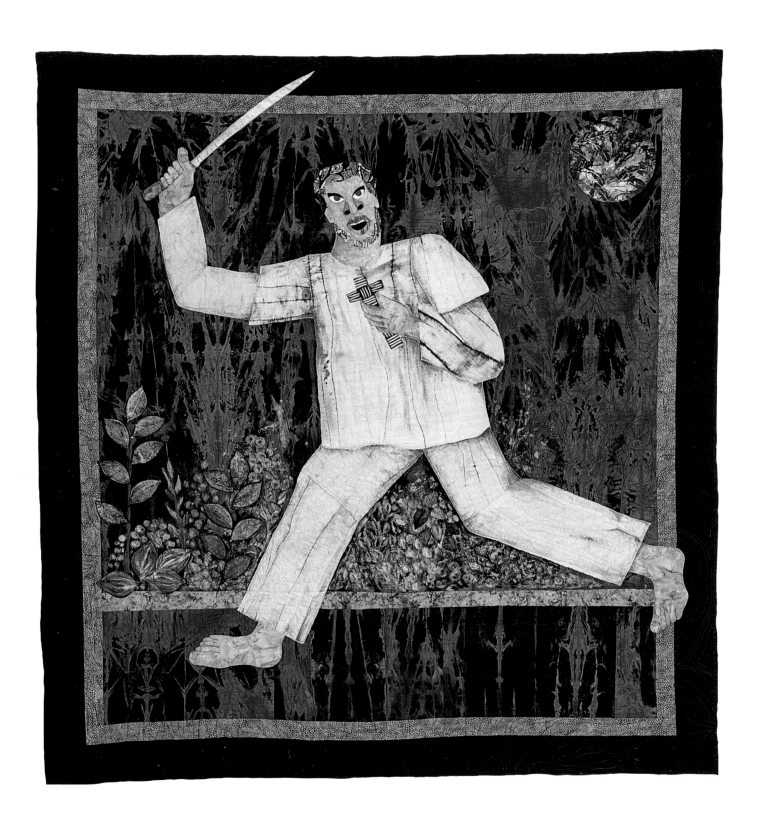

1831 | Nat Turner, Crusader for Freedom

Carole Richburg Brown (Cleveland Heights, Ohio); 2012; 57 x 61 inches; dyed cotton, fabric paint, colored pencils, fabric markers, rubber stamps, commercial cotton, cotton batting; direct painting on fabric, machine appliqué and free motion quilted, hand stamped; photo by Chas. E. and Mary Martin.

The idea for my quilt came to me because I often think about my ancestors, the people in whose footsteps I walk. I wonder what I would have done if I had lived during the time of slavery. Would I have survived as a slave? Would I have tried to run away? Would I have even tried to kill my master and others to achieve my freedom? Would I have been like Nat Turner?

I would not think of myself as a person leading a rebellion. I would label myself *A Crusader for Freedom.* I would want others to know that I was not a content slave. Singing and dancing would have been a way for me to send messages, not proof that I was happy and mindless.

Nat Turner was an American slave born on a plantation in Southampton County, Virginia, on October 2, 1800. His father disappeared when he was young; it was suspected that he was a runaway. Nat's grandmother raised him. He was very intelligent, even as a youngster, and was taught by his owner to read and do math. As he grew older, he began to preach, and people came to believe that he was a prophet. By 1828, Turner believed he was destined to achieve greatness. He was deeply religious, saw visions, and heard voices, which he felt were messages from God.

These voices from God led him to believe that he should fight for his freedom. When a solar eclipse was seen in Virginia on February 11, 1831, Turner thought that it was a sign that he should begin his rebellion. He waited until August 13, 1831, after another solar eclipse and an eruption of Mt. Saint Helens.

After several meetings with other slaves that he trusted, Turner and his followers gathered crude weapons that they found and began their march through the farms and plantations, killing the plantation owners and their families. Their number increased to about fifty slaves.

At last, a group of armed white men confronted them at one of the plantations and put an end to the revolt. Nat Turner escaped, but was caught two weeks later. He and his men were tried and convicted. He was hung on November 11, 1831. His freedom from slavery was achieved through death.

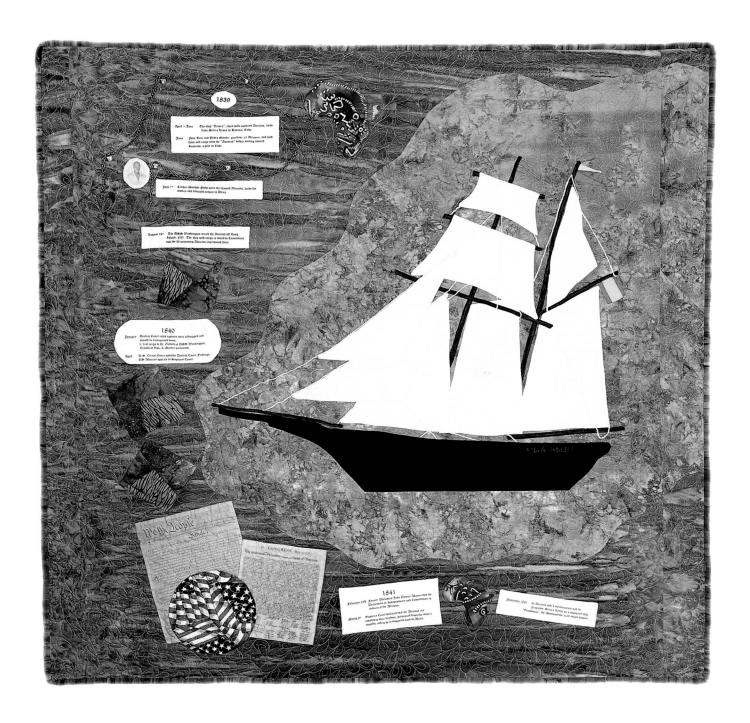

1839 | Amistad:
A Supreme Court Decision

Marjorie Diggs Freeman (Durham, North Carolina); 2012; 49 x 48 inches; commercial cotton, African cotton, cotton batting, cotton cord, grosgrain ribbon, metal chains and half-beads (shackles); machine appliqué, photo transfer, machine quilted; photo by Chas. E. and Mary Martin.

The story of the *Amistad* cannot be told in this quilt without the inclusion of two documents on which our country was founded. The fifty-six Africans on board *Amistad* had been taken from their homeland, survived the horrors of the Middle Passage, rebelled, and mutinied while en route to a life of slavery, only to be captured again off Long Island and imprisoned in Connecticut. They, as all people, wanted their freedom and the inalienable rights of "Life, Liberty and the Pursuit of Happiness," as promised in the Declaration of Independence. Though completely unaware of this document or the U.S. Constitution (which created a strong national government of the people with checks and balances that insured individual freedoms), these documents and the future of the remaining thirty-nine Africans were inextricably bound together.

For more than one-and-a-half years, arguments defending the Africans were heard in local and district courts; those unhappy with the decisions to free them ultimately appealed to the U.S. Supreme Court. Lawyers defending the surviving Africans cited the two documents above, resulting in the decision that they were born free, kidnapped in violation of international law, and illegally imported, and, therefore, were free to return home. The *Amistad* case is significant, as it was the first civil rights case ever tried before the United States Supreme Court. It became the foundation of our modern Civil Rights Movement.

The impact of the *Amistad* on our history also illustrates that the strength and courage of one person (Sengbe Pieh, a.k.a. Cinque, who led the mutiny) can affect many lives and alter history. It solidified and advanced the abolitionist cause throughout America and led civil libertarians to use the courts as a means to enforce equality. A replica of the *Amistad* at Mystic Seaport now serves as an educational tool to teach history, cooperation and leadership.

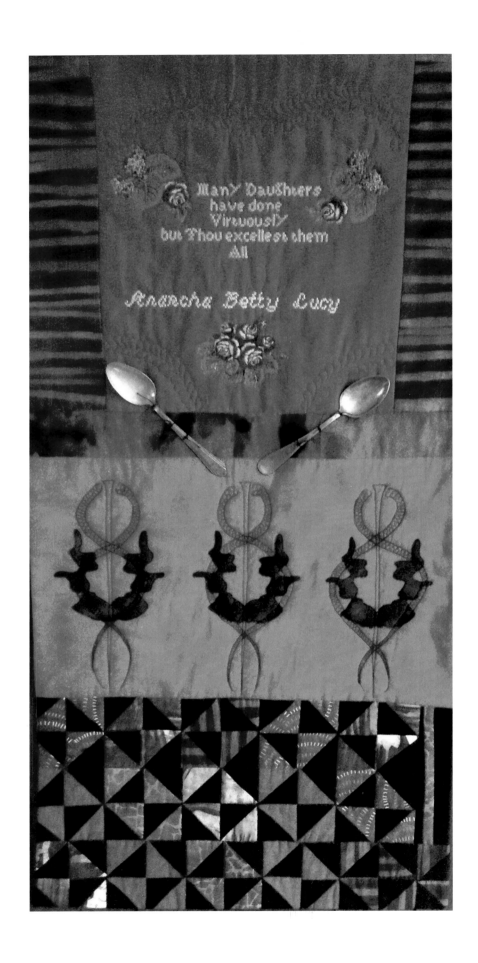

1845 | The Mothers of Gynecology

Michelle Flamer (Philadelphia, Pennsylvania); 2013; 42 x 22 inches; cotton fabrics, commercial and hand dyed, antique pewter spoons, silk and metallic threads, Rorschach Inkblot Test Number 7, hand embroidery, Broderie Perse, machine appliqué, traditional pieced blocks (Broken Dishes), and machine quilted; photo courtesy of artist.

Dr. J. Marion Sims, known as the father of American gynecology, has a statue in Central Park, New York City, commemorating his achievements. Less remembered and honored, however, are the three African slaves from the Westcott Plantation in Montgomery, Alabama, who were sent to Dr. Sims in 1845 for repair of fistulae. Their names were Anarcha, Betty, and Lucy. Pregnancies at a very young age and childbirth under harsh conditions left them with fistulae—holes between their vagina and rectum resulting in incontinence. Like broken dishes, these women were no longer useful for plantation work, so they were sent by their owner to Dr. Sims for a cure. Through painful trial and error, Dr. Sims performed experimental surgeries on these women without anesthetizing them. In his biography, Dr. Sims writes that Anarcha endured over 100 surgeries! Dr. Sims is credited with inventing the speculum, after inserting two pewter spoons into Anarcha's vagina. This quilt honors the courage of these brave African women and pays tribute to their selfless contribution to medical science.

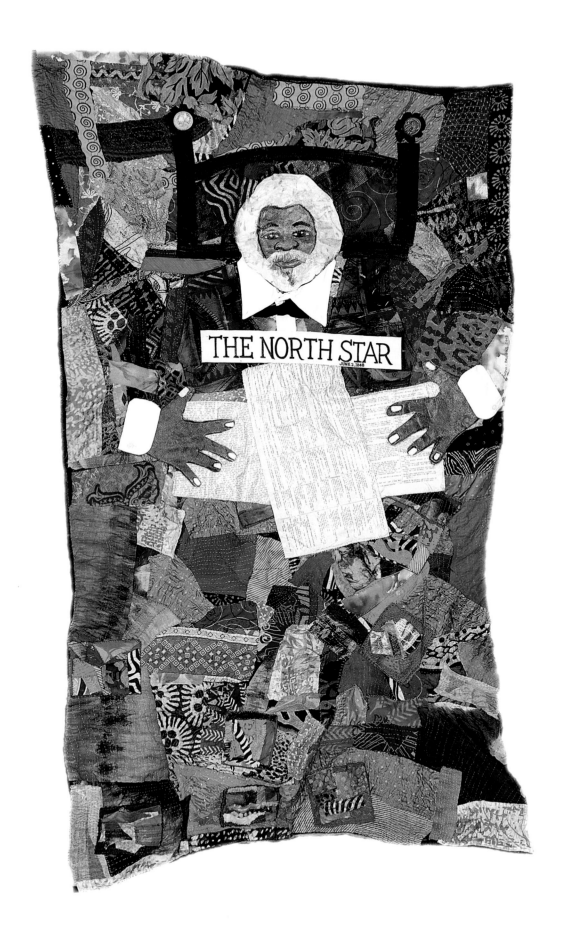

1847 | Life Scene

Gwendolyn Brooks (Washington, DC); 2012; 35 x 65 inches; acrylic paint, assorted cotton and synthetic fabrics, buttons, felt, newsprint, gel medium, silk threads, cotton batting, **c**ollage, and embroidery; photo by Chas. E. and Mary Martin.

My quilt is a fictionalized day in the life of Frederick Douglass in Washington, DC, in 1850. Frederick Douglass was a famous orator, writer, abolitionist, journalist, and the first black citizen to hold a U.S. government rank. Finally, he was an outspoken champion for women's rights. He is often referred to as "the father of the modern Civil Rights Movement."

Douglass is seated in his favorite chair, reading an early edition of the The *North Star*, an early anti-slavery newspaper that he published. *The North Star* was started in 1847 and was published until June 1851, when Gerrat Smith agreed to merge *The North Star* with *The Liberty Party Paper*. The motto of *The North Star* was, "Right is of no sex—Truth is of no Color—God is the Father of us all and we are all brethren." Notice the beautiful quilt that covers his legs. I imagine it was made by his wife to keep him warm on a chilly wintery evening.

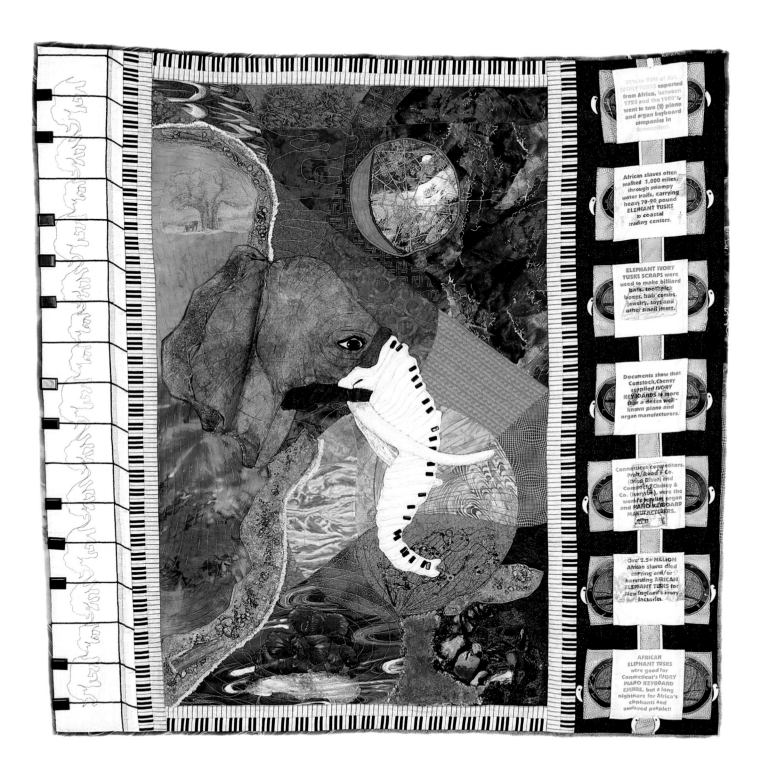

75% to 90% of ALL IVORY TUSKS exported from Africa, between 1720 and the 1900's, went to two (2) piano and organ keyboard companies in Connecticut.

African slaves often walked 1,000 miles, through swampy water trails, carrying heavy 70-90 pound ELEPHANT TUSKS to coastal trading centers.

ELEPHANT IVORY TUSKS SCRAPS were used to make billiard balls, toothpick boxes, hair combs, jewelry, toys and other small items.

Documents show that Comstock, Cheney supplied IVORY KEYBOARDS to more than a dozen well-known piano and organ manufacturers.

Connecticut competitors, Pratt, Read & Co. (Deep River) and Comstock, Cheney & Co. (Ivoryton), were the world's leading organ and PIANO KEYBOARD MANUFACTURERS.

Over 2.5+ MILLION African slaves died carrying and/or harvesting AFRICAN ELEPHANT TUSKS for New England's ivory factories.

AFRICAN ELEPHANT TUSKS were good for Connecticut's IVORY PIANO KEYBOARD EMPIRE, but a long nightmare for Africa's elephants and enslaved people!!

1847 | Ebony and Ivory

Carol Beck (Durham, North Carolina); 2010; 41 x 42 inches; printed cotton fabric, assorted dimensional embellishment items, puff paint, cotton batting; hand and machine pieced and quilted, thread painting, photo computer transfer, printed word panels; photo by Chas. E. and Mary Martin.

My quilt represents the many elephants and huge numbers of African slaves who died because of the greed of two Connecticut companies that needed elephant tusks to make ivory piano and organ keys.

Millions of East Africans were enslaved in Zanzibar, East Africa, by men such as the infamous, ruthless African ivory czar Tippo Tib, for the purpose of harvesting tusks from live African elephants and transporting them from the killing fields to American-bound ships. The tusks weighed over ninety pounds apiece, and each one was weighed at the port to determine the price. They were then loaded by the enslaved men onto the ships for transport, most of them going to the town of Deep River and the village of Ivoryton in Essex, Connecticut. These towns were home two large manufacturers of the ivory keys used on pianos and organs.

Richard Conniff explores the conflicting values of the owners of these factories and their claims of being abolitionists in his book, *When Music in Our Parlors Brought Death to Darkest Africa*. African ivory tusks were known as "white gold" in Connecticut and highly valued. Connecticut companies, Pratt, Read & Company in Deep River, and Comstock, Cheney & Company in Ivoryton, made all of the piano and organ keys for keyboard instruments everywhere in the world. by the early 1860s. Their businesses continued to grow through the nineteenth century. (Interestingly, former U.S. Vice-President Richard Cheney is a descendent of one of these factory owners.)

Millions of enslaved men in Africa were used to harvest and transport raw ivory, and many of them died, so that Connecticut could exist and grow.

The quilt has actual sand, rocks, and ocean wood on the quilt shorelines. There is a raised relief cargo ship in the upper right corner, surrounded by the connecting web of the slave trade. The foam, ocean-water edge is constructed using liquid plastic ice and lace. Beading and photo transferred text add to the visual narrative of the quilt.

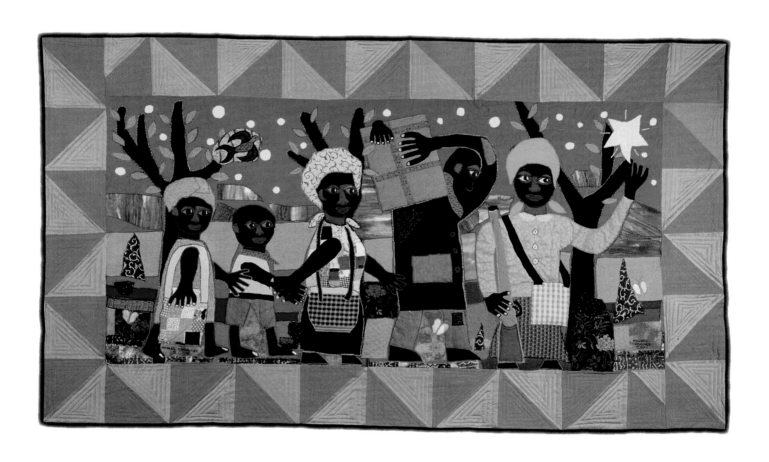

1849 | Harriet Tubman

Michael Cummings (New York, New York); 2004; 72 x 96 inches; cotton, cotton blends, cotton batting, beads, buttons; machine appliqué and quilted; photo by Karen Bell.

Harriet Tubman was an African-American abolitionist, humanitarian, and Union spy during the American Civil War. Born into slavery, Tubman escaped to Philadelphia in 1849. A Quaker woman hid her for a day or so when she first ran for freedom. To show her appreciation, Tubman gave the woman her only prized possession, a quilt she had made. She immediately returned to Maryland to rescue her family, including her parents. Tubman made more than twenty missions to rescue more than 300 slaves using the network of antislavery activists and safe houses known as the Underground Railroad. She later helped John Brown recruit men for his raid on Harpers Ferry and, in the post-war era, struggled for women's suffrage. She said that in all her trips she never lost a "passenger."

Harriet Tubman repeated the journey between the North and South over and over again. Tubman came up with several of her own techniques, which helped make the journey safer and more successful. One included using the master's own horse and carriage for the first part of the escape. Another was planning the escapes for Saturday night, leaving plenty of time until Monday morning, which was the earliest a runaway notice could be printed in the newspapers. Tubman even went so far as to carry a gun, which she used to threaten the fugitives if they became too tired or decided to turn back, yelling at them, "You'll be free or die." March 10, 2013, marked the 100-year anniversary of Harriet Tubman's passing.

My quilt represents my vision of Tubman leading her own family to freedom.

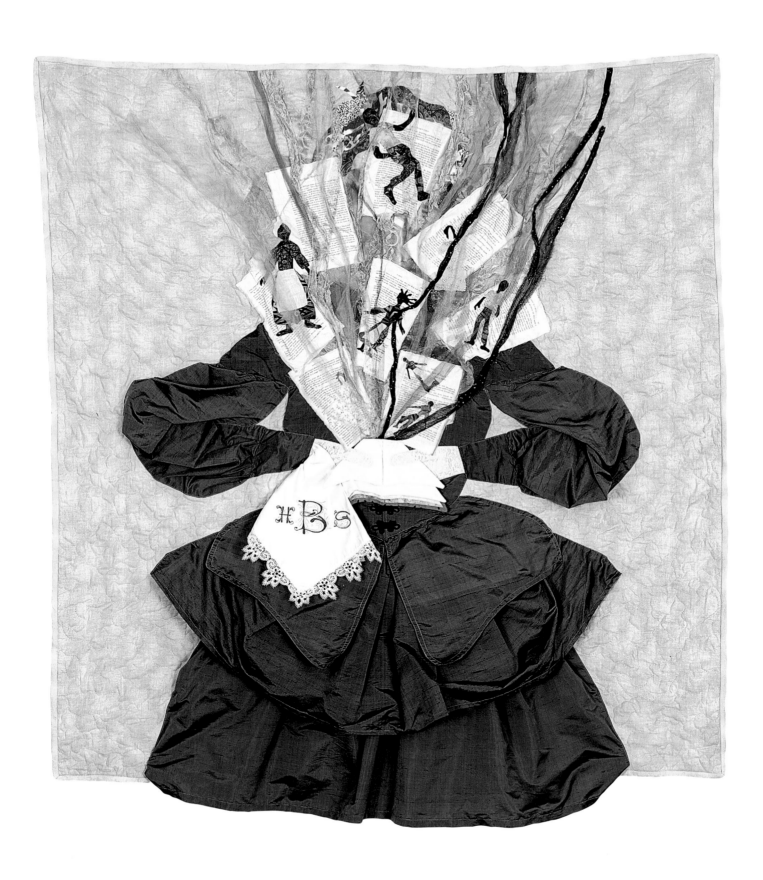

1852 | An Open Book to Freedom

April Thomas Shipp (Rochester Hills, Michigan); 2012; 50 x 50 inches; 100% cotton, silk Dupioni, organza, tulle, lace and photo transfer paper; machine quilting, hand and machine appliqué; photo by Chas. E. and Mary Martin.

The vision I decided to convey in creating this quilt is one of Harriet Beecher Stowe holding her novel as a backdrop, while a vortex of images explode from the pages of her book. I enjoy working with dimensional imagery; my goal was to make her look as if she could walk out of the quilt and stand beside you. I chose not to show her face, but rather portray the turbulence her novel created. Greeting Harriet B. Stowe at the White House, Abraham Lincoln was quoted as calling her the "little woman who wrote the book that made this Great War."

Harriet's dress is made of silk dupioni and organza, her petticoat is lace, and she is also wearing cotton pantaloons. Using fusible webbing and cotton batiks fabrics, I hand cut each character from the novel and laid them on photo-transfer fabric copies of the actual pages of Stowe's book.

I chose blue and gray tulle to symbolize the colors that would later be worn by the Union and Confederate troops; the red tulle symbolizes the lives that were lost and the blood that was shed.

Uncle Tom's Cabin was one of the most influential works to stir anti-slavery sentiments.

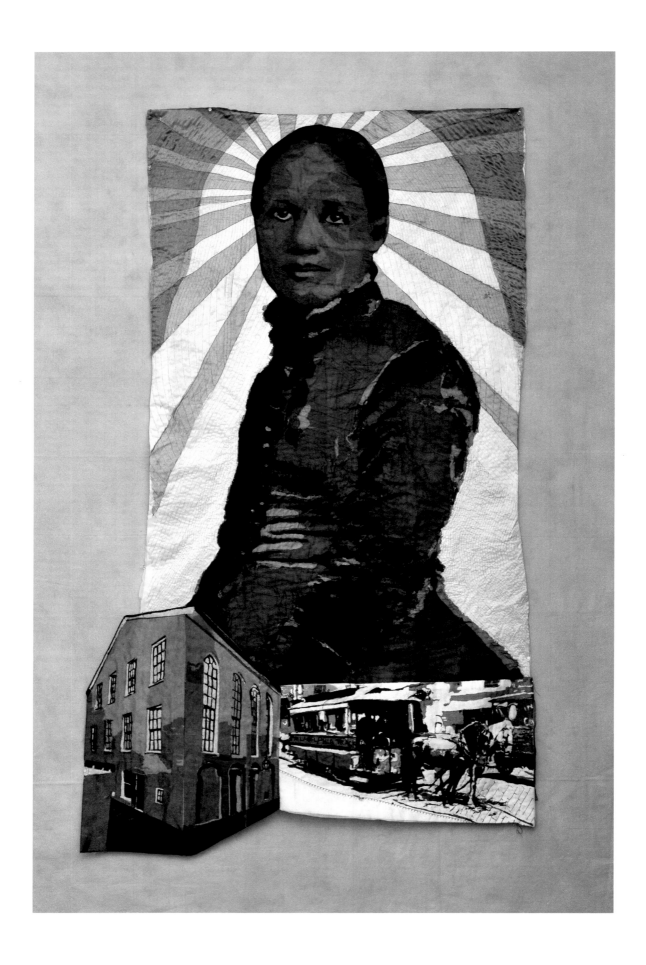

1853 | The Bronze Muse:
Frances Ellen Watkins Harper

L'Merchie Frazier (Dorchester, Massachusetts); 2013; 77 x 45 inches; sheer nylon fibers, monofilament threads; collage, machine quilted; photo courtesy of artist.

The seminal life and work of Frances Ellen Watkins Harper is the focus of my quilt, *"The Bronze Muse:" Frances Ellen Watkins Harper.* Frances ranks among courageous black women, including Rosa Parks and Sojourner Truth, who performed tireless acts of resistance, confronting the impact of slavery as model advocates for the cause of human and civil rights. She began her career as a public speaker and political activist after joining the American Anti-Slavery Society in 1853.

Born free in Baltimore, Maryland, she was a novelist, poet, orator, and abolitionist. One of the best-known black women of her time, Harper was referred to as "the Bronze Muse." During the Victorian era, when few women dared to speak before the public realm's mixed audiences, she was a much-admired and sought-after activist, and was hired by the Pennsylvania Anti-Slavery Society as official lecturer and agent, traveling throughout the United States and Canada.

Frances was orphaned at an early age and cared for by her uncle, Rev. William Watkins, founder of a school for black children, which she attended. Her fine education and entrepreneurial efforts were evidenced in the sale of over 50,000 copies of her numerous published works, which featured concepts of citizenship and nationhood that critiqued existing society and created models of reform. Her poem "The Slave Mother" denounces slavery's compromising of the powerful bond of mother and child.

Harper's activism as a black woman compelled her to prioritize racism above sexism, suggesting that African-American writers present their own stories to break the cycle of misrepresentation that contributed to the oppression of black Americans. The act of telling one's own story to affirm one's right to justice is illustrated in her 1892 novel, *Iola Leroy,* her poetry, *Poems on Miscellaneous Subjects,* and the recently rediscovered *Minnie's Sacrifice, Sowing and Reaping, Trial and Triumph.*

Harper spoke on the same themes about which she wrote—abolition, equal rights, temperance, education, community service, morality, and personal integrity—for numerous organizations and movements, including the Underground Railroad, the National Association of Colored Women, and the American Equal Rights Association.

She had moved to Pennsylvania when, in 1854, the fugitive slave law prevented her from returning to her home state of Maryland as a free woman. Harper's sit-in efforts to integrate Philadelphia's horse-drawn streetcars in 1857 are legendary. The quilt presents narrative images of incidents from her story, with the scenes of a Philadelphia horse-drawn streetcar and Boston's African Meeting House, where she delivered lectures in 1854 and 1864.

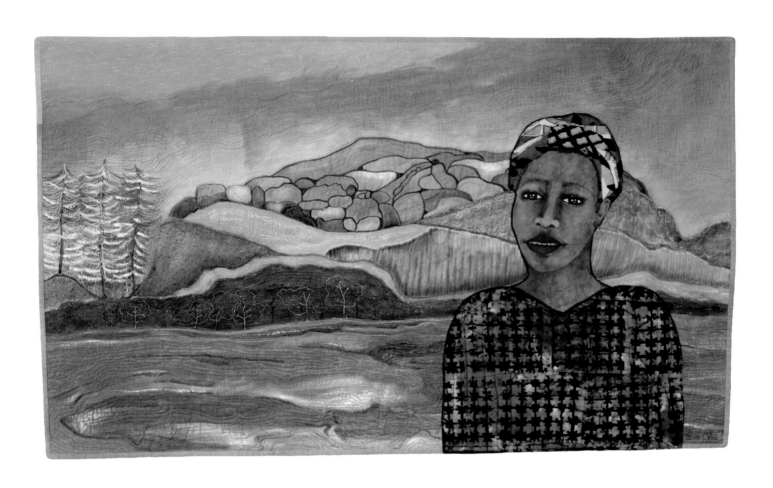

48

1858 | Julett Miles at the River's Edge

Valerie White (Denver, Colorado); 2008; 32 x 50 inches; cotton hand dyed by artist; fabric paint; oil based paint sticks, tulle, African fabric, cotton batting; drawing; hand painted; machine quilted; photo by Chas. E. Martin.

The story of Julett Miles is a sad but familiar chronicle. What makes her story important is that it is one of the rare documented accounts of a black woman's efforts to free her children from oppression. For me, Julett represents all of the untold stories of the brave women who tried in vain to rescue their children from the perils of slavery. This narrative is factually documented.

In 1851, John Gregg Fee purchased Julett from his father. Some information maintains that Julett had taken care of John Fee as an infant. Other facts reveal that his mother was not happy with her emancipation and insisted his father offer to buy her back. The son refused to sell her.

Upon her emancipation, Julett was immediately ordered off the farm. John Fee, Sr., would not release her children without a hefty price, which of course she did not have. It was at the strong request of John Fee's mother that Julett was given a home on that farm with her children and soon to be free husband. Julett and her husband remained on the farm in slavery rather than leave their children.

In 1858, Julett arranged for her two sons, three daughters, and four grandchildren to flee to Felicity, Ohio. In the early morning of Monday October 18, 1858, they were discovered on the banks of the Ohio River at Rock Springs in Bracken County, Kentucky. Julett had arranged for help to cross the dangerous Ohio River in the early morning light, but the "friends" from the other side of the river were not there. She was captured by slave traders and remanded to jail, charged with enticing slaves. The warrant bill was $500 for the nine children. Having no means to raise the money, her children were sold to slave traders in New Orleans. She was later transferred from the Bracken County Jail to the Kentucky State prison.

Having spent two years in Frankfort, Kentucky, in the State Penitentiary, Julett died in 1860.

On September 18, 2011, this quilt was exhibited at the Union Church in Berea, Kentucky, where John Gregg Fee, Jr., preached and established Berea College. Did what happened to Julett fuel John Fee's ideals? Discovering her, I felt charged with the responsibility of telling her story. "Hallelujah, Julett crossed over."

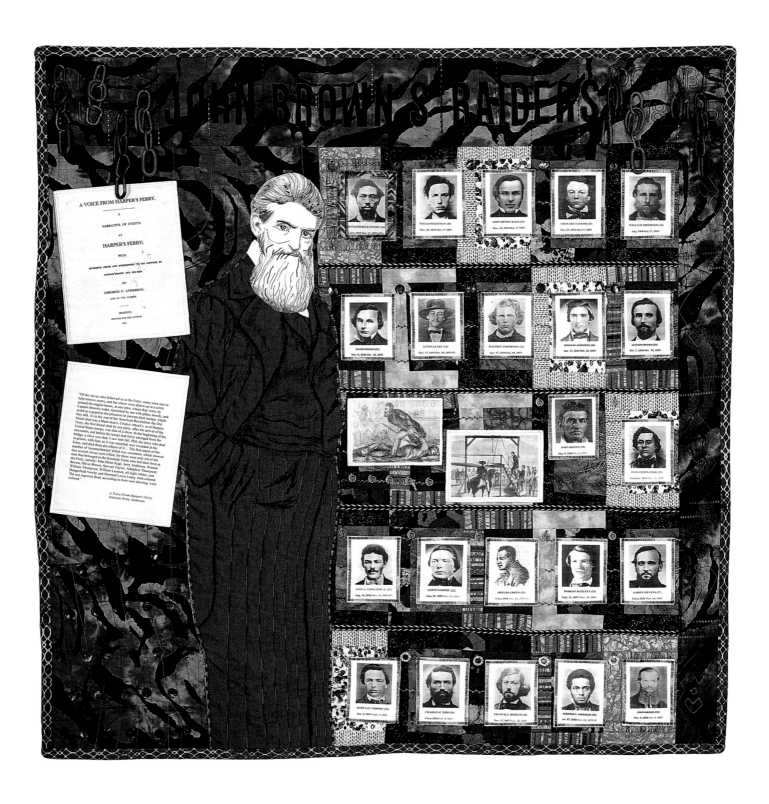

1859 | John Brown's Raiders

Jakki Dukes (Shaker Heights, Ohio); 2012; 50 x 50 inches; cotton, metallic and synthetic threads, metal mesh chains, cotton batting; pieced, appliqué, inkjet print images, stencil painted; photo by Chas. E. and Mary Martin.

In Hudson, Ohio, where John Brown resided for about twenty years, the Historical Society houses one of the largest collections of materials related to Brown in the world. I have spent a bit of time poring through the boxes, but I was not inspired to create a quilt until I read the profiles of his accomplices. What intrigued me most were their young ages and varied backgrounds. Among the twenty-one men were three sibling sets, an uncle and nephew, a Brown in-law, a Canadian, a descendent of a slave owner, and an escaped slave whose wife had begged him to gain her freedom before she was sold—five blacks and sixteen whites bound in a fateful effort to end slavery. Sixteen died and five survived the occupation and the executions. The attack on the armory at Harpers Ferry, Virginia, took place between October 16 and 18, 1859.

On the quilt, the people are arranged in order of their deaths. All images placed before John Brown's execution scene, are the men died during the days of the occupation. The men on the following two rows were executed for their participation. The oldest raider and first to die was Dangerfield Newby. The second to die was the youngest, William Leeman, who was twenty years old. He had been with John Brown in Kansas when he was about seventeen years old, trying to keep Kansas from becoming a slave state.

On the day of his execution, Oberlin student, John A. Copeland, Jr., is quoted as saying, "I am dying for freedom. I could not die for a better cause. I had rather die than be a slave." The last row shows the survivors.

The last survivor was John Brown's son, Owen, who died in 1889. The book pages to the left of John Brown are from the only firsthand publication written by a survivor who had been inside Harpers Ferry. Osborn Perry Anderson, a free Black man, wrote *A Voice from Harper's Ferry* in 1861. Both Frederick Douglass and Harriet Tubman had been approached about participating in the effort to arm slaves while meeting with Brown in Canada. Douglass thought the plan was destined to fail, and Tubman was sick during the event.

I applaud Brown's dedication and I am grateful to all who sought to end slavery, but it should also be noted that he was joined by black people (free and slave) who were also committed to the change. This fact is frequently overlooked when discussing the abolitionist movement. It is important to me that others recognize the special people who tried to correct a wrong.

The quilt is pieced, machine quilted, and enhanced with painted lettering and stitch details. Most fibers are cotton, including the images, which were printed onto cotton and appliquéd to the background. Metallic mesh chains were added to emphasize the desire for freedom.

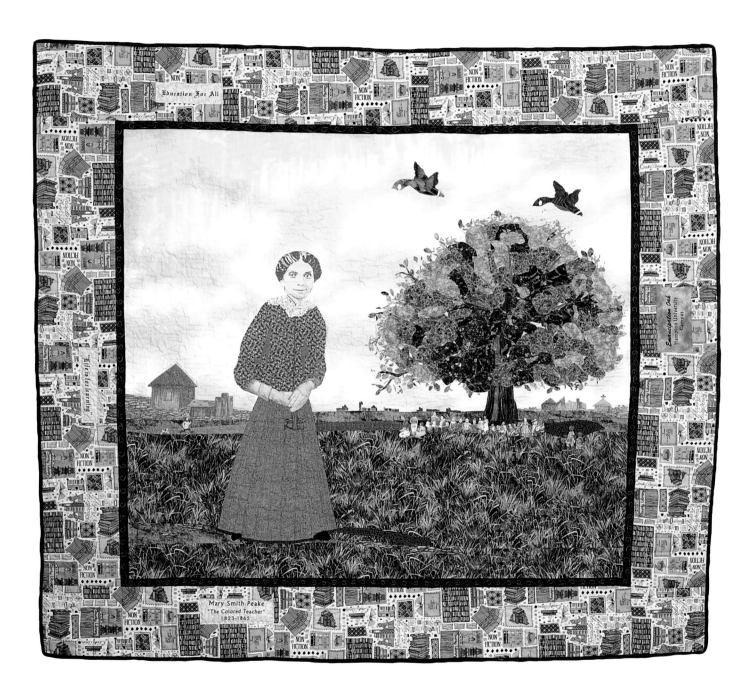

Mary Smith Peake
"The Colored Teacher"
1823–1862

1861 | Mary Peake:
First Colored Teacher

Harriette Alford Meriwether (Pittsburgh, Pennsylvania); 2012; 72 x 82 inches; cottons, vintage prints, cotton batting; piecing, appliqué and machine quilted by Janet Oakes; photo by Chas. E. and Mary Martin.

In 1861, under a simple oak tree, Mary Smith Peake was one of the first black teachers to teach children of freed slaves.

Many have written accounts of education for freedmen and their children. However, the Rev. Lewis C. Lockwood's eloquent account of Mary Smith Peake touched me in a special way. He was the first missionary to the freedmen at Fort Monroe in Virginia, and he greatly admired Mary Peake. Touched by this account and other writings, I created a rendition of Mary Smith Peake, a woman larger than life, preparing to teach children of former slaves. She was known as one of the first colored teachers. Hired by the American Missionary Association, she began teaching freed children on September 17, 1861, outside, under a large oak tree in Phoebus, a small town in Elizabeth City County, known today as Hampton, Virginia.

In 1863, the Virginia Peninsula community gathered under this oak tree to hear the first southern reading of President Abraham Lincoln's Emancipation Proclamation, and the tree became known as the "Emancipation Oak." This historic tree is located on the campus of Hampton University (formally Hampton Institute) and designated a National Historic Landmark. The Emancipation Oak still stands as a symbol of hope, courage, determination, and inspiration for education for all. The tree depicted in the quilt is representative of the Emancipation Oak and symbolizes all that Mary Smith Peake envisioned for the community she served.

The children in this quilt represent those who came from nearby Fort Monroe, a place of refuge for freed and escaped African-American slaves seeking asylum. During the American Civil War, Union forces retained control of Fort Monroe. The Union had defined slaves as contraband to avoid returning them to slaveholders, so any slave that made it to Fort Monroe would find a haven. The Union constructed the Grand Contraband Camp near Fort Monroe to house them. The children are said to have exhibited a remarkable desire to learn, and over time, even white teachers expressed their amazement at the children's interest and abilities. Today, children still come from as far as the "east is from the west," and they know that life is for learning. The birds (flying geese) interspersed on the quilt, denote our constant quest to ascend towards our personal ambitions. This inner yearning must never cease to flow.

Mary Smith Kelsey Peake's unwavering dedication—from her early upbringing and teachable moments, to her education in Virginia, especially in Alexandria, her development of character, her strong desire to reach out to others, and her powerful resolve for human accomplishment—led me to a place of confirmed creativity. In addition, inspiration came from my father, Rev. James A. Alford (deceased), my sister Rosemary A. Whitehurst of Norfolk, Viginia, and my friend Clarence Curry and his wife Agnes. Clarence grew up in Aberdeen Gardens, Hampton, Virginia, near Mary Peake Boulevard, and once said, "we knew the streets were named after notable black achievers, but never researched who these people were." Lastly, I was inspired by those who helped to move the mountains of racial and human injustice.

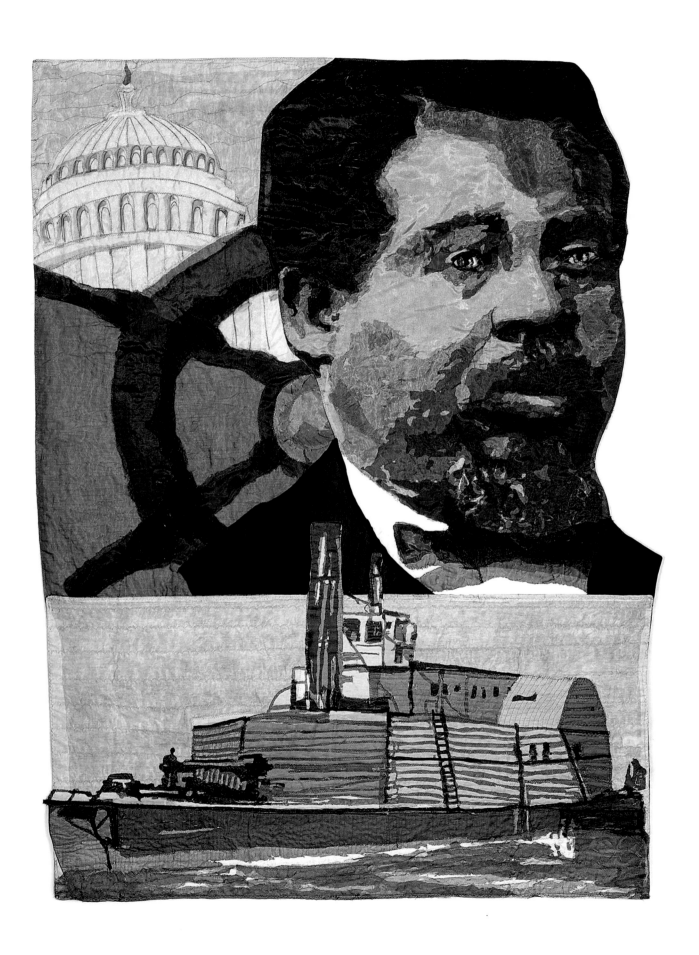

1862 | Robert Smalls:
Wheeling Freedom

L'Merchie Frazier (Dorchester, Massachusetts); 2012; 38 x 64 inches; organza, cotton batting, monofilament thread; appliqué; collage layering, machine quilting; embroidery; photo by Chas. E. and Mary Martin.

My people need no special defense, for the past history of them in this country proves them to be equal of any people anywhere. All they need is an equal chance in the battle of life.
—Robert Smalls, November 1, 1895

Robert Smalls (1839–1915) was born on April 5, 1839, in Beaufort, South Carolina, where his mother was enslaved. His Gullah name was Swonga. He escaped slavery in 1862, along with his family. As an wheelman on a steamer called the *CSS Planter* in Charleston Harbor, he and the other enslaved crew members on the vessel conspired to commandeer the *Planter*, taking it past five Confederate checkpoints and surrendering its contents to the northern Union naval fleet out in the harbor, where it was blockading the important southern port. Robert, knowing the waterways and codes, succeeded in his effort.

As pilot of the ship, President Abraham Lincoln rewarded Smalls handsomely with bounty-money and a commission into the Union Navy as a captain of a vessel —the *Planter*. He was the first black Captain of a U.S. Naval vessel.

Three months later, Smalls would visit Abraham Lincoln in the White House to plead for the opportunity for blacks to fight for the Union. Just days afterwards, Lincoln approved the raising of the first black troops to be dressed in the blue uniform of the North. Robert Smalls was instrumental in helping to start the 1st South Carolina Infantry of U.S. Colored Troops and was responsible for transporting the 54th Massachusetts Regiment to Fort Wagner in 1863.

Smalls would go on to pilot the *Planter* for the Union cause and take part in several important engagements around Charleston and the Sea Islands. After the Civil War, he and a few other black men were elected to the U.S. Congress, where he served for five terms.

Robert Smalls's story is an amazing one, showing his courage, determination, sacrifice, risk, and reward.

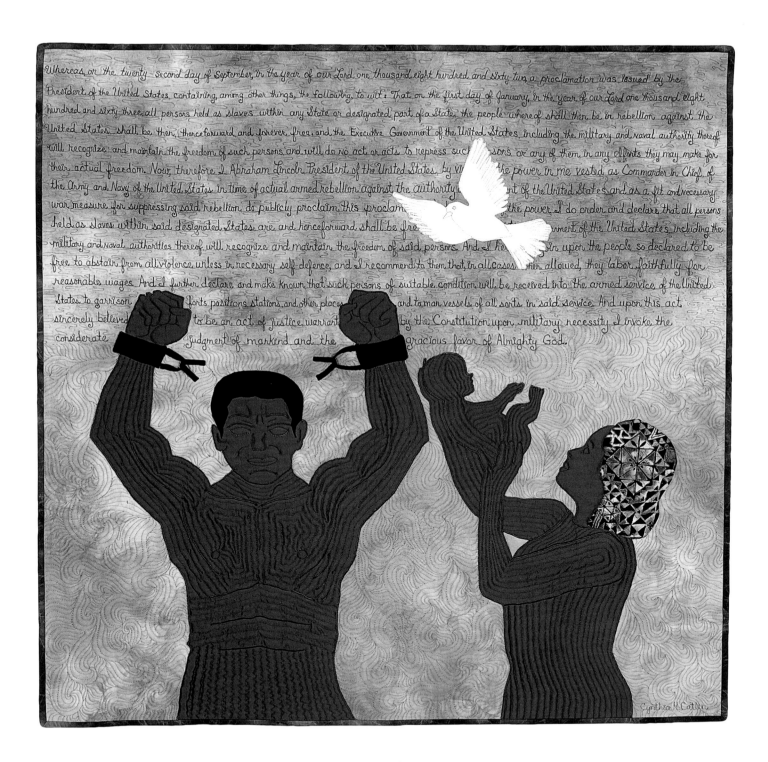

56

1863 | The Beginning of Social Justice

Cynthia Catlin (San Pedro, California); 2012; 35 x 35 inches; dyed cottons, suede, wool batting, and metallic and rayon threads; machine appliqué, machine quilting, free-motion machine quilting and embroidery; photo by Chas. E. and Mary Martin.

In 1863, President Lincoln issued the Emancipation Proclamation declaring, "all persons held as slaves" within the Confederate states "are, and henceforward shall be free." This proclamation was a massive turning point in our history. This order also publicly declared that such persons of suitable condition are received into the armed services of the United States.

This was the beginning of social justice in America, though only the slaves who lived in areas of rebellion against the Union were freed. Emancipation brought immense jubilation to many slaves, but numerous lives went unchanged, as they were not told of their new freedom by their slave masters and remained in bondage for several more years. Even so, this singular event in American history initiated the journey of social justice that is still progressing to this day.

This artwork is intended to represent the enormous contribution slaves made to the fabric of this country. As we honor the signing of the Emancipation Proclamation, we celebrate the journey to freedom.

We celebrate and give praise to the strength of the African-American family and the value of humanity for all persons. The background of this artwork is stitched with excerpts from the Proclamation. The breaking of chains indicates freedom at last. The uplifted baby represents a "hallelujah" moment in time and hope for the future. Future generations will forever recognize this enormous achievement in our national history. The white dove symbolizes the Holy Spirit and the blessing of this declaration. This proclamation began a continuous celebration of freedom, liberty, and justice. It also created the opportunity to recognize the many contributions of African-Americans to the strength of this country. Each one of us now has the opportunity to spread our wings and soar. Each time you look at this textile art, may it renew your strength!

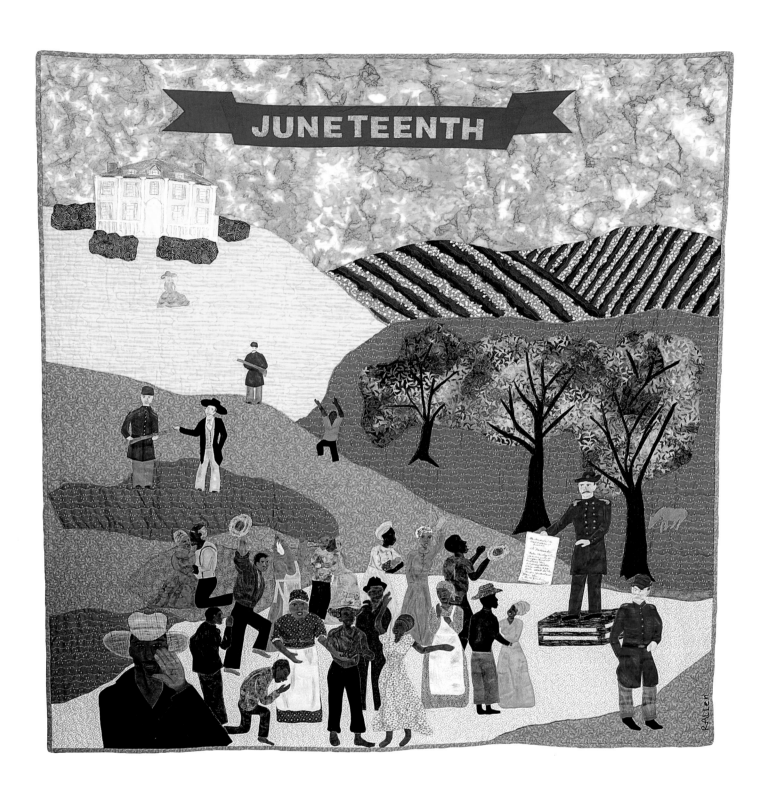

1865 | Juneteenth

Renee Allen (Ellenwood, Georgia); 2012; 60 x 60 inches; cotton fabric, cotton thread, colored pencils, cotton batting; machine appliqué and quilting, hand painted with acrylic paint and hand-drawn appliqué images; photo by Chas. E. and Mary Martin.

Juneteenth, or June 19, 1865, is considered the date when the last slaves in America were freed. President Abraham Lincoln issued the Emancipation Proclamation on September 22, 1862, with an effective date of January 1, 1863, but it was not until two-and-a-half years later that slaves in Texas learned of their freedom.

During the Civil War, Texas did not experience any significant invasion by Union forces. As a result, slavery in Texas continued to thrive. News of the emancipation was suppressed, probably due to the overwhelming influence of the slave owners.

On June 19, 1865, Union General Gordon Granger and Federal troops arrived in Galveston, Texas, to take possession of the state and enforce the emancipation of its quarter-million slaves. General Granger issued General Order Number 3, which read in part, "The people of Texas are informed that, in accordance with a proclamation from the Executive of the United States, all slaves are free. This involves absolute equality of personal rights and rights of property between former masters and slaves, and the connection heretofore existing between them becomes that between employer and hired labor."

As depicted in the quilt, after the proclamation, there were joyous, yet timid outbreaks among the ex-slaves. Prayers were whispered and shouted, songs were sung, and hands and burdens were lifted.

Unsure of exactly what the future held, the newly liberated slaves felt optimistic. They were hopeful that families could stay together and that legal marriage licenses could be obtained. Freedom meant the right to travel freely. Many freedmen gave themselves new names after learning to read and write.

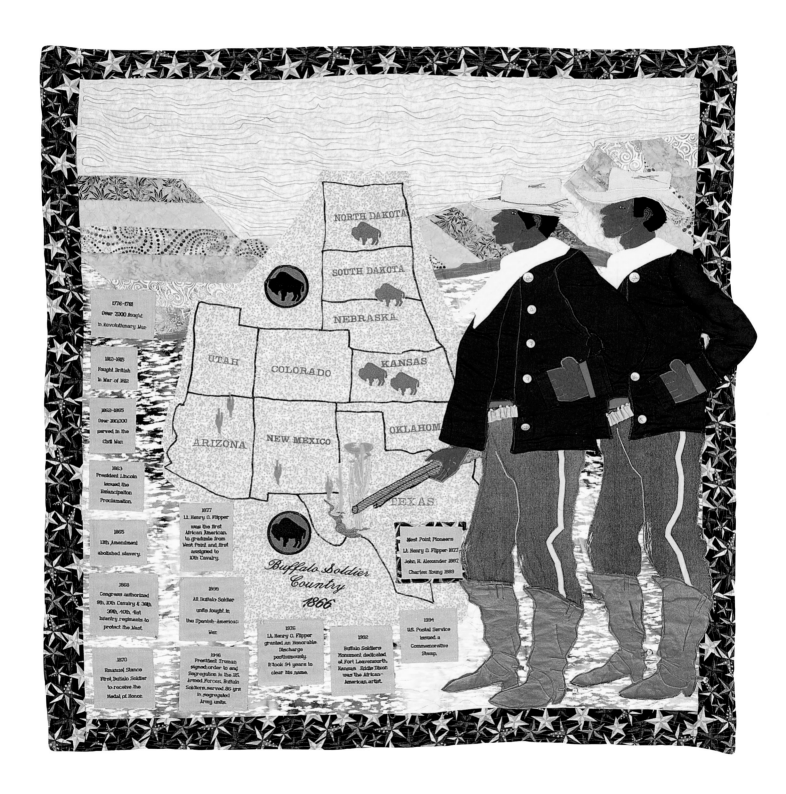

1866 | The Undaunted Buffalo Soldier

Gloria Kellon (Shaker Heights, Ohio); 2012; 50 x 50 inches; cotton, faux leather, metal buttons, Persian lamb fur, grosgrain ribbon, knit, cotton batting; strip piecing, appliqué, machine embroidery and quilted; photo by Chas. E. and Mary Martin.

The life of the Buffalo Soldier, often considered a romantic adventure today, was, in reality, a life of constant danger, long days in the saddle, harsh living conditions, poor food, equipment, and shelter, as well as racism. African-American soldiers have fought in every great war in American history, from the American Revolutionary War until today's wars. In the Civil War alone, 200,000 African-Americans served to bring about change.

In 1866, at the end of the Civil War, Congress established The 10th Calvary of the U.S. Army. Many African-Americans men jumped at the opportunity to enlist for five years and earn $13 dollars a month to start a new life. Their mission was to protect the settlers moving westward and to help build and defend these new communities. At the outset, the soldiers were given substandard barracks, no flag, poor horses, and no blankets or uniforms. Their commanding officers were prejudiced and did not want to lead them.

In spite of these obstacles, the African-Americans fought courageously and had the lowest desertion rate of all of their counterparts. Over the years, the outstanding performances led to the establishment of more units. It is said that Native Americans named the Buffalo Soldiers out of respect for their capabilities and because of their hair. Among Native Americans, the buffalo was admired.

Buffalo Soldiers fought in the Indian Wars, Spanish American War, Philippine-American War, Mexican Expedition, Battle of Ambos Nogales, World War I, and World War II. Twenty-three Buffalo Soldiers received the Medal of Honor at the close of the Indian Wars. The 54th Massachusetts Regiment Volunteer Infantry and the 1st South Carolina Infantry both volunteered and fought during the Civil War and the War of 1812.

The ninth Calvary regiment was considered to have outstanding equestrians. On one occasion, its men were detached to teach the West Point officers to ride. William O. Flipper, an ex-slave, was admitted to West Point. After four years of enduring racism and studying diligently, he received his commission as second lieutenant in the U.S. Army.

In the Korean War, the 24th Infantry served as the last of the segregated regiments. In 2005, Mark Matthews, the oldest living Buffalo Soldier, died at the age of 111. Many Buffalo Soldiers serve as Park Rangers today.

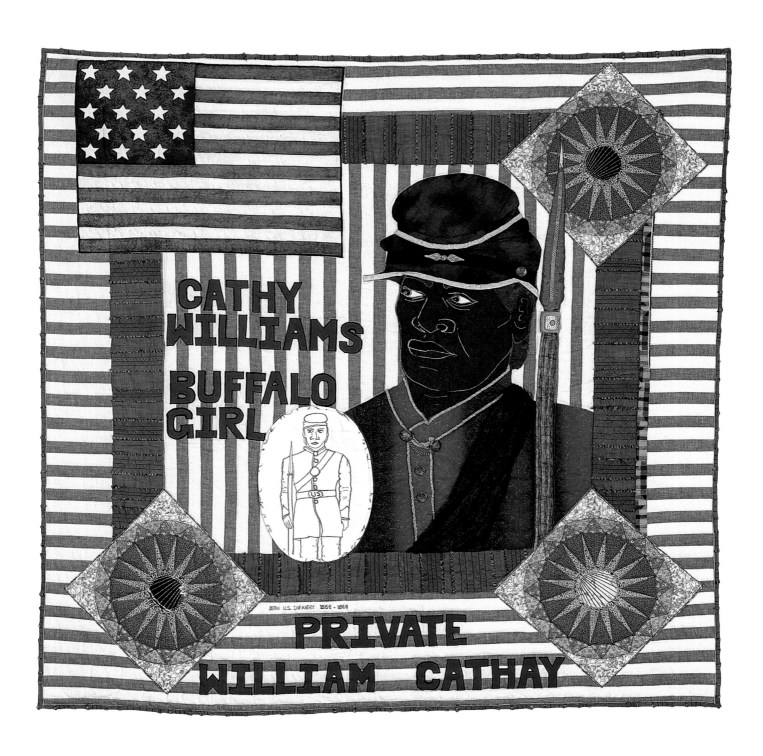

CATHY WILLIAMS BUFFALO GIRL

38TH U.S. INFANTRY 1866 - 1868

PRIVATE WILLIAM CATHAY

1866 | Cathy Williams:
Female Buffalo Soldier

Allyson Allen (Sun City, California); 2012; 50 x 50 inches; cotton, velvet; satin, African and ethnic prints; embellished with glass beads, fabric yo-yo's, buttons, metal chain, leather, jewelry findings, silver rayon thread and gold cording, cotton batting; in-set center panel with thread drawn details, hand and machine appliqué and quilted; photo by Chas. E. Williams.

Cathy Williams was born in 1850 in the state of Missouri to a free man of color and a woman in bondage; her status was that of a slave. In 1861, during the early stages of the American Civil War, captured slaves were classified by the Union as "contraband," and were pressed into military service. Williams worked as a cook and laundress for the Union Army. She traveled with the Army through Arkansas, Louisiana, and Georgia over the next few years. In November 1866, after the Civil War, she enlisted in the U.S. Army disguised as a man, becoming "Private William Cathay." She was assigned to the 38th Infantry, a unit of Buffalo Soldiers serving first at Fort Cummings, New Mexico then, later, at Fort Bayard until 1868. Soon after enlisting, Williams contracted smallpox and was hospitalized several times over the next two years. She suffered from the effects of that disease, as well as arthritis, fatigue, and the effects of the harsh New Mexico environment. Eventually, a post surgeon discovered she was a woman and reported her to the post commander. She was discharged from the Army in October 1868. Cathy Williams is the only documented woman to enlist and serve in the Regular U.S. Army during the 19th century.

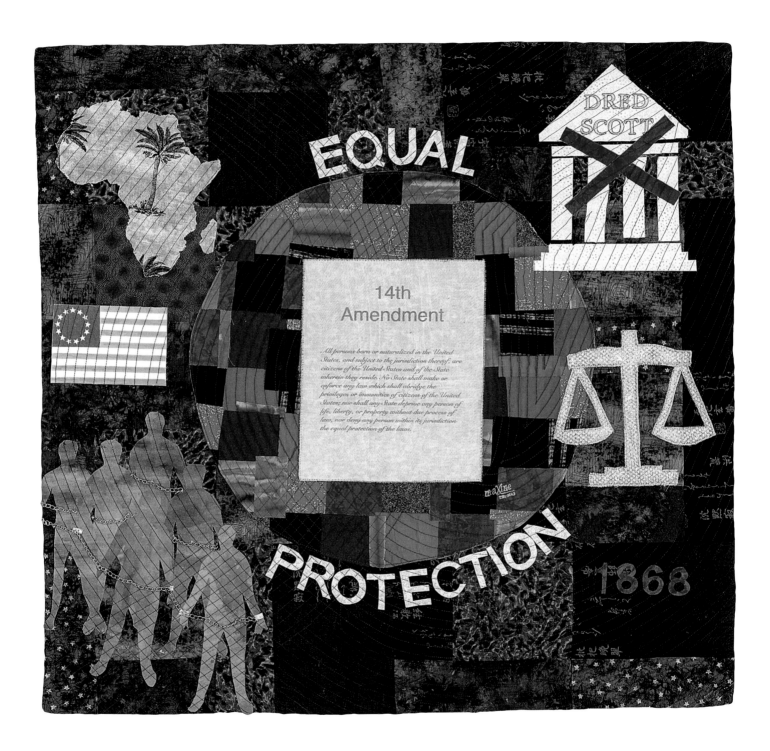

EQUAL

PROTECTION

DRED SCOTT

14th
Amendment

All persons born or naturalized in the United
States, and subject to the jurisdiction thereof, are
citizens of the United States and of the State
wherein they reside. No State shall make or
enforce any law which shall abridge the
privileges or immunities of citizens of the United
States; nor shall any State deprive any person of
life, liberty, or property without due process of
law, nor deny any person within its jurisdiction
the equal protection of the laws.

1868

1868 | 14th Amendment

Maxine S. Thomas (Jamestown, Ohio); 2012; 60 x 60 inches; commercial and hand dyed cotton, cotton batting, metallic thread; machine appliqué and quilted; photo by Chas. E. and Mary Martin.

In 1868, the Fourteenth Amendment to the Constitution was ratified, defining U.S. citizenship and equal protection. The amendment was proposed in response to issues related to former slaves following the American Civil War. The 14th Amendment states that individuals born or naturalized in the United States are American citizens, including those born as slaves. The amendment nullified the 1857 decision in Dred Scott v. Sandford, which had ruled that blacks were not citizens. It affirmed that no person should be denied "equal protection of the laws," and required the states to provide equal protection under the law to all persons (not only to citizens) within their jurisdictions. The amendment was used in the mid-20th century to dismantle legal segregation, as in Brown v. Board of Education. Its Due Process Clause has driven many important and controversial legal cases regarding privacy rights, such as in the abortion rights cases, and other issues. The first section formally defines citizenship and requires the states to provide civil rights. The second section establishes rules for establishing the number of a State's representatives in Congress, essentially counting all residents for apportionment and reducing apportionment if a state wrongfully denies a person's right to vote.

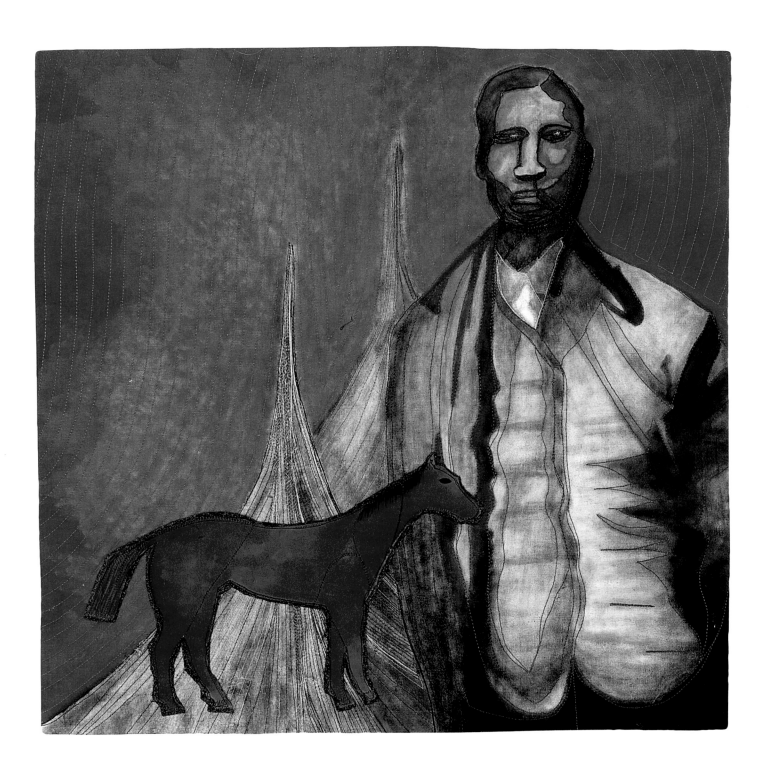

1875 | Oliver Lewis

Karen R. Davis (Louisville, Kentucky); 2012; 19 x 20 inches; cotton, wool batting, thread, acrylic paint, ink, synthetic fiber, and dyed by artist; hand painting, drawing, machine stitched, and appliqué; photo by Chas. E. and Mary Martin.

Born in Louisville, Kentucky, and raised by a mother who loved horseracing, Oliver Lewis was the first jockey to win the Kentucky Derby, a race that would later be known as "the fastest two minutes in sports." His commemoration was a natural selection for me.

In 1875, Lewis rode Aristides in the inaugural Derby at then-named Louisville Jockey Club. The twin spires, the allure, glitz, and glam of Churchill Downs was something that, in 1875, could only be imagined in the far-off future. Thus, the quilt consists of the dreamy gaze of Lewis in this quilt, the undecorated winning horse, and the twin spires (an element from decades later) set behind him.

Lewis was one of thirteen African-American jockeys in the race, out of a total of fifteen jockeys. Although the Derby, in its beginning, did not have mass appeal among all sectors of society, it did provide a way for African-Americans to improve their economic status. Lewis only raced for one season, but remained in the industry by working as a bookie (then legal) in Cincinnati.

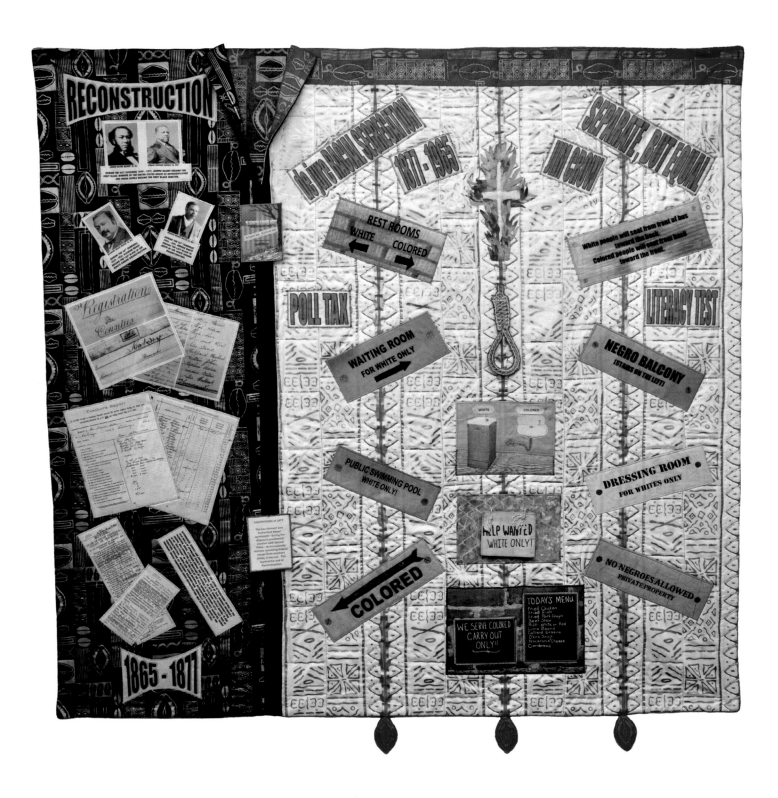

1877 | 'Buked, Scorned, and Resilient

Marlene Seabrook (Charleston, South Carolina); 2012; 50 x 50 inches; African and commercial fabrics, photo transfers, Prismacolor pencils, Tsukineko ink; Eta; transfer art paper, zipper, iPad apps, cotton batting; machine appliqué and quilted; photo by Chas. E. and Mary Martin.

Both of my maternal great-great grandfathers voted in the election of 1876. By the time I reached voting age seventy-five years later, that privilege had been denied or thwarted for many persons of my race for seventy-four years. The 2012 election year was a powerful reminder of how achieved gains can be lost!

During Reconstruction, blacks flourished politically at national, state, and municipal levels. South Carolina became the only state in the Union with a majority black legislature. It is no surprise that this was disturbing to whites in the state where the first shots of the Civil War were fired, the state that had been the first to secede from the Union. The "Red Shirt" movement started there with the purpose of coordinating voter intimidation and fraud and putting an end to majority negro rule. Leaders of the movement were responsible for a July 1876 incident in the town of Hamburg that became known as the "Hamburg Massacre" and began the "unzipping" of Reconstruction. The recognized leader of the Hamburg incident was part of a group that went to Washington during the 1876 presidential contest between Rutherford Hayes and Samuel Tilden. In a backroom deal, now known as the Compromise of 1877, South Carolina agreed to give Hayes its electoral votes if Hayes would promise to remove all federal troops—Reconstruction enforcers—from the state. Hayes kept his side of the deal and Reconstruction was "unzipped."

Almost a century of de jure racial segregation followed—from 1877 until the Voting Rights Act of 1965. Marked by violence and bloodshed, they were called the Jim Crow years.

The Fifteenth Amendment prohibited explicit disenfranchisement based on race or prior enslavement, but Southern states went around the law, using techniques of violence, fraud, poll taxes, literacy tests, arbitrary registration practices, and white-only primaries. Congress did not uphold the Fourteenth Amendment, which allowed it to reduce the congressional representation of Southern states in proportion to its illegal disenfranchisement. The Supreme Court undermined Federal Executive powers to protect black voting rights and ignored blatant racial discrimination. While blacks never lost the right to vote in the North, they could not live in many places. Between 1890 and 1968, thousands of all white "sundown towns" were established. These "no blacks after dark" suburbs excluded blacks through legal formalities or violence and forced them into urban ghettoes.

While I heard or read about cross burnings and lynchings, my most vivid personal memories of the Jim Crow years involve the signs. There were signs everywhere—handwritten, printed, painted, nailed, screwed—to remind persons of African heritage that their country, the United States of America, considered them to be second class citizens. Using digital technology and transfer artist paper, I recreated signs that I remembered as the most insulting. There were times when I literally could not work on the quilt, as feelings long suppressed, and some that I never realized existed, bubbled to the surface. The old negro spiritual "I've Been 'Buked and I've Been Scorned" came to my mind, as I thought about the indignities, abuse, and lynching.

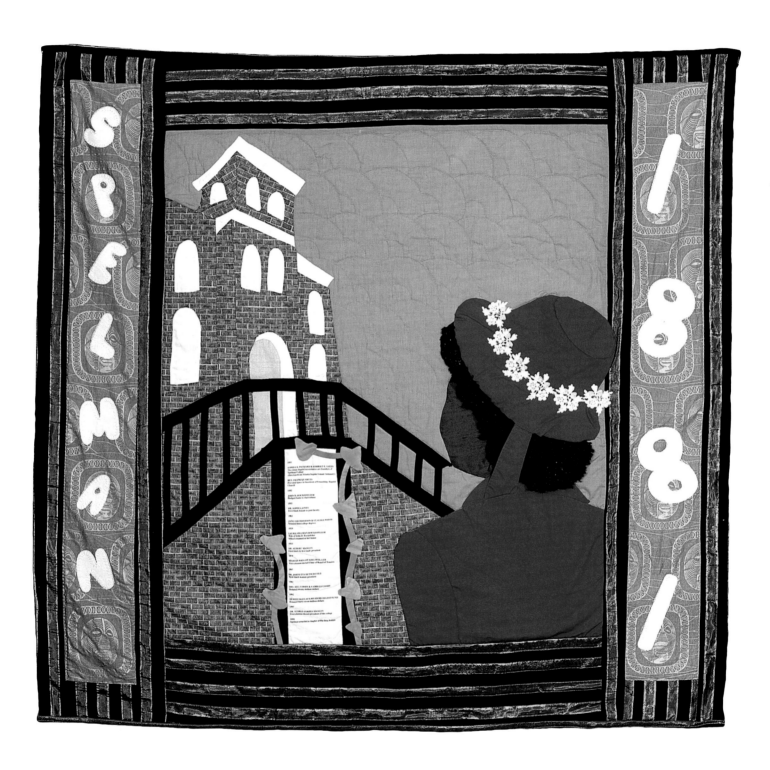

1881 | History of Spelman College

Hilda Vest (Detroit, Michigan); 2012; 50 x 50 inches; cotton, Ghanaian fabric, yarn, cotton batting; appliquéd and quilted; photo by Chas. E. and Mary Martin.

The history of Spelman College began in 1881, when two white missionaries, Sophia Packard and Harriet Giles, founded the school as Atlanta Baptist Female Seminary. They believed that all women had the right to an education. Rev. Frank Quarles provided space in the basement of his church while John D. Rockefeller supported their efforts through his philanthropy. In 1884, the school was renamed Spelman Seminary in honor of Rockefeller's wife, Laura Spelman. The first class consisted of ten women, several of whom were former slaves. Giles and Packard promoted strict Victorian-era standards, which meant that women wore hats and gloves in public, and always behaved in a genteel manner.

Among the many Spelman traditions is the Ivy Oration. The senior class meets to reflect on their years at Spelman and the valedictorian delivers the Ivy Oration. Afterwards, she plants ivy beside one of the buildings to enhance the beauty of the campus.

Inspiration for my quilt began with a replica of Packard Hall, which was dedicated in 1888 and is named in honor of Sophia Packard. It represents the school and serves as a symbol of education.

The woman in the quilt represents a typical student of the Victorian Era, while the plant demonstrates the outcome of the Ivy Oration. Since former slaves were part of the first class, African textiles are included as homage to their presence. Blue and white are incorporated into the quilt because they are the school colors. Finally, the text includes pertinent historical facts, such as the generous donation by Drs. Bill and Camille Cosby.

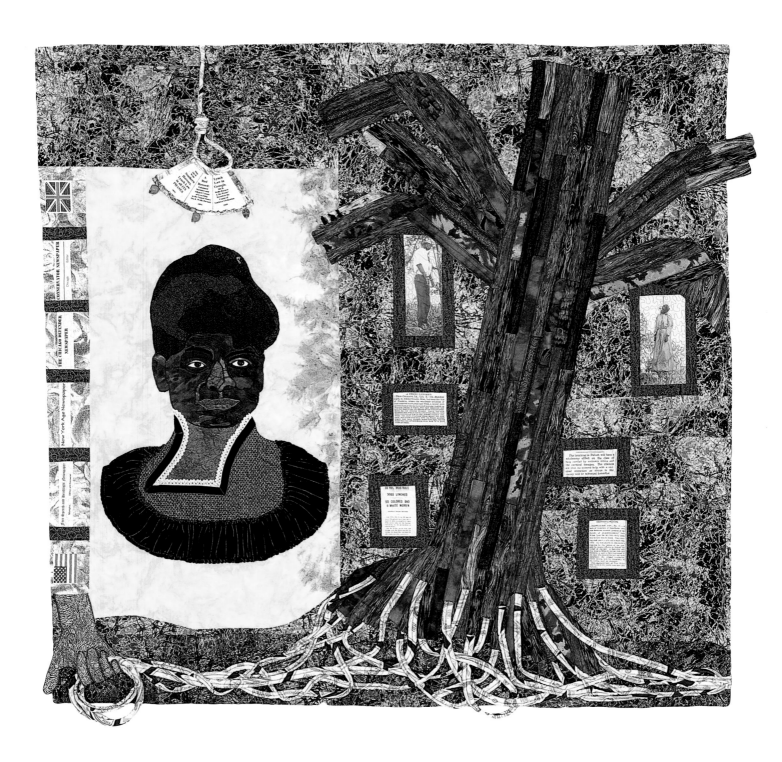

1892 | An Extraordinary Woman for No Ordinary Day

Sauda A. Zahra (Durham, North Carolina); 2012; 50 x 50 inches; commercial cottons, batik and velveteen fabrics; photo transfers; embellishments, cotton batting; machine and hand pieced, machine and hand quilted; photo by Chas. E. and Mary Martin.

Ida B. Wells (July 16, 1862–March 25, 1931) is credited with initiating the first anti-lynching campaign in the United States. She was twenty-nine years old when she launched her crusade against lynching after three friends were lynched in Memphis, Tennessee. On March 9, 1892, Thomas Moss, Calvin McDowell, and Henry Stewart, owners of the People's Grocery Company, were lynched for crimes they did not commit. Wells, a journalist and co-owner/editor of the black *Free Speech and Headlight* newspaper, was outraged and wrote articles about their lynchings. Her speech in 1892, "Southern Horrors: Lynch Laws in All Its Phases," was pivotal to her mission to expose the horrific violence against blacks. Wells used the power of her writing, investigative journalism, and persuasive rhetorical prowess to campaign against lynching throughout the United States and Europe.

The quilt represents significant aspects of Wells's fight against lynching. Her portrait is surrounded by a bright background to illuminate her efforts to shine a light on one of the darkest times in American history. Despite threats from whites to lynch her, Wells was determined to challenge the reasons given by whites for lynching. The large tree represents the magnitude of the violence against blacks and the breadth of her crusade. It is tilted to emphasize how Wells single-handedly shook the foundation of lynching by exposing what she believed was at its root: lynching was meant not to penalize criminals but was a way to control, terrorize, or punish blacks who competed economically with whites.

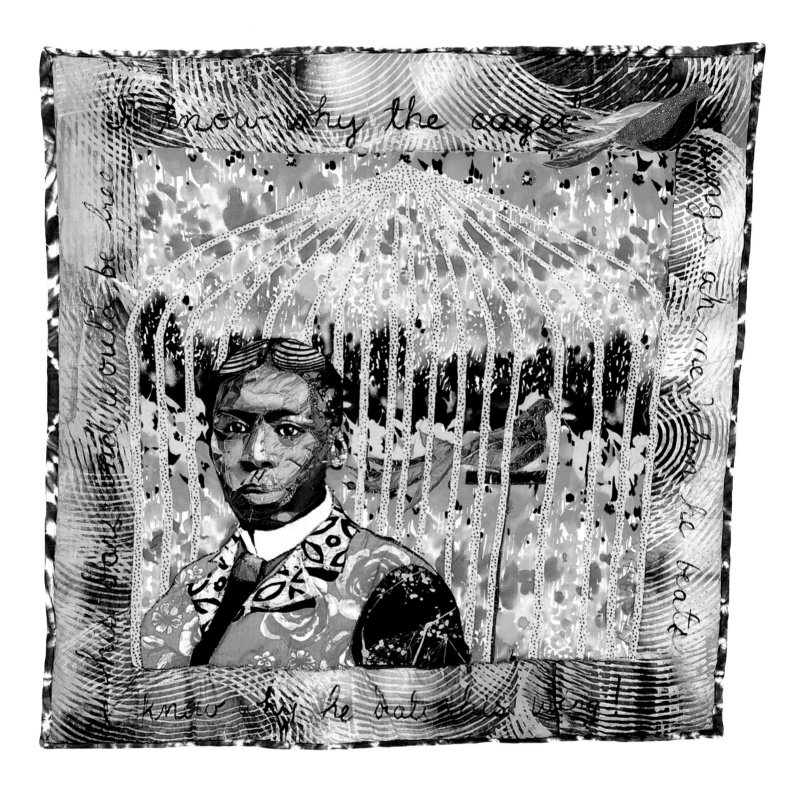

1896 | I Know Why the Caged Bird Beats His Wings

Bisa Butler (South Orange, New Jersey); 2012-13; 50 x50 inches; cotton; rayon; linen; silk; chiffon, cotton batting; machine appliqué and quilted; photo by Chas. E. and Mary Martin.

I went to school in Washington DC; Howard University to be exact. Every day, when I walked to school, I would pass Dunbar High School. I would see the football team practicing or kids on their way home, but I never knew who the school was named after or why. Later, at school, I was introduced to the words of Paul Laurence Dunbar and I was inspired and intrigued. I was contemplating changing my own major from Architecture to Art and I was faced with a dilemma. My father asked me how I expected to make a living as an artist, but I was convinced I had the answer. I read about Paul Laurence Dunbar, who was one of the first nationally accepted African-American writers at a time when the literacy rate of African-Americans was only 30%. Just seeing his picture and reading his eloquent words filled me with hope. When I read about the "little brown baby wif spa'klin' eyes" and "the mask that grins and lies," I realized that this young man made a name for himself in this world. If he could do it, so could I.

I learned that Paul Laurence Dunbar High School was actually the first high school for African-American students in the country. The name was chosen because Dunbar stood for education, pride, class, and success. Every photo I have seen of Dunbar shows him smartly dressed, wearing spectacles, and looking far wiser than his young years. He wrote both in standard English and in a Negro dialectic style. This showed me that he was not afraid or embarrassed by the way uneducated African-Americans spoke. Dunbar wanted the world to hear his poems the way our people, our folk, would have actually spoken them. His words allow me to hear what many African-Americans actually sounded like so many years ago. When I read "Jump back, honey, jump back," I could hear the same rhythm in his words that I hear in Hip-Hop music today.

Paul Laurence Dunbar, the "poet laureate of the Negro race," published *Lyrics of a Lowly Life*, which contains some of his best and most famous verse. I chose to put a few lines from Dunbar's poem, "Sympathy," around the borders of my quilt, because there is no better way to depict a writer than to use his own words.

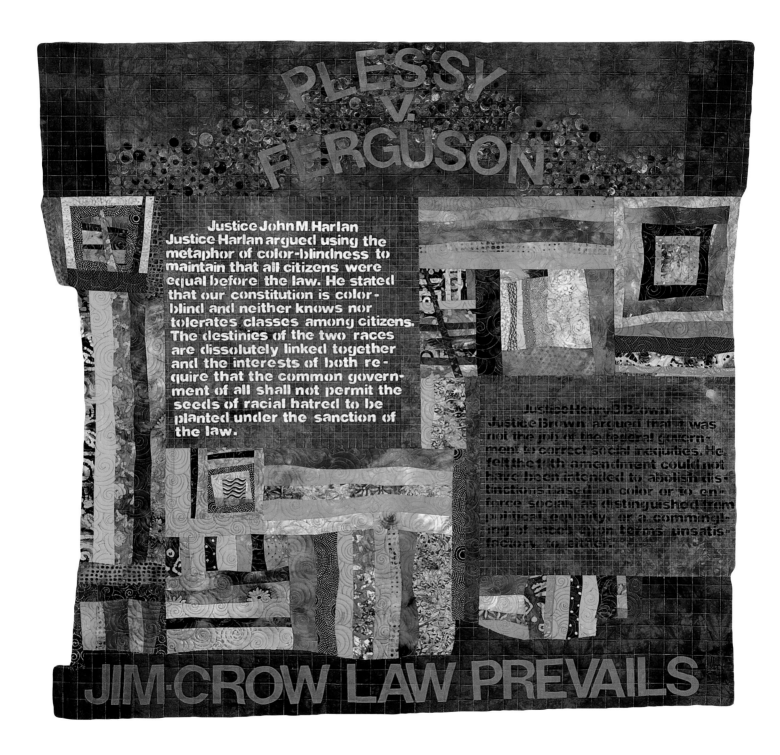

PLESSY V. FERGUSON

Justice John M. Harlan
Justice Harlan argued using the metaphor of color-blindness to maintain that all citizens were equal before the law. He stated that our constitution is color-blind and neither knows nor tolerates classes among citizens. The destinies of the two races are dissolutely linked together and the interests of both require that the common government of all shall not permit the seeds of racial hatred to be planted under the sanction of the law.

Justice Henry B. Brown
Justice Brown argued that it was not the job of the federal government to correct social inequities. He felt the 14th amendment could not have been intended to abolish distinctions based on color or to enforce social, as distinguished from political equality, or a commingling of races upon terms unsatisfactory to either.

JIM-CROW LAW PREVAILS

1896 | Plessy v. Ferguson

Linda Gray (Indianapolis, Indiana); 50 x 50 inches; painted and dyed cotton, embroidered lettering, paint, metallic and polyester threads, cotton batting; painted, appliqué and machine quilted; photo by Chas. E. and Mary Martin.

In the spring of 1890, when the Separate Car Act, a bill designed to segregate the white passengers from the black, came before the Louisiana legislature, it was met with opposition. Louis Martinet, a mulatto lawyer, physician, and the editor of the *Crusader* newspaper, and a group of like-minded citizens protested the bill. Despite their opposition, the bill passed in the State Senate. In response to the passage, Martinet and his allies formed a new organization called the Citizens' Committee to Test the Constitutionality of the Separate Car Act.

On June 7, 1892, Homer Plessy, a man who was one-eighth black, walked pass the "Colored" sign at the New Orleans train station and purchased a first-class ticket to Covington. After boarding the train, Plessy told the conductor that by Louisiana law he was a black man. He was asked to retire to the colored coach known as the Jim Crow car. When Plessy refused to switch coaches, he was arrested and booked. Plessy's act of civil disobedience was no happenstance. It was a carefully orchestrated plan by Martinet's committee to test the law. Martinet hired a private detective and won the cooperation of the railroad company; the railroad secretly objected to the Separate Car Act because it created additional expenses by requiring them to run extra cars. To ensure Plessy's safety and avoid any violence, Martinet arranged with the railroad for an arrest to occur before the train started.

There were two major leaders of the plan. Martinet was joined by Albion Tourgee, a famous novelist, lawyer, and judge, and perhaps the nation's leading white proponent of racial equality. Although Tourgee lived in New York, he became the lead attorney for the test. Local attorney James Walker handled the defense, and Judge John Howard Ferguson presided over the case. Unlike most lawyers, Tourgee and Walker wanted a guilty verdict so they could appeal the decision to the next level. After hearing arguments from both sides, Ferguson issued his decision. He maintained that the state had the power to regulate railroads that operated completely within its borders. Plessy's lawyers petitioned the Louisiana Supreme Court to hear the case. In the brief to the court, Tourgee and Walker argued that the Separate Car Act violated both the Thirteenth Amendment, which banned not only slavery but also "badges of servitude," such as segregation, and the Fourteenth Amendment, which gave citizenship to African-Americans and prevented states from making laws that abridged the privileges or immunities of its citizens.

On December 19, 1892, Justice Charles E. Fenner rendered his decision for the Louisiana Supreme Court. By ruling against Homer Plessy, the door for another appeal, this time to the United States Supreme Court, was opened. At the helm of the Supreme Court was Chief Justice Melville W. Fuller. On May 18, 1896, a little more than a month after hearing the arguments, Justice Henry Billings Brown delivered the 7 to 1 majority decision in Plessy v. Ferguson that upheld the previous rulings. Justice David J. Brewer did not participate in the decision, so eight, rather than nine, judges decided the case. Justice Marshall Harlan was the lone dissenter. This decision legalized segregation.

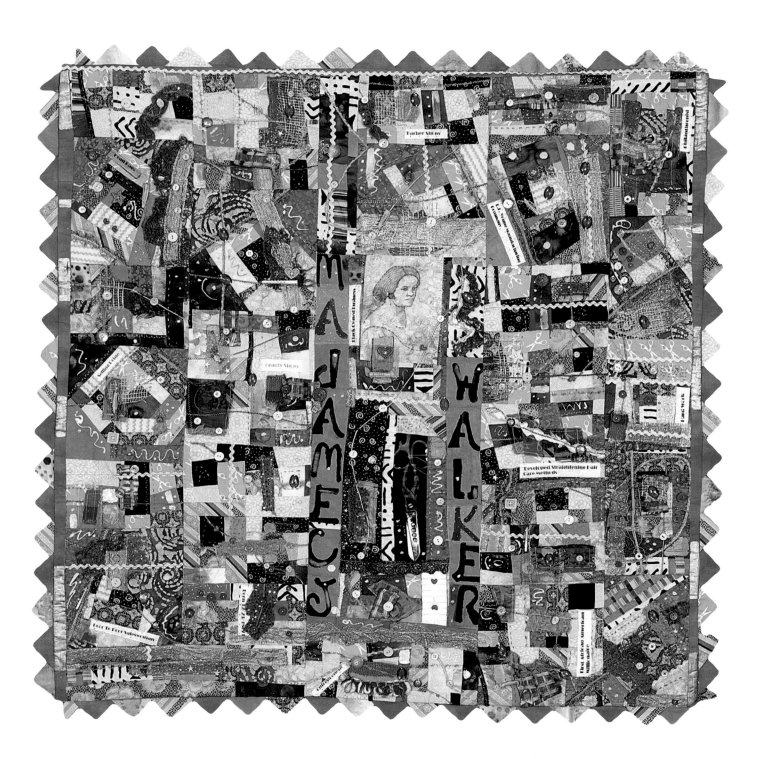

1907 | Madame C. J. Walker

Latifah Shakir (Lawrenceville, Georgia); 2012; 50 x 50 inches; cotton, acrylic ink, found objects, beads, button, zippers, cotton batting; machine piecing, collage, hand drawing, machine quilted; photos by Chas. E. and Mary Martin.

Sarah Breedlove, known as Madame C. J. Walker, was an American entrepreneur and philanthropist, and is regarded as the first self-made female millionaire in America. She made her fortune by developing and marketing a successful line of beauty and hair products for black women. Like many women of her era, Sarah experienced hair loss. Because most Americans lacked indoor plumbing, central heating, and electricity, they bathed and washed their hair infrequently, often resulting in scalp disease. Sarah experimented with home remedies and products already on the market until she finally developed her own shampoo and an ointment that contained sulfur to make her scalp healthier for hair growth. Her headquarters and factory were in Indianapolis, Indiana, and she sold her products throughout the United States.

Breedlove was a teacher and trained other black women in order to help them build their own businesses. She also gave lectures on political, economic, and social issues at conventions sponsored by powerful black institutions. After the East St. Louis Race Riot, she joined leaders of the National Association for the Advancement of Colored People (NAACP) in their efforts to support legislation to make lynching a federal crime. At her death, she was considered to be the wealthiest African-American woman in America.

My quilts always tell a story about myself. This quilt celebrates black entrepreneurship. Madame C.J. Walker was a great inspiration for me becoming an entrepreneur in the cosmetology field for ten years. Creating this quilt filled me with joy and brought back great memories of teaching, styling, and receiving awards.

My art quilt is an illusion of space with expression of brilliant color, fabric overlapping and textured with embellishments of trims, couching, buttons, and paint. Meditative stitching is also part of my design style. I like throwing something quirky onto my quilts, such as antique rollers, that helps me tell the story of Madame Walker. Using recycled fabrics, such as sweaters and shirts, and mixing them with new fabrics, keeps the quilt contemporary.

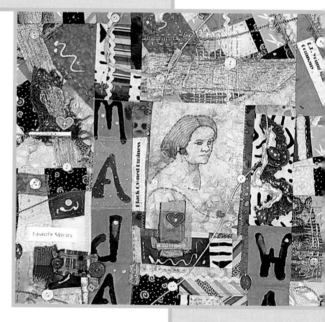

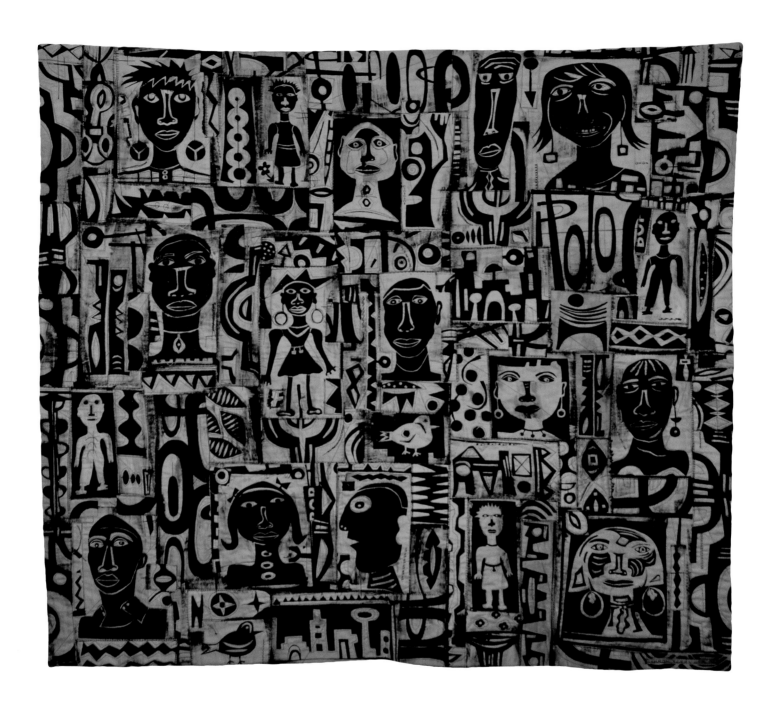

1909 | United

Sharon Kerry-Harlan (Milwaukee, Wisconsin); 2010; 60 x 60 inches; cotton fabric and batting; discharged dye, machine quilted; photo by Chas. E. and Mary Martin.

The National Association for the Advancement of Colored People (NAACP) is an African-American civil rights organization formed in 1909 "to ensure the political, educational, social, and economic equality of rights of all persons and to eliminate racial hatred and racial discrimination." Its name, retained in accordance with tradition, uses the once common term *colored people*. The NAACP was formed partly in response to the continuing, horrific practice of lynching and the 1908 race riot in Springfield, the capital of Illinois and resting place of President Abraham Lincoln. Appalled at the violence being committed against blacks, a group of white liberals, which included Mary White Ovington and Oswald Garrison Villard, both the descendants of abolitionists, William English Walling, and Dr. Henry Moscowitz, issued a call for a meeting to discuss racial justice. Solicitations for support went out to more than sixty prominent Americans, and a meeting date was set for February 12, 1909. This was intended to coincide with the 100th anniversary of the birth of President Abraham Lincoln, who emancipated enslaved African-Americans. Though the meeting did not take place until three months later, this date is often cited as the founding date of the organization. Some sixty people, seven of whom were African-American (including W.E.B. Du Bois, Ida B. Wells-Barnett, and Mary Church Terrell), signed the call, which was released on the centennial of Lincoln's birth.

My quilt represents all people, regardless of race or religion, who work together to bring about peace and equal rights for all people living in America. Each person is different, yet they come together to form a congruent piece.

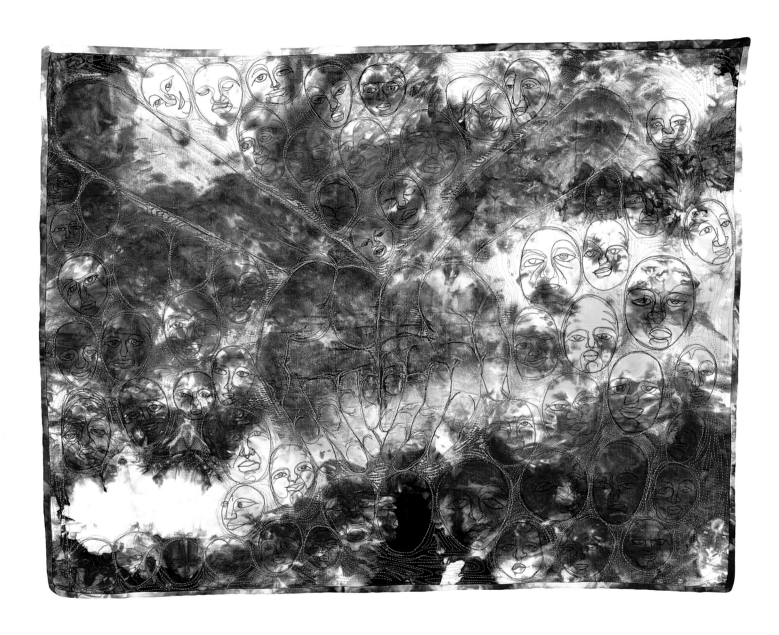

1910 | Take All the Memories Your Hands Can Hold

Lauren Austin (Shanghai, China); 2012; 31.5 x 28 inches; dyed by artist cotton fabric, ink, cotton batting; thread painting, machine quilted; photo by Chas. E. and Mary Martin.

My grandfathers both left the South in the early 1900s, during the "Great Migration," when thousands of black people migrated to the North for economic, political, and social opportunities. The few stories I have about those times came from other people. Grandpa Turner and Daddy Bob rarely spoke about their past to their grandchildren. My maternal grandfather once said only, "I escaped the South. Don't ever go there." I feel now that he was trying to protect me from those memories, perhaps to let me be a child for a little while longer. I now look at family photos from that era and wish I knew more about the past.

I always enjoyed artist Jacob Lawrence's series *The Migration of the Negro*, which documents the African-American's Great Migration with images of people struggling to leave southern racial terrorism, establish themselves in an urban environment, and recreate the community and culture they left behind. Lawrence published a children's book using the series, called *The Great Migration: An American Story*. His work is iconic and intimidating—I had to do something different. My image of hands surrounded by faces asks the question "What did you bring north?" The hands and faces invoke secret memories held by our elders and the unknown stories that later generations cannot grasp. Like water cupped in our hands, eventually, their memories are gone.

In Isabel Wilkerson's book, *The Warmth of Other Suns: The Epic Story of America's Great Migration*, tensions between people in families arise because untold things are not understood. This book gave me a way to talk to my father about his past and what he remembered or was told about his father. We began a dialogue that continues to peel away the secrets and helps me to understand the past. I want our generation to open up, to speak to and listen to each other and fill our hands with all the memories we can hold. Stories of past struggle give us strength for our own battles against oppression. Tell the story and I promise to listen.

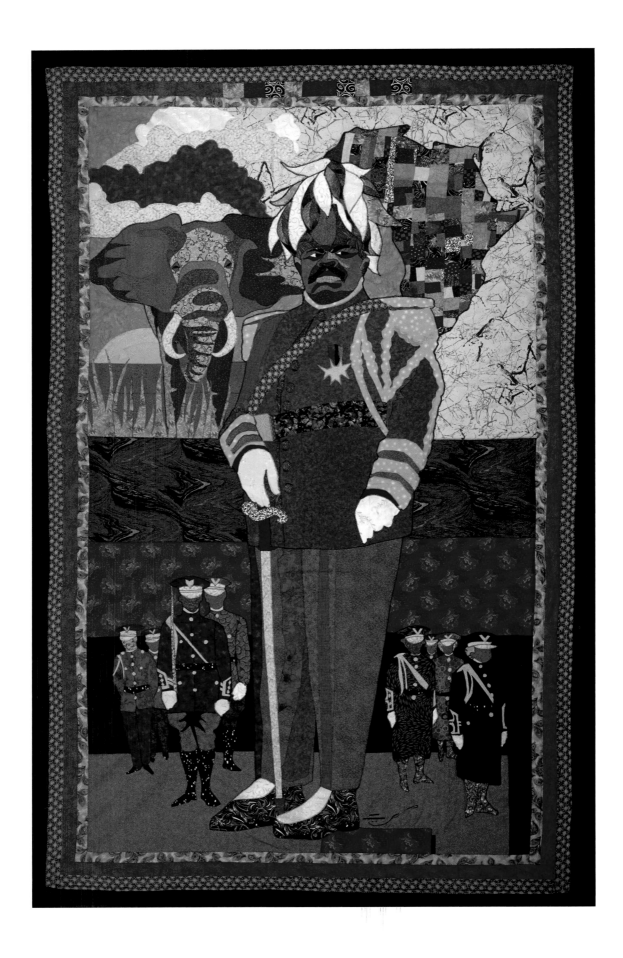

1917 | Marcus Garvey

Ramsess (Los Angeles, California); 2013; 60 x 101 inches; cotton fabric, thread and batting; appliqué; photo courtesy of artist.

Marcus Garvey has always been a major figure in my life, and I was further inspired by a new documentary I saw about him earlier this year. I used the image of the elephant as a symbol to represent both his strength and his connection to Africa.

Marcus Garvey was an orator for the Black Nationalism and Pan-Africanism movements, to which end he founded the Universal Negro Improvement Association in 1917. The Association was dedicated to promoting African-Americans and resettlement in Africa. At one point, his organization had over two million followers.

Garvey's message of pride and dignity inspired many in the early days of the Civil Rights Movement. For Garvey, Africa was the ancestral home and spiritual base for all people of African descent. His political goal was to take Africa back from European domination and build a free and united black Africa. He advocated the Back-to-Africa Movement and organized a shipping company called the Black Star Line, which was part of his program to conduct international trade between black Africans and the rest of the world in order to "uplift the race" and eventually return to Africa.

Garvey was the most influential black leader of the early 1920s. He was not interested in having a "slice of the pie" of the American life; he was interested in creating an entirely separate nation-state. Like the National Association for the Advancement of Colored People (NAACP), Garvey campaigned against lynching, Jim Crow laws, denial of black voting rights, and racial discrimination. Where UNIA differed from other civil rights organizations was on how the problem could be solved. Garvey argued for segregation rather than integration, because he doubted Anglo-Americans would ever agree to African-Americans being treated as equals.

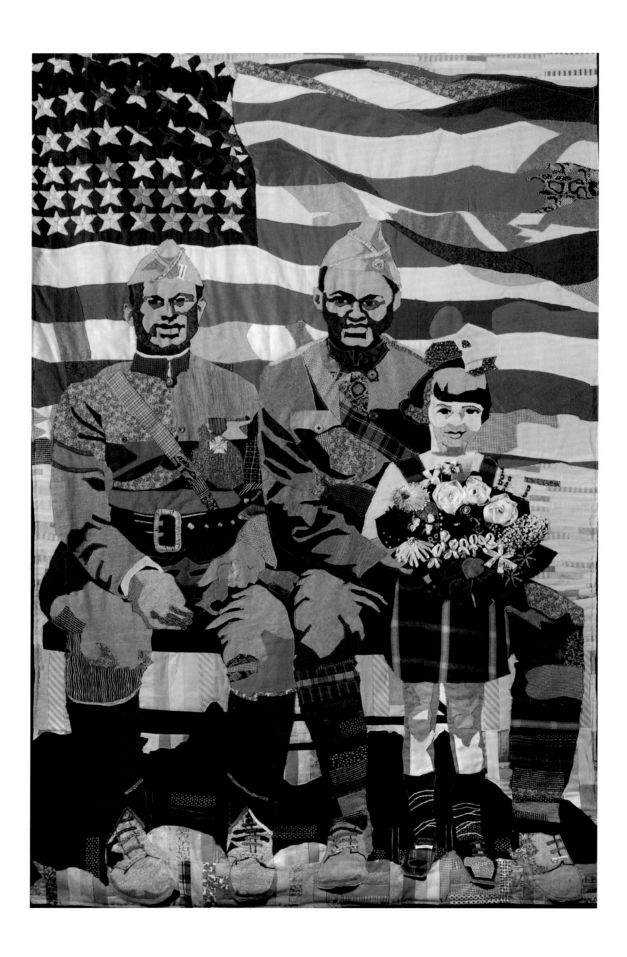

Dawn A. Williams Boyd (Atlanta, Georgia); 2010; 70 x 48 inches; assorted fabrics, silk ribbons, found objects, cotton batting; machine pieced, appliquéd and quilted, hand embroidered and embellished; photo courtesy of artist.

We served. Whether as boat pilots along the Atlantic coast or as non-combat laborers building bridges in Germany, we served. Whether as slaves substituting for their masters, as ammunition handlers, or a guards of German spies, we served. Lord Dunmore's Ethiopian Regiment, composed of escaped slaves, fought against the Continental Army. Louisiana's Native Guard was a Confederate militia of free persons of color. Buffalo Soldiers, the first peacetime all-black regiment in the regular U.S. Army, fought against the Comanche and Cheyenne natives, as white—and black —settlers migrated west. Whatever we were called, when America finally called on us, we came to her aid in astonishing numbers. African-American soldiers have fought—and died in significantly higher proportions than their white comrades—in every war, police action, and conflict from the Revolutionary War to the War in Iraq. We served to keep the world free, though often times, we were not free ourselves.

In World War I, the 369th Infantry Regiment, called the Harlem Hellfighters, was mostly comprised of African-American men from New York state. Formerly the 15th New York National Guard, they were the first all-black regiment to be shipped overseas with the U.S. Expeditionary Forces. Though the unit was initially relegated to labor services, building bridges, and digging trenches, in April 1918, the U.S. Army decided to assign the unit to the French Army for the duration of the United States' participation in the war. The 369th Infantry Regiment went into the trenches as part of the French 16th Division. They spent 191 days in combat, longer than any other American unit in the war, during which they neither surrendered an inch of Allied Territory nor lost a soldier to capture. Though they suffered a casualty rate of thirty-five percent, they were the first Allied unit to reach the Rhine. The French government awarded the regiment the *Croix de Guerre* with Silver Star for the taking of Séchault, in the (Champagne-Ardenne region) of France. During the war, no Negro soldier received the U.S. Congressional Medal of Honor, America's highest award for military heroism.

La Croix de Guerre is from my sixteen-piece series of images and related text entitled *Sins of the Fathers,* which explores racially motivated discrimination and violence against black Americans throughout U.S. history. It is my first mostly black and white piece and the first piece on which I have used the crazy quilt technique on a large scale.

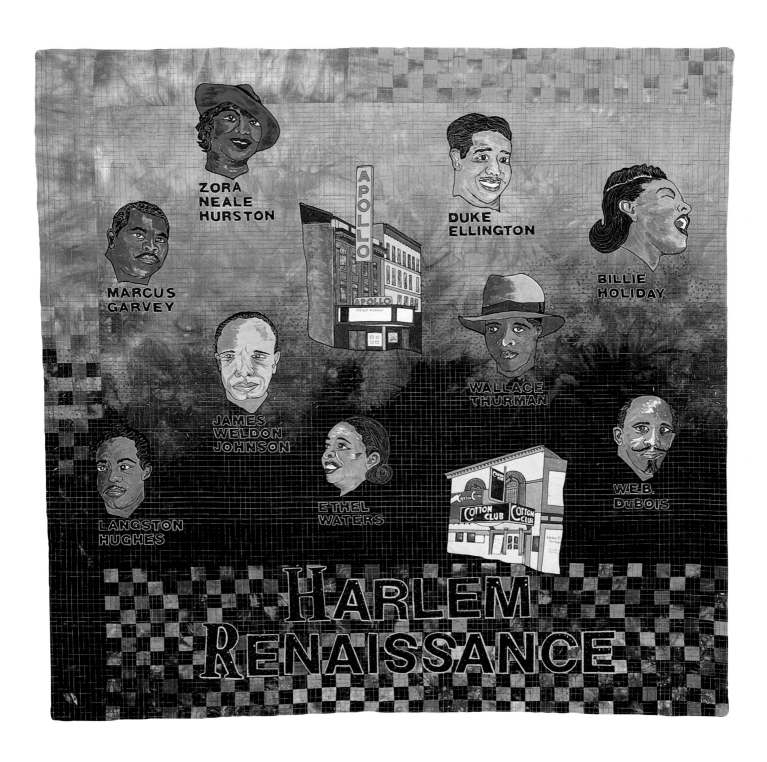

ZORA NEALE HURSTON

DUKE ELLINGTON

BILLIE HOLIDAY

MARCUS GARVEY

JAMES WELDON JOHNSON

WALLACE THURMAN

LANGSTON HUGHES

ETHEL WATERS

W.E.B. DuBOIS

HARLEM RENAISSANCE

1920 | In Vogue:
The Harlem Renaissance

Linda Gray (Indianapolis, Indiana); 2012; 50 x 50 inches; cotton fabric, Tsukineko inks,, cotton batting, metallic and polyester threads; stenciled text, machine pieced, appliqué and quilted; photo by Chas. E. and Mary Martin.

Originally called the "New Negro Movement," the Harlem Renaissance was the literary and intellectual flowering that ushered in a new black cultural identity in the 1920s and 1930s. It grew out of the changes that had taken place in the African-American community since the abolishment of slavery. A contributing factor was the Great Migration of blacks to northern cities, which concentrated ambitious people in places where they could encourage each other. It was a "spiritual coming of age," in which the black community was able to seize upon its first chances for group expression and self-determination. With racism still rampant and economic opportunities scarce, creative expression was one of few avenues available to African-Americans in the early twentieth century. The Harlem Renaissance transformed social disillusionment into race pride. Black-owned magazines and newspapers flourished. Publications like Charles S. Johnson's *Opportunity* became the leading voice of black culture. *The Crisis*, with Jessie Redmon Fauset as editor, launched the literary careers of such writers as Langston Hughes and Countee Cullen.

Other luminaries of the period included writers Zora Neale Hurston, Claude McKay, Jean Toomey, Wallace Thurman, and Nella Larsen. Visual artists, such as painters Aaron Douglas and Jacob Lawrence, and sculptors, such as Meta Warrick Fuller, Richmond Bathe, and Augusta Savage, created many of the period's most dramatic and distinctive works of art. The movement was, in part, given definition by two anthologies: James Weldon Johnson's *The Book of American Negro Poetry* and Alain Locke's *The New Negro*. The white literary establishment soon became fascinated with the writers of the Renaissance and began publishing them in large numbers. However, for the writers themselves, acceptance by the white world was less important than the expression of their individual "dark-skinned" selves. In the field of music, jazz, which was typically considered a symbol of the South, was modified and its popularity soon spread throughout the country, taking it to an all-time high. The blues and big band sounds flourished. Innovative musicians like Fats Waller, Duke Ellington, and Jelly Roll Morton were very talented and competitive and were considered to have laid the foundation for future musicians of their genre. This period was marked by exciting nightlife in Harlem's cabarets, particularly the Cotton Club. In the performing arts genre, talented actors, singers, and dancers, such as Florence Mills, Ethel Waters, and Bill "Bojangles" Robinson, ushered in an era of black musicals. Two performers who made a significant impact on the world of classical music were Roland Hayes and Paul Robeson.

What made this period significant was the fact that the "Negro" was in vogue. For the first time in history, large numbers of black artists could earn their livings and be critically acknowledged in their fields. The era was successful in that it brought the black experience clearly into the forefront of American cultural history. Not only through an explosion of culture, but on a sociological level, the legacy of the Harlem Renaissance is that it redefined how America and the world viewed the African-American population.

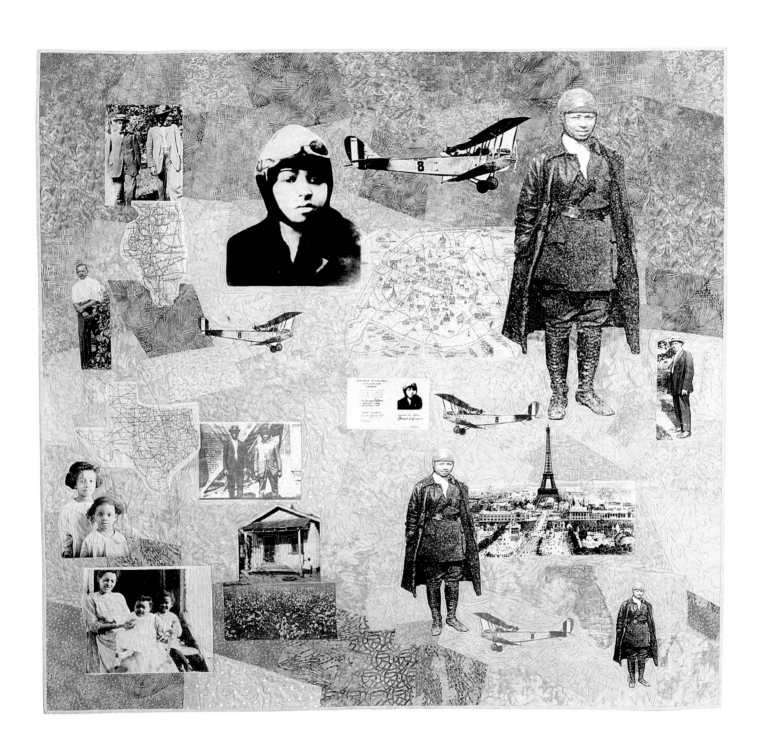

90

Her Heart was in the Clouds

Marion Coleman (Castro Valley, California); 2012; 60.5 x 60.5 inches; photo transfers, found objects, fiber collage, fusing, poetry, cotton, polyester, wool, thread, cotton batting; machine quilting, machine appliqué; photo by Chas. E. Martin.

Her Heart was in the Clouds, a visual narrative about aviator Bessie Coleman, is a continuation of work inspired by people, history, and social/cultural events, and their impact on our individual and community relationships. This work explores traditional and contemporary techniques related to quilting and fiber collage and uses historical documents to tell Coleman's story, along with images from my collection of vintage photographs. I have used my imagination to recall the story of her life, beginning in east Texas, then moving on to Chicago where she developed relationships with patrons who helped her get to Paris, where she was able to get her pilot's license. On June 15, 1921, Coleman became not only the first African-American woman to earn an international aviation license from the *Fédération Aéronautique Internationale*—the first American of any gender or ethnicity to do so—but also the first African-American woman to earn an aviation pilot's license. She made her final flight at the age of thiry-four in Florida. I hope that her bravery and adventurous spirit is conveyed in this quilt. Bessie Coleman had refused to let race and gender prevent her from realizing her goals. She was a woman who soared above her humble beginnings and left a legacy for men and women, alike, who followed their dreams.

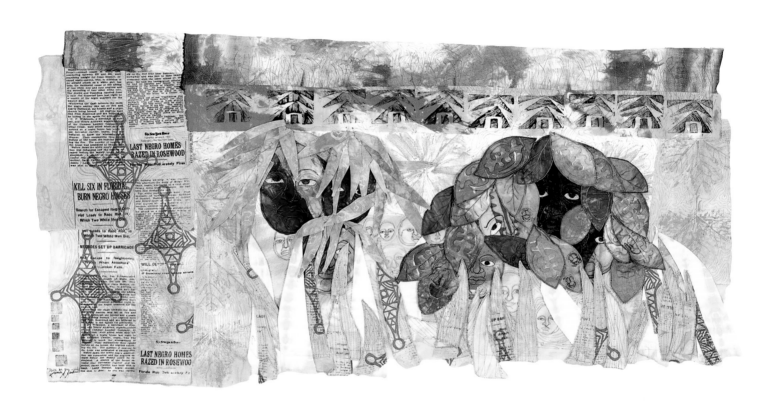

1921 | We Hid in the Woods and Swamp

Lauren Austin (Shanghai, China); 2012; 57 x 28 inches; artist hand-dyed cotton, cotton batting; dyeing, stamping, machine and hand appliqué, machine quilted; photo by Chas. E. and Mary Martin.

This piece contains my thoughts about the 1921 Rosewood, Florida, massacre by white North/Central Floridians, who destroyed a living, flourishing African-American town. This event changed the lives of survivors in ways I can only imagine.

Living in Volusia County, Florida, for five years, I cautiously learned about the area's landscape. The Central Florida wilderness is distinct. Palm, sawtooth, palmetto, and Spanish moss grow so densely in some places that the only way through is to hack a path by machete. Bromeliads and orchids grow wild. Live oak trees belie their name with gnarled, twisted, dead-looking limbs low to the ground, bearing tough leaves. Cacti and thorny plants abound, guaranteed to scratch passers-by. Extremes of temperature —freezing nights and sweltering days—make camping trips rare and miserable. Bugs, alligators, and snakes flourish. Mule deer, birds and less harmful wildlife are scarce. Visiting this environment, I felt awe, but hardly welcome. Leaving for home, I felt like a survivor.

The Rosewood Massacre began on the night of New Year's Eve in 1921. Based on a white woman's accusation of rape by a black man, a town of almost 400 people was burned to the ground by a white vigilante mob. Black families were driven into the surrounding woods. Rosewood citizens were beaten, shot, and lynched. Those that could ran into the swamp and brush to hide for a week, eventually seeking safety on trains passing nearby that carried some to safety further north.

As the town was set ablaze, calls for help to law enforcement went unanswered. Newspapers as far away as New York City reported the ongoing, desperate situation. No one with power or authority did anything. Eventually, life returned to "normal," but Rosewood was never rebuilt and the scrub reclaimed its territory.

The larger story of the struggle by brave Rosewood survivors to overcome their experience, to educate their communities, state, and country about what happened so long ago, and to get reparations from the state of Florida for its conscious disregard of their right to safety and security in their homes, can be found in *Like Judgment Day: The Ruin and Redemption of a Town called Rosewood* by Michael D'Orso.

I wanted my art to give a visually arresting picture of the pain and suffering, as well as the intense fear of hiding in the woods and swamp. Can you imagine listening to crackling fire and smelling the acrid smoke as your home, your church, and your whole life were being purposely burned away to nothing, simply because you were black? I hope your imagination can go there.

May we always remember.

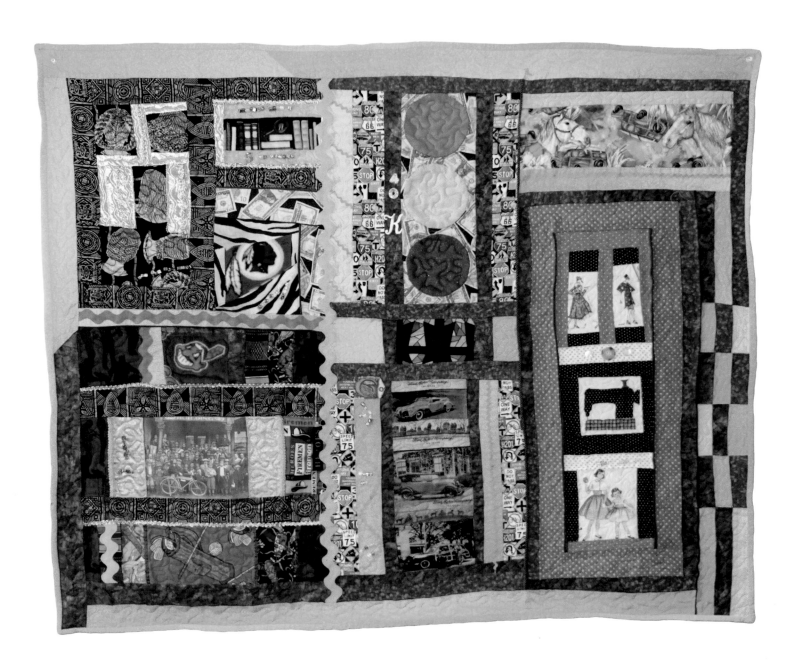

1923 | Smarter Than a Fifth Grader

Charlotte Hunter (Cincinnati, Ohio); 2013; 46 x 53 Inches; commercial cotton, metallic trims, beads, found object, cotton batting; machine appliqué and quilted; photo by Chas. E. and Mary Martin.

Garrett Augustus Morgan was born in Paris, Kentucky, to former slaves. His grandfather, John Hunt Morgan, was a Confederate colonel. With only a fifth grade education, Morgan came to Cincinnati, Ohio, where he worked odd jobs. Moving to Cleveland, Ohio, in 1895, he worked as a broom pusher in a sewing machine factory. He taught himself to repair sewing machines, and eventually opened his own sewing machine repair shop. Later, he founded a clothing manufacturing company and employed thirty-two people.

Morgan, sometimes called the "black Edison," was responsible for many inventions. He patented a belt fastener and zigzag attachment for sewing machines. Looking for a means to reduce needle friction on woolen fabric, Morgan stumbled upon a hair relaxer and developed the G.A. Morgan Hair Refining Cream. Later, he developed a safety helmet and gas mask for service members and firefighters. In one well-publicized event, he used these devices to rescue men from an explosion in an underwater tunnel beneath Lake Erie.

Despite his unrivaled bravery, he found it necessary to disguise himself as an Indian, "Big Chief Mason," to sell his products. The knowledge that he was a Negro would have caused a sharp decline in safety equipment sales.

Morgan patented his inventions. In 1923, he received a patent for the traffic signal, a hand operated device that reduced congestion of automobiles, horses and buggies on ever more crowded roads. General Electric purchased the patent for $40,000.

With this phenomenal sum, Morgan purchased land and established the first black country club in Wakeman, Ohio. He is believed to be the first black man to own an automobile in Cleveland.

Always striving to right the mistreatment and misconception of black people, he published the *Cleveland Call*, which became the *Cleveland Call and Post*. He established the Cleveland Association of Colored Men, which later merged with the NAACP.

Garrett Morgan died in 1963. In 1991, to finally recognize him for his most heroic deed, the city of Cleveland renamed the lake front waterworks plant in his honor.

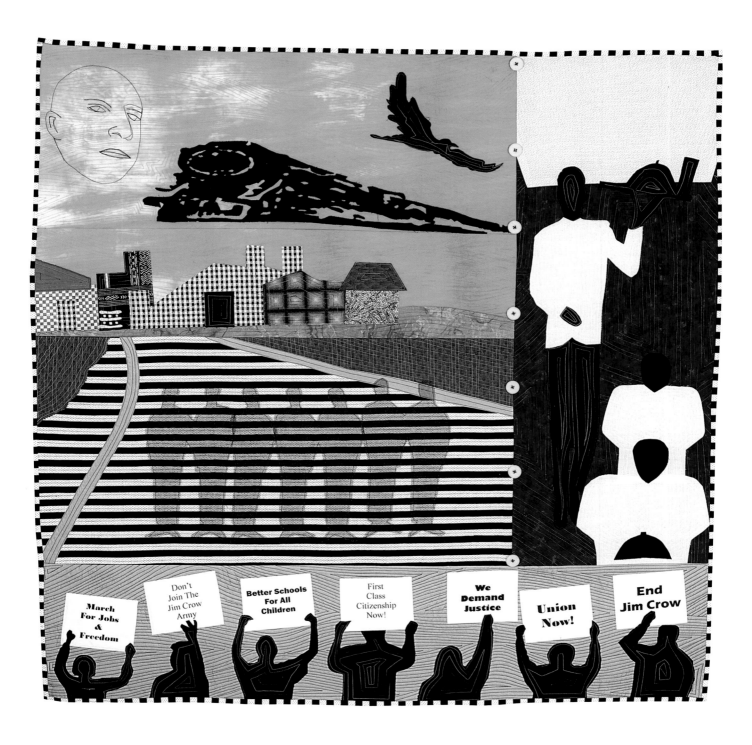

1925 | A. Phillip Randolph

Trish Williams (Peoria, Illinois); 2012; 50 x 50 inches; artist hand dyed cottons, commercial cottons, silk, polyester, and fiberglass screen, cotton batting; machine pieced, appliquéd and quilted; photo by Chas. E. and Mary Martin.

The inspiration for this piece came from my love of the city of Chicago, Illinois, and its wonderful architecture. I enjoy visiting different areas of the city and one day had just driven through the Pullman community. Passing by the A. Phillip Randolph museum, I marvelled at the well-kept homes and manicured lawns, and thought about how that neighborhood came into being. When I returned home my email included the call for artists for this exhibition and I immediately scanned the list of honorees in hopes that there might be one or two with connections to Chicago and, behold, A. Phillip Randolph was there.

Industrialist George Pullman created the community of Pullman and the railroad sleeping cars known as the "Palace Cars." Pullman believed that former house slaves of the plantation South had the right training to serve the businesspersons who would patronize his "Palace Cars." Pullman became the biggest single employer of African-Americans in post-Civil War America.

"Asa Philip Randolph (April 15, 1889–May 16, 1979) began his political life by organizing the Brotherhood of Sleeping Car Porters, the first predominantly Black labor union. Besides the labor movement, he provided leadership to the Civil Rights Movement, and socialist political parties. During World War II, Randolph was involved in the early Civil Rights Movement, leading the March on Washington Movement, which persuaded President Franklin D. Roosevelt to issue Executive Order 8802 in 1941, banning discrimination in the defense industries during World War II. After the war, in 1948, Randolph was instrumental in President Harry S. Truman's decision to issue Executive Order 9981, ending segregation in the armed services.

In 1963, Randolph was the head of the March on Washington, organized by Bayard Rustin, at which Reverend Martin Luther King, Jr., delivered his "I Have a Dream" speech. Randolph inspired the Freedom budget, sometimes called the "Randolph Freedom budget," which was aimed at solving the economic problems facing the black community, particularly workers and the unemployed.

This quilt was created in segments, like the different events in which Randolph took part as he attempted to create a more harmonic existence between citizens of this nation. I chose to use African wax prints, my own hand-dyed cotton, commercial cottons, dressmaker's fabrics, and fiberglass window screen. The many black-and-white prints were chosen to express the conflicts between the races. This piece was machine quilted and appliquéd with both fused and raw edges. I also added some vintage buttons as embellishments.

Ramsess (Los Angeles, California); 2012; 48 x 156 inches; cotton fabric, thread and batting; appliqué; photo courtesy of artist.

I have long been a fan of Josephine Baker and previously rendered her image in pen, ink, and acrylics. This quilt was inspired by a trip to France, where I had the opportunity to visit her chateau. I returned home inspired to create a quilt dedicated to Baker. She was often referred to as the "Black Pearl," therefore I included imagery of pearls in the quilt.

Josephine Baker was instrumental in the introduction of the Jazz Age to Europe; she helped represent American culture at a time when Europeans thought America had no culture. In 1926, Baker starred in La Folie du Jour at the Follies-Bergère Theater. Her jaw-dropping performance, including a costume of sixteen bananas strung into a skirt, cemented her celebrity status. Josephine became one of the most photographed women in the world, and, by 1927, she earned more than any entertainer in Europe. Her exotic, sensual act reinforced the creative images coming out of the Harlem Renaissance in America.

Josephine became a citizen of France in 1937, and served France during World War II in numerous ways. When World War II erupted, Baker worked for the Red Cross during the occupation of France. She entertained troops in both Africa and the Middle East. Perhaps most importantly, however, Baker did work for the French Resistance, at times smuggling messages hidden in her sheet music. For these efforts, at the war's end, Baker was awarded both the Croix de Guerre and the Legion of Honour with the Rosette of the Resistance, two of France's highest military honors.

Despite her attachment to Paris, Josephine felt it was her duty to help advance the Civil Rights Movement in America. She would not perform in theaters that discriminated, refusing to go on stage until blacks were allowed to sit in the same areas as whites. Josephine also spoke at the 1963 March on Washington.

When Baker died in 1975, more than 20,000 people crowded the streets of Paris to watch the funeral procession on its way to the Church of the Madeleine. The French government honored her with a 21-gun salute, making her the first American woman buried in France with military honors.

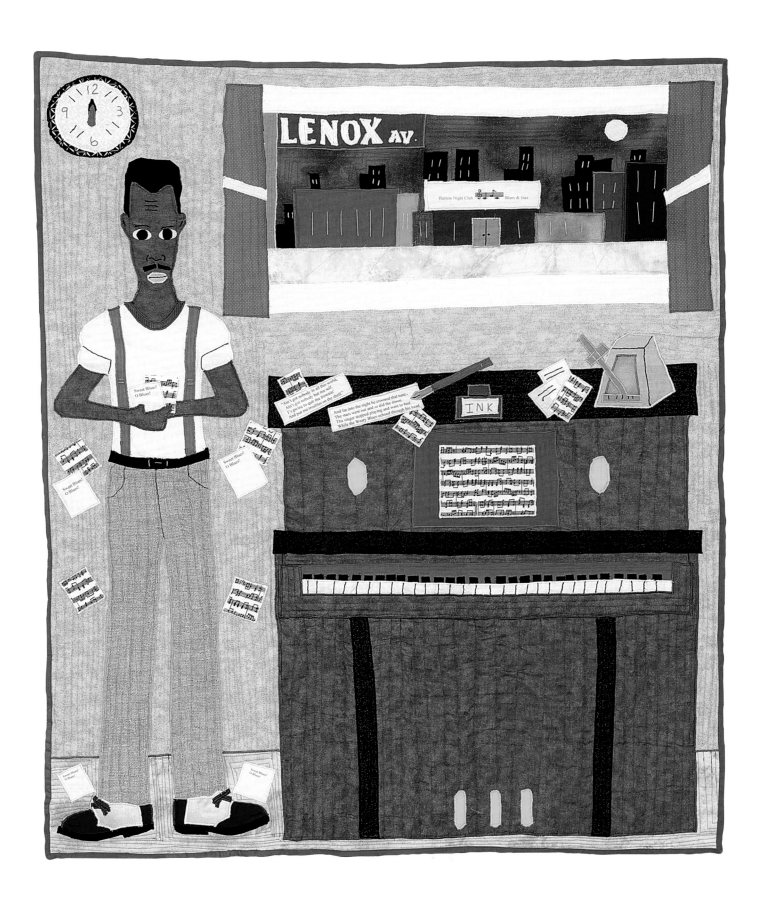

1926 | Far Into the Night:
The Weary Blues

Sherise Marie Wright (Calumet City, Illinois); 2012; 34 x 41 inches; cotton fabric, embroidery floss, cotton batting; machine quilting, hand embroidery; photo by Chas. E. and Mary Martin.

The inspiration behind my quilt is based on the last stanza of Langston Hughes's "The Weary Blues," published in 1926. An African-American piano player stays up far into the night, focusing on his dream and pondering who he is in the world. The world he sees from his window calls him in the night to Lenox Avenue. The cityscape reveals the place of his existence and self-expression—a Harlem Night Club. Time does not matter for the piano player, for he stays awake all night as blues notes echo in his head. Music is his escape. Sheet music and notes fall gently to the floor as he feels the blues. After he has written how he feels, the piano player leaves his notes sitting on top of his piano with his pen in place. He is a man who has only himself, and, through music, is able to let go and express who he is.

The Weary Blues is about self-expression and how African-Americans fought for the privilege to live out their dreams. The piano player expresses himself through music and it is through music he is able to put his troubles on a shelf. He is able to believe in his hard-fought dreams, and I believe this is why he is weary. He is a man that longs to take his place in the world. His music is liberating and, at night, music pours from him. *The Weary Blues* embodies his way of life and his passion, but it also means we as a people must continue to try to fulfill our dreams.

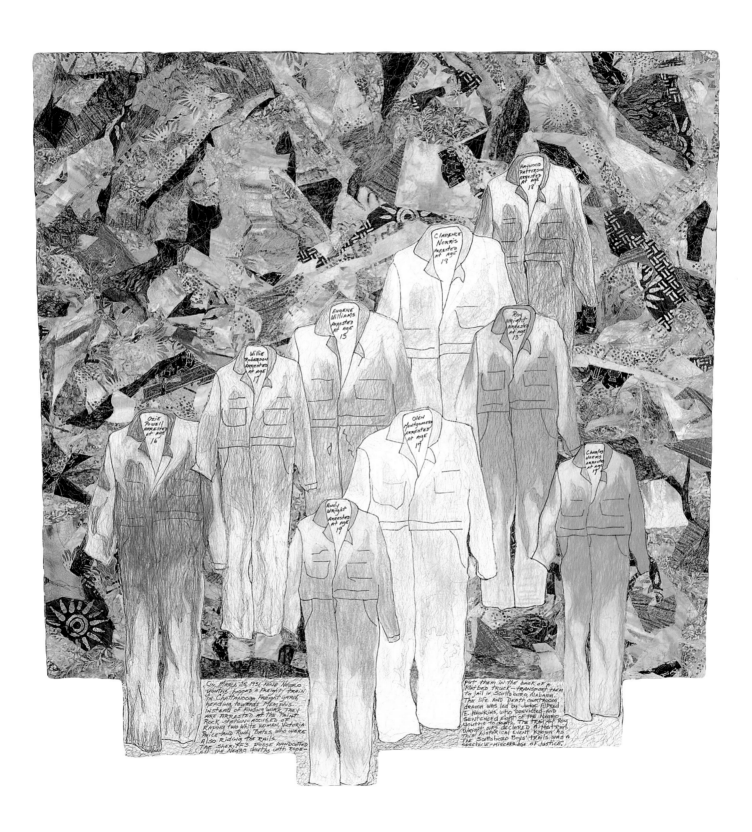

Haywood
Patterson
Arrested
At Age
18

Clarence
Norris
Arrested
At Age
19

Eugene
Williams
Arrested
At Age
15

Roy
Wright
Arrested
At Age
13

Willie
Roberson
Arrested
At Age
17

Ozie
Powell
Arrested
At Age
16

Olen
Montgomery
Arrested
At Age
17

Charles
Weems
Arrested
At Age
19

Andy
Wright
Arrested
At Age
19

On March 25, 1931, nine Negro
youths hopped a freight train
in Chattanooga freight yard
heading towards Memphis.
Instead of finding work, they
were arrested at the Paint
Rock station accused of
raping two white women, Victoria
Price and Ruby Bates, who were
also riding the rails.
The sheriff's posse handcuffed
all the Negro youths with rope-

put them in the back of a
flatbed truck-transport them
to jail in Scottsboro Alabama.
The life and death courtroom
drama was led by Judge Alfred
E. Hawkins, who convicted and
sentenced eight of the Negro
youths to death. The trial of Roy
Wright was declared a mistrial.
This historical event known as
the Scottsboro Boys' trials was a
spectacle-miscarriage of justice.

1931 | The Scottsboro Boys:
The Arrest

Patricia Montgomery (Oakland, California); 2012; 62 x 75 inches; batiks and commercial cotton, pastel and ink drawn, cotton and rayon threads, cotton batting; fused collage and machine quilting; photo by Chas. E. and Mary Martin.

On March 25, 1931, nine Negro youths hopped a freight train heading towards Memphis. Instead of finding work, they were arrested at the Paint Rock station, accused of raping Victoria Price and Rudy Bates, two white women who were also riding the rails. The sheriff's posse hand-cuffed all the Negro youths with tape, put them in the back of a flatbed truck, and transported them to jail in Scottsboro, Alabama.

Judge Alfred E. Hawkins, who convicted and sentenced eight of the Negro youths to death, led the life-and-death courtroom drama. The trial of the ninth youth, Roy Wright, was declared a mistrial. This historical event, known as the Scottsboro Boys' trials, was a spectacle—a miscarriage of justice.

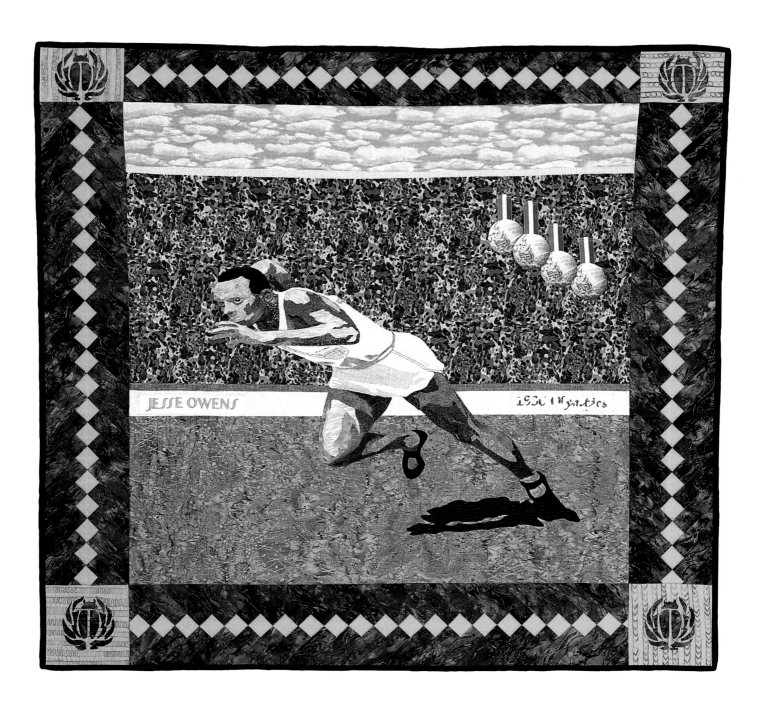

1936 | In Memory of Jesse

Julius J. Bremer (Cleveland, Ohio); 2012; 45 x 47 inches; cotton, acrylic paint, cotton batting; painted, fused, free motion quilting; photo by Chas. E. and Mary Martin.

Life can be filled with trials and tribulations, but we find strength through faith. When I look back on the life of Jesse Owens, I see an individual who showed an abundance of strength. He persevered through many obstacles, both physically and mentally.

As an athlete, he spent hour after hour practicing to develop the physical strength to become one of the fastest humans in the world. His devotion to his running enabled him to become a hero not only to African-Americans but also to the United States as a whole.

While I honor Jesse Owens for his achievements during the 1936 Olympics in Berlin, Germany, I also thank him for creating a path that future African-American athletes may follow with pride and gratitude. His success was bittersweet, for, while he did much in proving the superiority of the United States in Germany, he was still faced with prejudices on his return home from the Olympics.

Let us remember him for the path maker he was. Thank you Jesse!

This quilt is made of fused cotton fabric and is free-motion quilted. The highlights were done using acrylic paint and penciling. I made the border to represent the colors and emblem (Scarab) of East Technical High School in Cleveland, Ohio, which Jesse Owens attended. I also share proud memories of being a "Scarab," having graduated from the same school as Jesse.

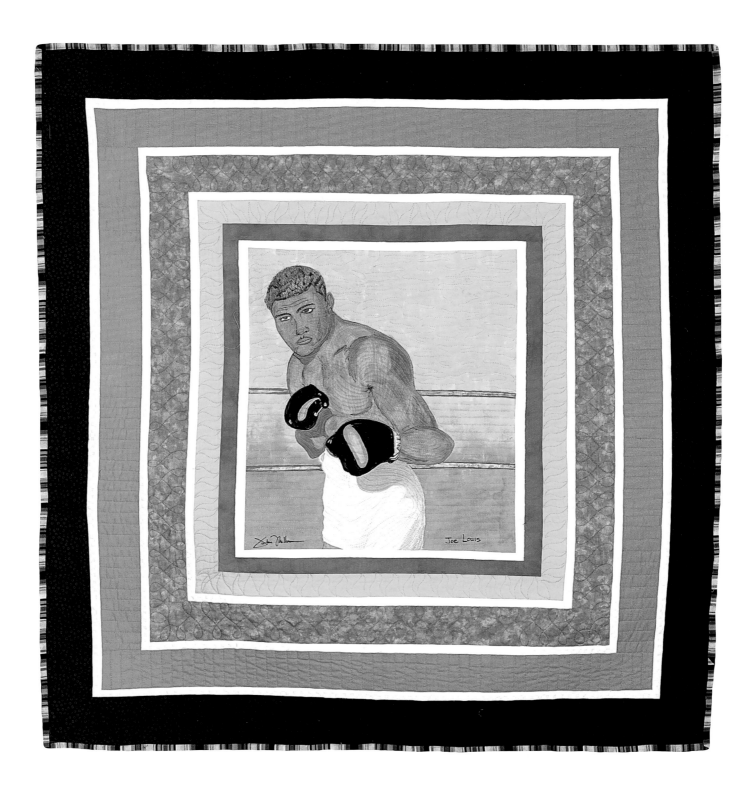

1937 | Joe Louis

Edward Bostick (Brooklyn, New York); 2010; 43 x 46 inches; cotton sheeting, cotton batting, cotton thread, acrylic paint; painted, machine quilted; photo by Chas. E. Martin.

Joe Louis, the Brown Bomber, was born May 14, 1914, in the cotton-field county of Lafayette, Alabama, to Munn and Lilly Barrow. His father was a sharecropper and the grandson of a slave. Joe Louis Barrow was the eighth child of the family.

Joe Louis's family life was shaped by financial struggle. The children slept three to a bed. His father was committed to a state hospital when Joe was just two years old. Joe had little schooling and, as a teenager, took on odd jobs in order to help his mother and his other siblings. The family relocated to Detroit, where he found work as a laborer at the River Rouge Plant of the Ford Motor Company. He briefly studied cabinet making at Bronson Vocational School. In his off time, he took violin lessons. While attending Bronson, a friend recommended he try boxing. He was not an immediate success—he debuted as a lightweight and was knocked down three times in his first fight. Nevertheless, he showed promise. By 1934, he held the national Amateur Athletic Union light-heavyweight title and finished his amateur career with an astonishing forty-three knockout victories in fifty-four matches.

He was the world heavyweight-boxing champion from June 27, 1937 until March 1, 1949; Joe Louis held the title longer than anyone else in history. On October 26, 1951, he called it quits for good after Rocky Marciano knocked him out in the eighth round at Madison Square Garden.

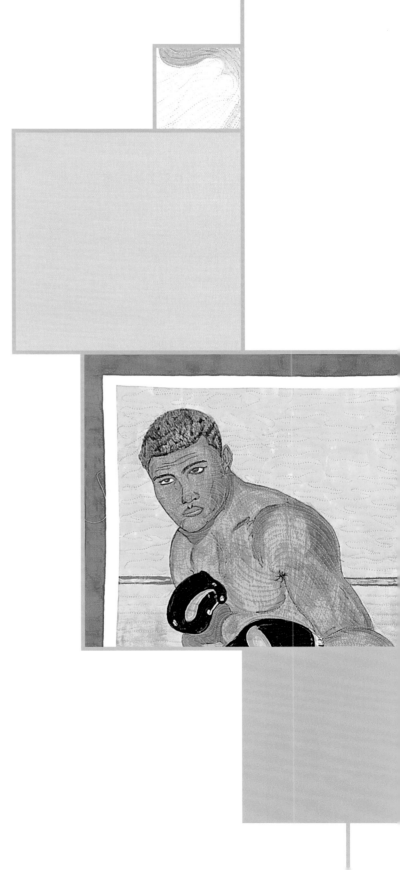

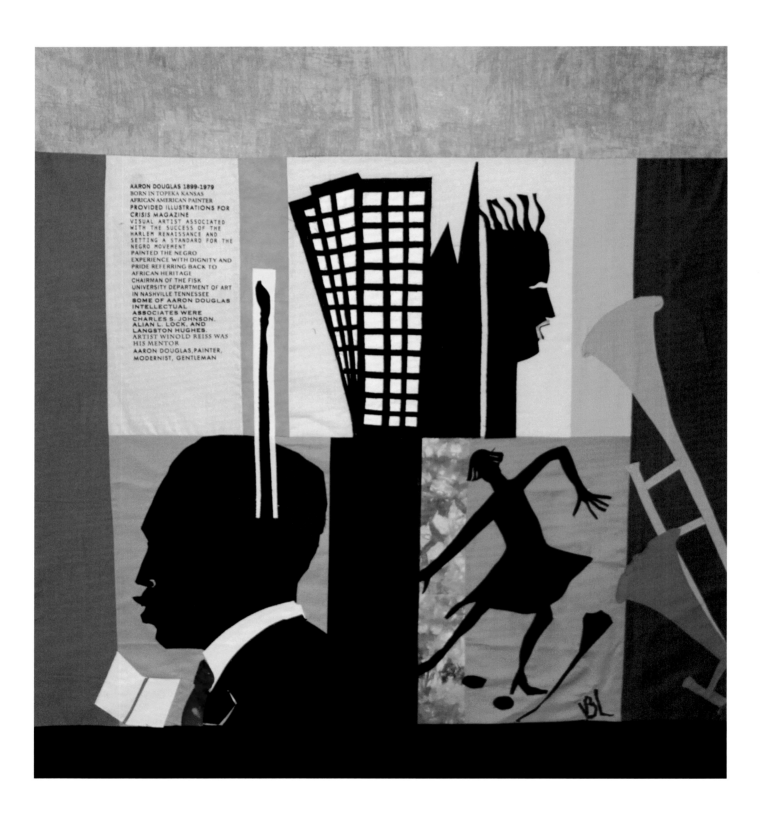

AARON DOUGLAS 1899-1979
BORN IN TOPEKA KANSAS
AFRICAN AMERICAN PAINTER
PROVIDED ILLUSTRATIONS FOR
CRISIS MAGAZINE
VISUAL ARTIST ASSOCIATED
WITH THE SUCCESS OF THE
HARLEM RENAISSANCE AND
SETTING A STANDARD FOR THE
NEGRO MOVEMENT
PAINTED THE NEGRO
EXPERIENCE WITH DIGNITY AND
PRIDE REFERRING BACK TO
AFRICAN HERITAGE
CHAIRMAN OF THE FISK
UNIVERSITY DEPARTMENT OF ART
IN NASHVILLE TENNESSEE
SOME OF AARON DOUGLAS
INTELLECTUAL
ASSOCIATES WERE
CHARLES S. JOHNSON,
ALIAN L. LOCK, AND
LANGSTON HUGHES.
ARTIST WINOLD REISS WAS
HIS MENTOR
AARON DOUGLAS, PAINTER,
MODERNIST, GENTLEMAN

1939 | Aaron Douglas:
Renaissance Man

Viola Burley Leak (Washington, DC); 2012; 40 x 48 inches; cotton; cotton batting; machine quilted and appliqué; photo by Chas. E. and Mary Martin.

Aaron Douglas was an African-American painter and graphic artist who played a leading role in the Harlem Renaissance of the 1920s and 1930s. Inspired to become a painter after viewing a magazine photo of Henry O. Tanner's (another celebrated African-American painter) painting of Christ and Nicodemus meeting in the moonlight on a rooftop, Douglas is referred to as "the father of African-American art."

Douglas had a unique artistic style that fused his interests in modernism and African art. A student of German-born painter Winold Reiss, he incorporated parts of Art Deco along with elements of Egyptian wall paintings in his work. Best represented by black-and-white drawings with black silhouetted figures, as well as by portraits, landscapes, and murals, Douglas's art fused modernism with ancestral African images, including fetish motifs, masks, and artifacts. His work celebrates African-American versatility and adaptability, depicting people in a variety of settings—from rural and urban scenes to churches to nightclubs. His illustrations in books by leading black writers established him as the leading black artist of the period.

His engagement of African and Egyptian design brought him to the attention of W.E.B. Du Bois and Dr. Alain LeRoy Locke, who were pressing for young African-American artists to express their African heritage and African-American folk culture in their art. Douglas contributed illustrations to the two most important African-American magazines of the period, *The Crisis* and *Opportunity*. He also provided illustrations for books and painted canvases and murals. Working with Wallace Thurman, he tried to start a new magazine displaying the work of younger artists and writers. In the early 1930s, Aaron Douglas completed the most important works of his career, his murals at Fisk University, in Nashville, Tennessee, and at the Schomburg Center for Research in Black Culture.

Later in his career, Douglas founded the Art Department at Fisk University, where he taught for thirty years and helped the university amass one of the most important collections in the country. He was my teacher in college and a mentor. In this quilt, printed comments give biographical facts about the artist. The paintbrush is Douglas's introduction as a painter, while the black and white buildings refer back to Douglas's representation of Harlem and the city. The black face is an echo of the Harlem renaissance and the emergence of African-American culture during that period. The dancing figure, the white book near Douglas's silhouette, and the paintbrush stand for the expansion of the performing arts, literature, and visual arts to include a positive focus on the Negro. The trombones are a symbol of music but, even more important, they serve as a reminder of Aaron Douglas's best known illustrations of *God's Trombones: Seven Negro Sermons in Verse,* by James Weldon Johnson.

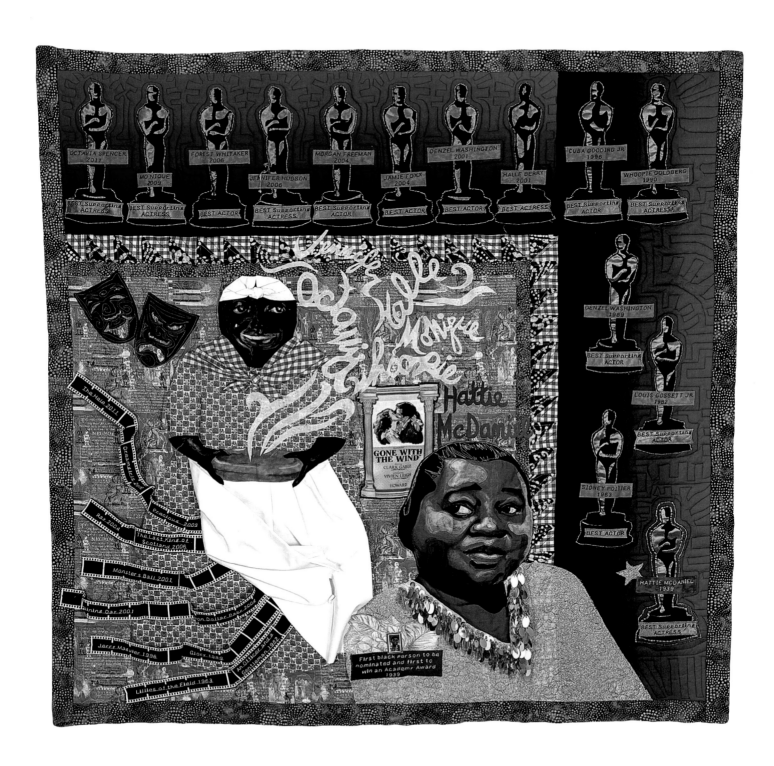

1939 | Mammy's Golden Legacy

Laura Gadson (New York, New York); 2012; 51 x 51 inches; cotton, paint, buttons, beads, cotton batting, acrylic paint; machine appliqué and embroidery, hand painting, machine quilting; photo by Chas. E. and Mary Martin.

We stand on the shoulders of those who came before us. Some of those shoulders may not have been sitting on an erect spine, but they have laid a foundation just as proud and sturdy as any other. Hattie McDaniel's winning of the "Best Supporting Actress" Academy Award in 1939 was the beginning of a long line of prestigious Oscar nominations and golden wins in a variety of categories. Her role as an enslaved servant in *Gone with the Wind* has been criticized by some, but the historically based, yet fictitious role of Mammy could never be played by the weak or the stupid. Though she could never wear all of her pride or her smarts on her sleeve, she was the hand that rocked the cradle; the role of caregiver was thrust upon her, allowing for the molding of generations, both black and white.

Just like Mammy, McDaniel took the social position she was given and paved a way for herself and for those who followed. A black "working" actress in the 1930s and 1940s had a limited choice of roles on both stage and screen. What African-Americans can afford to call buffoonery today was one of the few ladders to success a black performer had. Without these small steps in an industry full of all kinds of stereotypes, the journey toward today's opportunities would never have begun. I salute all those who have been Mammy so that the rest of us can dare to be even more.

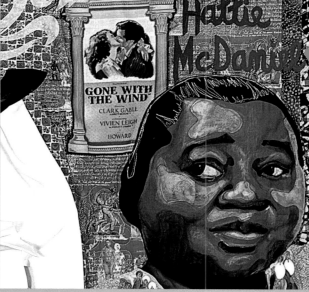

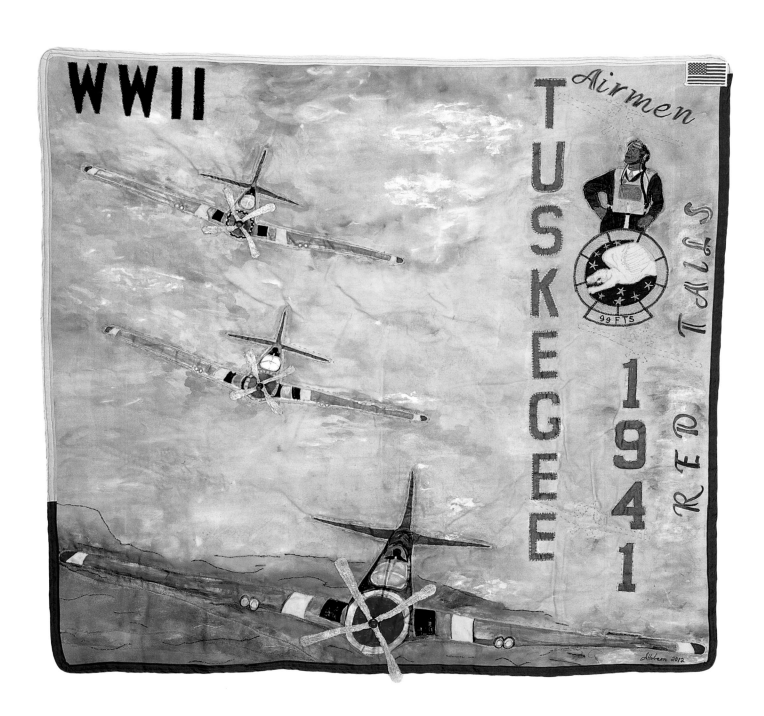

1941 | Red Tails:
Tuskegee Airmen

Janice F. Hobson (Chicago, Illinois); 50 x 50 inches; 2012; commercial cotton; embroidery thread; commercial threads; fabric paint; cotton batting; fabric painting; embroidery, hand and machine appliqué; hand and machine quilting; photo by Chas. E. and Mary Martin.

Despite adversity and limited opportunities, African-Americans have played a significant role in U.S. Military history over the past four centuries. Prior to World War II, the U.S. Army Air Corps did not employ negroes (the respectful term in that era) in any role, a policy that found its justification in a racist and inaccurate report written in the 1920s.

Political pressure exerted by Civil Rights organizations and the negro press finally brought about changes in military policy. In 1940, President Franklin D. Roosevelt ordered the U.S. Army Air Corps to build an all-Negro flying unit. To train pilots for this new squadron, the U.S. Army Air Corps opened a new training base in central Alabama, at the Tuskegee Institute (Moton Field), in June 1941. The military selected Tuskegee Institute as a civilian contractor for the following reasons: Tuskegee Institute's strong interest in providing aeronautical training, engineering, and technical instructors; existing facilities; and a climate with ideal flying conditions year round.

The Tuskegee Airmen were the first African-American soldiers to successfully complete their training and enter the U.S. Army Air Corps (Army Air Force). They became known as the 99th Pursuit Squadron, later renamed the 99th Fighter Squadron. The squadron was deployed to North Africa in April 1944 and was later sent to Sicily. Their courageous and heroic service earned the 99th increased combat opportunities and respect. On July 4, 1944, the 99th was joined by three other squadrons, the 100th, 301st, and the 302nd, to form the 332nd Fighter Group.

In total, almost 1,000 aviators were trained as America's first African-American military pilots, becoming one of the most highly respected U.S. fighter groups of World War II. In addition, more than 10,000 African-American men and women, both military and civilian, served in a variety of support roles.

When given the opportunity, the Tuskegee Airmen proved to the American public that African-Americans could become successful military leaders and pilots. Their performance helped pave the way for desegregation of the military, beginning with President Harry S. Truman's Executive Order 9981 in 1948.

My quilt, entitled *Red Tails*, is a tribute to the legacy of the Tuskegee Airmen and the military and civilian men and women who made it all possible.

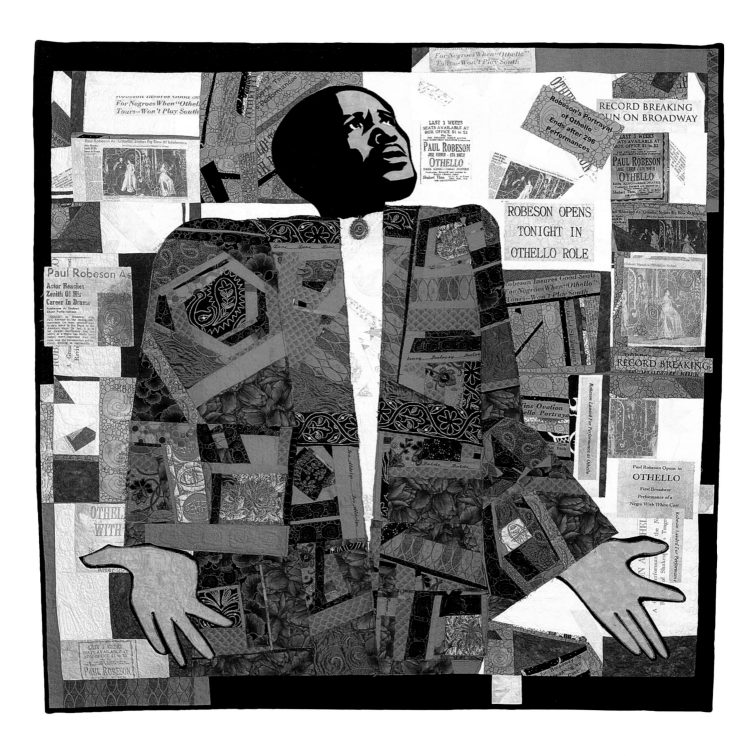

114

1943 | Paul Robeson as Othello on Broadway

Glenda Richardson (Fort Washington, Maryland); 2012; 50 x 50 inches; tea-dyed vintage linen, commercial cottons, velvet, rayon, beaded lace, cotton batting; photo transfer, machine appliqué, embroidery and quilted; photo by Chas. E. and Mary Martin.

Paul Robeson's 1943 portrayal of Othello was historic for a number of reasons. He was the first African-American to play the character on Broadway, with a supporting cast of white actors. He received rave reviews, played to sold-out houses, and took a stand against racial intolerance.

His contract stipulated that in each theater a block of tickets for the best seats would be at his disposal. This would assure that good seats would be available for African-American patrons, at a time when they were often relegated to the balcony, if allowed entrance at all. He also refused to take the production to the South, insisting that all of his performances play to integrated audiences. He also played benefit shows for local orphanages and arts organizations.

In my quilt, the theatricality of the performance is conveyed in the dramatic stage lighting, the sweeping hand gestures, and his sumptuous robes. His garment is also embroidered with words, such as "pride" and "jealousy," relating to the themes of the play. The red tulips worked into the costume are symbolic of passion and undying love. The locket around his neck displays the letter "D" for Desdemona. The composition also includes photo-transfers of newspaper articles that report the historic import of this event.

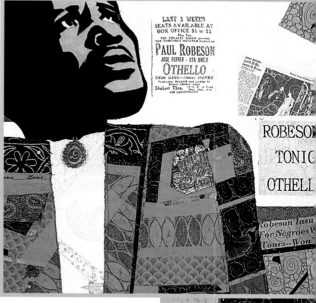

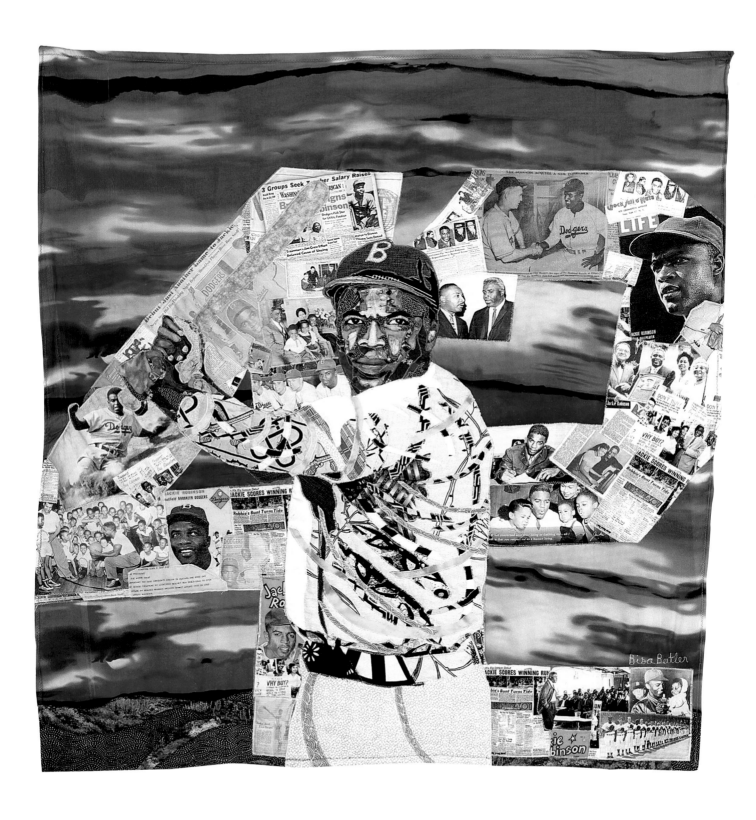

1947 | "42"

Bisa Butler (South Orange, New Jersey); 2012-13; 50 x 50 inches; cotton; rayon; linen, cotton batting; machine appliqué and quilted; photo by Chas. E. and Mary Martin.

Jack Roosevelt Robinson, scholar, Hall of Famer, trail blazer, civil rights icon, husband, father, soldier, and, once more for emphasis, major league baseball player. What an honor to be chosen to make a quilt about Jackie Robinson. He has long been a hero of mine. I always wondered what makes a person become so special. What makes one person so very different and more outstanding than the rest? All my life I have been taught to admire and respect Jackie Robinson and it was especially fortunate that, while I was working on this artwork, the Jackie Robinson movie, *42*, was being released. The movie gave me a small, dramatic glimpse into the life of Jackie Robinson that I never imagined before. Jackie Robinson's name was in the news and in the mouths of my high school students. He was no longer just a figure in history, but a man that I could understand as a living, breathing human being. My students and I were born after Jackie Robinson passed away so the movie *42* was a special gift. It was an insight that we were lucky to get.

As I researched Jackie Robinson, I came across articles, newspaper clippings, and photos that allowed me access into his world. It was special and amazing to take on the challenge of recreating his likeness in fabric alone. With each piece of fabric I put down, I knew that I had to get it right. I felt as if I had been entrusted to do my very best to put a little of the real Jackie Robinson into my quilt. I felt like the release of the movie was a special sanction for me to go ahead and do my thing, a nudge from the heavens not to be intimidated.

I knew I wanted the scale of my piece to be as close to life size as possible, because I knew there was no way I could make a "little" Jackie Robinson. I used primarily blues and whites because I wanted to pay homage to the Brooklyn Dodgers' blue and white colors. I wanted to use African and American fabrics because that was Jackie Robinson's heritage. I wanted the numbers (42) behind him to pay respect to Robinson's uniform number, and to give a nod to the movie that helped me. I needed to include pictures of the Robinson family, especially his wife, Rachel Robinson.

I hope that, one day, either Mrs. Robinson or one of the Robinson children can see this artwork and know that I have tremendous respect for their husband and father, and did my best to show it.

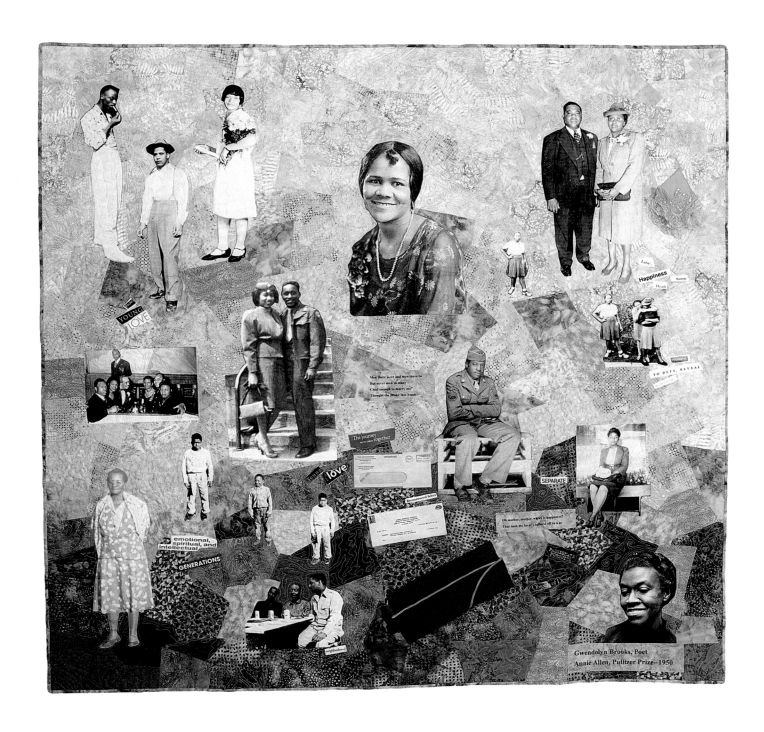

Gwendolyn Brooks, Poet
Annie Allen, Pulitzer Prize—1950

1950 | Annie's Life

Marion Coleman (Castro Valley, California); 2012; 60.5 x 62.5 inches; photo transfers, found objects, fiber collage, fusing, poetry, cotton, polyester, wool, thread, cotton batting; machine quilting, machine appliqué; photo by Chas. E. and Mary Martin.

 Annie's Life is one of two artistic interpretations of the 1950 Pulitzer Prize winning poem "Annie Allen" by Poet Laureate Gwendolyn Brooks. For this piece, I have used a collection of vintage photographs, documents, and lines from the poem to present the life of a woman from adolescence to middle age. This is a story about time, hope, dreams, distance, disappointment, betrayal, and loneliness. *Annie's Life* could be my mother's story or my own, as each of us has faced the joys and sorrows of everyday events. With the work I was presented with the opportunity to read and re-read an honored work of literature and present my own interpretation of what was most significant to me as a woman at this stage of my own life. As with many of my fiber collage works, I have written words throughout as part of the fabric of Annie Allen's life.

1951 | His Instruments for Justice

Lauren Austin (Shanghai, China); 2012; 45.5 x 35 inches; cotton, silk, organdy, cotton batting; photo transfer, painting, silkscreen, appliqué, machine quilted; photo by Chas. E. and Mary Martin.

This quilt is about Harry T. Moore, often described as one of the first martyrs for civil rights. He worked for the NAACP in central Florida in the 1930s and 1940s. He taught school, became a principal in Mims, Florida, and organized for pay parity between white and black teachers. He agitated for voter rights for black people many years before Martin Luther King, the Student Nonviolent Coordinating Committee, and the Congress of Racial Equality, and publicized cases of corruption and brutality in law enforcement. Harry and his wife, Harriet, were murdered on Christmas Eve, 1951, by a bomb placed under their home in Mims.

I lived in central Florida for five years. I grew to love the intense green landscape, the closeness to both land and ocean, and the amazing, hidden, heroic history of the black people who stayed when so many people went north to other opportunities.

This piece shows the desk from which Moore wrote his letters and made phone calls agitating for change. I wanted to incorporate some of the symbols of Harry T. Moore, who he was and what was important to him. There are two photographs on his desk. The first is of his family: Moore, his wife Harriet, and their two daughters. His family traveled with him as he crossed Florida attending meetings and giving speeches. Harriet refused to be separated from him during these journeys, so the whole family would travel together. The other photograph is of Moore's father, Johnny. Johnny Moore died when his son was nine years old, and Harry always strove to live up to his memory and make his father proud.

Moore was a shy person, not given to big speeches or rallies. He communicated best one-on-one with African-American farmers, mill workers, teachers, and students. He worked to convince them to register to vote, to bolster their spirits, and to give them courage in a disheartening age. However, in Harry T. Moore's time, communication was difficult. People lived far apart and there were no cell phones or emails to keep people connected. The typewriter and the telephone were Moore's tools. His typewriter was portable and went with him as he traveled the many miles between isolated farmhouses. Moore had huge telephone bills from the hours he spent talking to people around the country. I wanted to get across how important these tools were to Moore in his work.

Underlying the struggle of self-determination was the economic importance of black people in the harvest of the citrus crops. The powers-that-be needed the inexpensive labor of oppressed African-American workers to pick the oranges, but this proved untenable as the culture began to change. Terror was then used to keep African-Americans from protesting and changing their conditions, and it was this terror that Moore fought against. Nevertheless, despite all the difficulty surrounding oranges and their harvest, the fruit was of vital importance to the African-American community. Moore planted orange trees in his backyard, his plan for a retirement that he never got to enjoy.

1951 | Honoring Henrietta Lacks

Adriene Cruz (Portland, Oregon); 2012; 45 x 30 inches; cotton, beads, cotton batting; beading, embroidery, hand quilted; photo by Chas. E. and Mary Martin.

Henrietta Lacks first came to my attention in 1995, when my friend Charlotte Lewis discovered that HeLa cells were used for cancer research. At the time, little was known about Henrietta, other than that she was a black woman who died of cervical cancer in 1951, when she was only thirty-one. Charlotte made a small quilt, honoring Henrietta Lacks and her cells, as she fought her own battle with cancer.

Sixteen years passed before I heard again of Henrietta Lacks and her famous cells. Rebecca Skloot, author of *The Immortal Life of Henrietta Lacks* wrote:

> Scientists know her as HeLa. She was a poor Southern tobacco farmer who worked the same land as her slave ancestors, yet her cells—taken without her knowledge—became one of the most important tools in medicine. The first "immortal" human cells grown in culture, they are still alive today, though she has been dead for more than sixty years. HeLa were vital for developing the polio vaccine, revealed secrets of cancer, viruses and have been bought and sold by the billions.

Skloot's book unlocked some of the mystery of Henrietta Lacks. A great sadness remained with me about Henrietta and her family. Henrietta would never know the impact her cells would have in the world of medicine. Even her family did not know until 1972, when a scientist asked for blood samples to study the genes of her children. After twenty years of HeLa cells, the Lacks family learned their mother's cells had been scattered all over the planet. The Lacks family tried to get more information concerning Henrietta, but was ignored until the publication of Skloot's research papers.

In my quilt, Henrietta's faint image is repeated four times, embedded in the letters HELA, along with fabric and beads representing her immortal cells. Sections of the fabric surrounding Henrietta are from clothing belonging to my late husband, Larry Dunham, who also lost his battle with cancer.

Since the completion of my quilt, scientists sequenced Henrietta Lacks's genome; they made it public in 2013 without asking the family's permission—clearly, a violation of privacy. The National Institute of Health acknowledged their error after objections from the family and invited two of Lacks's descendants to be part of the HeLa Genome Data Access working group. In August 2013, an agreement with the Lacks family was announced, granting them some control over how Henrietta Lacks's genome is used. And Still We Rise.

1952 | Invisible Men

Kelly D. Davis (Plymouth Meeting, Pennsylvania); 2012; 50 x 50 inches; organza, acrylic paint, cotton batting; collage, hand painting, machine quilted; photo by Chas. E. and Mary Martin.

Ralph Ellison is a significant figure in African-American history as the author of *The Invisible Man*, published in 1952. The existential novel depicts an African-American civil rights worker from the South who, after moving to New York, becomes increasingly alienated due to the racism he encounters. The novel was regarded as a groundbreaking reflection on race and marginalized communities in America. The impact of this novel is still felt today.

My quilt was an effort to depict the invisible man, nameless and faceless in today's society. In addition to the watery image of the man, if you look very closely, you will see the images of eyes in the dark blue background. Written over the man is one of the most famous quotes from the book, "I am an invisible man. I am a man of substance, of flesh and bone, fiber and liquids—and I might even be said to possess a mind. I am invisible; understand, simply because people refuse to see me." These are the eyes of the many men in my life who may be invisible to the greater society, but have been significant figures in my life. They are the eyes of my father, my uncles, my mentor, and my brother. I also asked my close friends to take pictures of the eyes of the significant men in their lives. We have three generations of men from one family: grandfather, father and son. Husbands and brothers are also included.

My quilt attempts to honor those men who get up every day and go to work, provide for their families, and influence their communities. My experience is not unique. These men are our unsung heroes. They are the heroes in my life. They may be invisible to many but their existence has shaped my life.

My quilt was made in honor of my "Invisible Men."

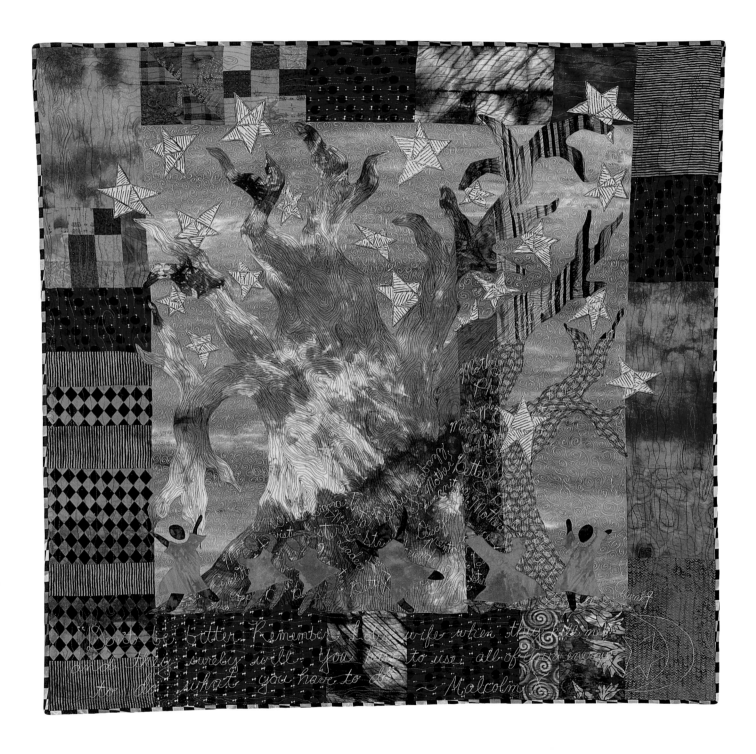

1954 | My Foundation

Myrah Brown Green (Brooklyn, New York); 2012-2013; 50 x 50 inches; cotton fabric, cotton batting; machine pieced, appliqué and quilted; photo by Chas. E. and Mary Martin.

Malcolm X became a minister of the Nation of Islam's New York Temple in 1954. His wife, Betty Shabazz, was an educator who received her doctorate in education from the University of Massachusetts Amherst. Dr. Betty Shabazz and Malcolm X continue to be thought of as one of the world's most iconic couples. Both advocates for the rights of blacks, their life's work continues to influence all areas of world culture. Malcolm X once wrote to his wife, "Don't be bitter. Remember Lot's wife when they kill me, and they surely will. You have to use all of your energy to do what it is you have to do." When I first read those words, they resonated in my soul. I could feel the deep love Malcolm X had for Dr. Betty Shabazz and his knowing that she was the epitome of that woman who embodies relentless strength in all aspects of womanhood. Unlike Lot's wife, who looked back and was turned to a pillar of salt, Malcolm X knew that Dr. Shabazz had the strength to get through the assassination he foresaw. She would be left to raise six daughters, build her career, and continue living as a Muslim.

My Foundation represents the true love, support, and trust of a man for a woman and a woman for a man. A few of Dr. Shabazz's professional and personal titles appear to be carved in the tree. The six figures represent the Shabazz daughters. They are dressed in red. Red is one of the colors typically worn during funerals by Ghana's Ashanti and Akan people. The red tells us that Malcolm X and Dr. Betty Shabazz are now with their ancestors.

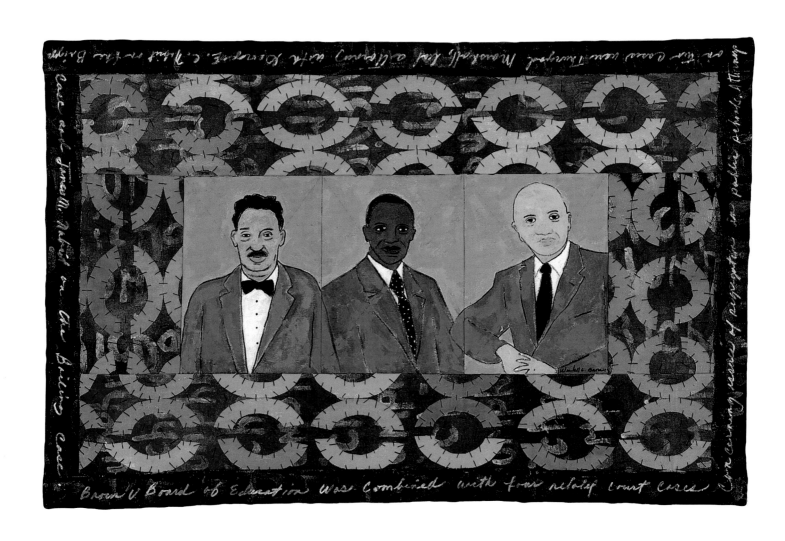

1954 | Brown v. Board of Education:
George E. C. Hayes, Thurgood Marshall, and James Nabrit

Wendell George Brown (Columbia, South Carolina); 2012; 34 x 23 inches; pieced and quilted cotton fabric, cotton batting; machine quilting, acrylic paint on canvas; photo by Chas. E. and Mary Martin.

After completing the quilt *Brown v. Board of Education*, I sat a while and thought about how much I had learned. Moreover, I thought about how much I did not know about the groundbreaking case that made segregation in schools unconstitutional. A lawsuit sparked by the denial of the right of two sisters, Linda and Terry Brown, to attend an all-white elementary school in Topeka, Kansas, became the focus of the struggle for integration and combined with four other cases it found its way to the United States Supreme Court. George E. C. Hayes, Thurgood Marshall, and James Nabrit, pictured in my quilt, were only three of a team of black attorneys who fought this injustice.

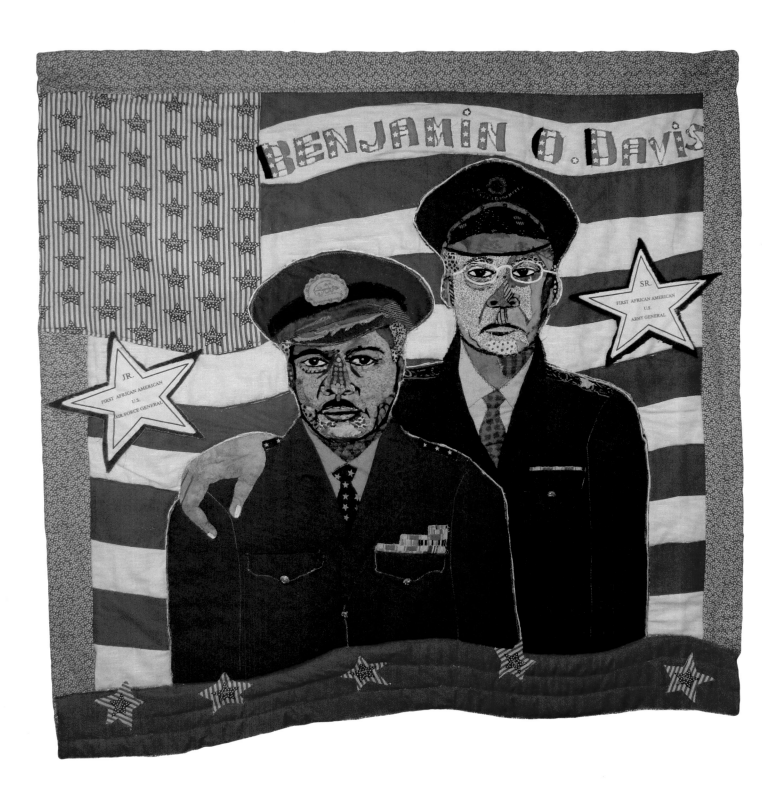

1954 | Benjamin O. Davis, Senior & Junior

Margene G. May (Canton, Ohio); 2013; 40 x 40 inches; cotton, wool blends, buttons, yarn, fabric glue, cotton batting; hand and machined stitched; photo by Chas. E. and Mary Martin.

Benjamin O. Davis, Sr., became the first African-American Brigadier General in the United States Army in 1954. He served in the Phillipine-American War and World Wars I and II. His son, Benjamin O. Davis, Jr., also broke racial barriers in 1962, when he became the first African-American Major General in the United States Air Force. Because of discriminatory practices, both were relegated to all black units. Ben, Jr., was placed in charge of the Tuskegee Airmen and was instrumental in challenging U.S. military practices, which lead to integration in the military.

The approximately twenty-year difference in the achievements of father and son can be seen in subtle things: the accomplished rank of one-star general of the father versus the four-star rank of the son; the role of skin color, as the very light-complexioned were chosen first; and challenge of achieving rank in the Air Force branch, which was more difficult. However, they both faced adversity from their fellow officers based strictly on their race and had to prove daily that blacks were qualified to lead.

The quilt shows the father/son together with strong, determined expressions. The father is in the background, indicating that he was there first. His arm on his son's shoulder indicates pride, protection, and support. Although the son is actually taller, at 6 feet 2 inches, he looked up to and admired his father's accomplishments because his father was the catalyst for his own achievement. The background U.S. flag, represents America, still honored despite the reality of segregation in the military. Their names in the stars show that they are major players who, though gone, are forever emblazoned in history.

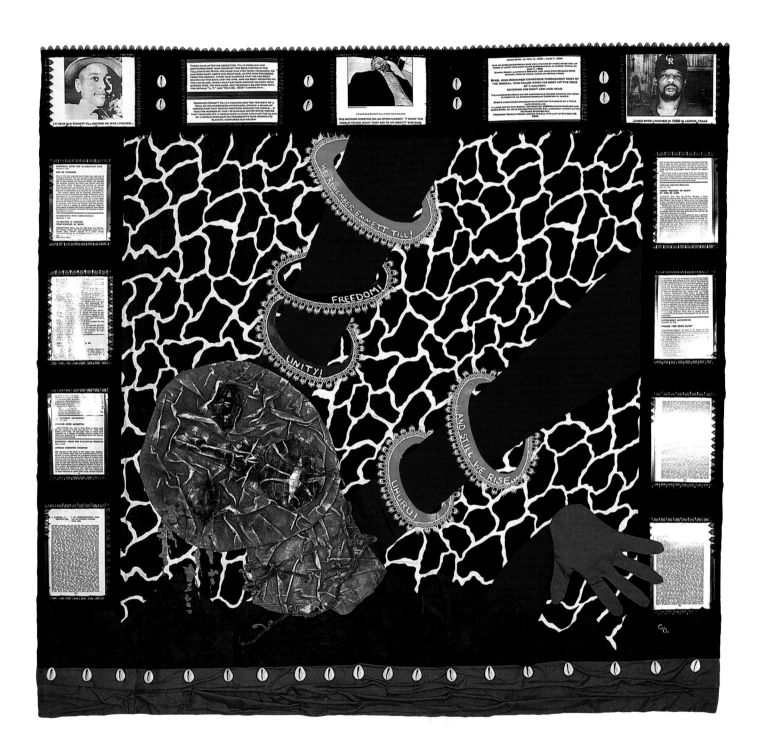

1955 | The Lace Doesn't Lessen
the Horror of Pulling Emmett from the Water

Charlotte O'Neal (Arusha, Tanzania); 2012; 50 x 50 inches; cotton, acrylic paint, photo-transfer, plastic, beads, found objects, cotton batting; painted, fabric manipulation, hand and machine quilted; photo by Chas. E. and Mary Martin.

My first dream vision of this quilt was a close-up of Emmett's beautiful eyes, with the long, long lashes (it looks to me) in the famous photo of him as a 15-year-old sporting a country-boy fedora. Those beautiful, thick lashes cover the ripped, swollen lid on Emmett's gouged out, still bleeding eye, and the lashes shield the glassy stare of his other eye. That is what I saw first in my vision, and then the rest of the piece just grew around it.

From the mottled, waterlogged skin of his swollen face and head to the barbed wire wrapped around his neck, and the lace-edged newspaper reports of lynchings that border the piece, it all serves as a lesson in history for those who have never heard of the Emmett Till lynching and those who have, but need a refresher course.

The arms lifting him gently out of the water that had covered him for three days represent our resilient communities and the fact that hope flows eternally…and still we rise!

I devised techniques that I'd never used before, in order to realize the quilt in my vision—and it was not a struggle at all. It spoke to me. I was simply the vehicle—the hands and fingers it needed.

Moreover, after I had finished and it hung in my studio bedroom, I cried as I stared at Emmett's long eyelashes and the blood surrounding and matting some of them together.

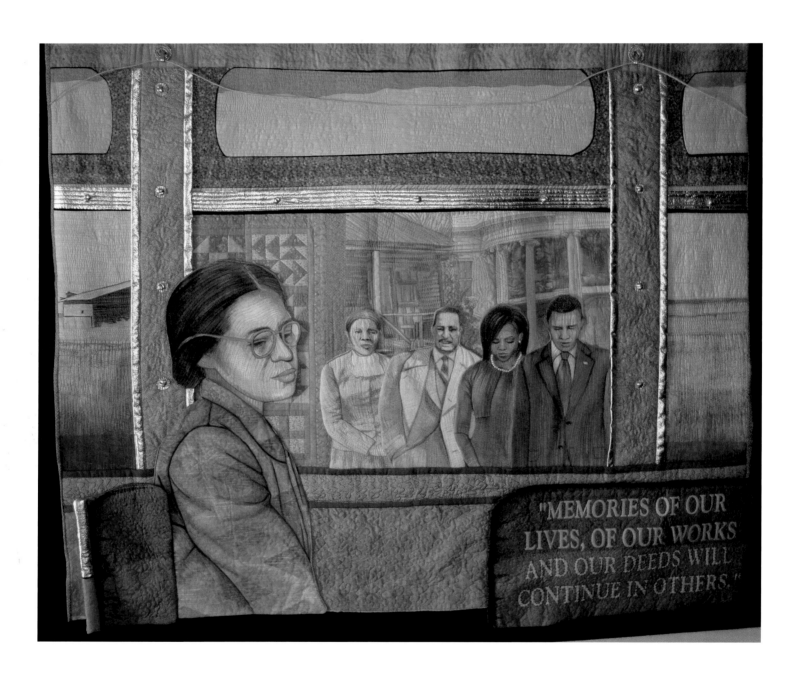

1955 | A Seat for Rosa

Carolyn Crump (Houston, Texas); 2010; 36 x 36 inches; cotton fabric, cotton thread, ribbon, beads, metal, felt, cowrie shells, plastic, cotton batting; appliqué, fabric manipulation, hand painted, printed, machine quilted; photo courtesy of artist.

On December 1, 1955, Rosa Parks refused to surrender her seat to a white passenger on a Montgomery, Alabama, bus. It was practice that African-Americans give up their seats in the back of the bus after the white section was filled. Her refusal to do this and her subsequent arrest spurred a citywide boycott. After a year-long boycott, the city of Montgomery had no choice but to lift the law requiring segregation on public buses.

In the quilt, Harriet Tubman, Thurgood Marshall, and Barack and Michelle Obama look on as Rosa Parks refuses to give up her seat on the bus. Tubman, an abolitionist, and Marshall, the first African-American appointed to the Supreme Court, symbolize the many African-Americans who devoted their lives to, and paved the way for, liberty and opportunities for African-Americans. As the first African-American president elected in the United States, Barack Obama and First Lady Michelle Obama look towards the bus. Their presence in this piece symbolizes the changes that have occurred in the African-American community through slavery, Reconstruction, and the Civil Rights Movement. The Obamas are benefactors of these efforts. Behind Parks is a patchwork quilt to symbolize the fact that both she and Harriet Tubman were quiltmakers.

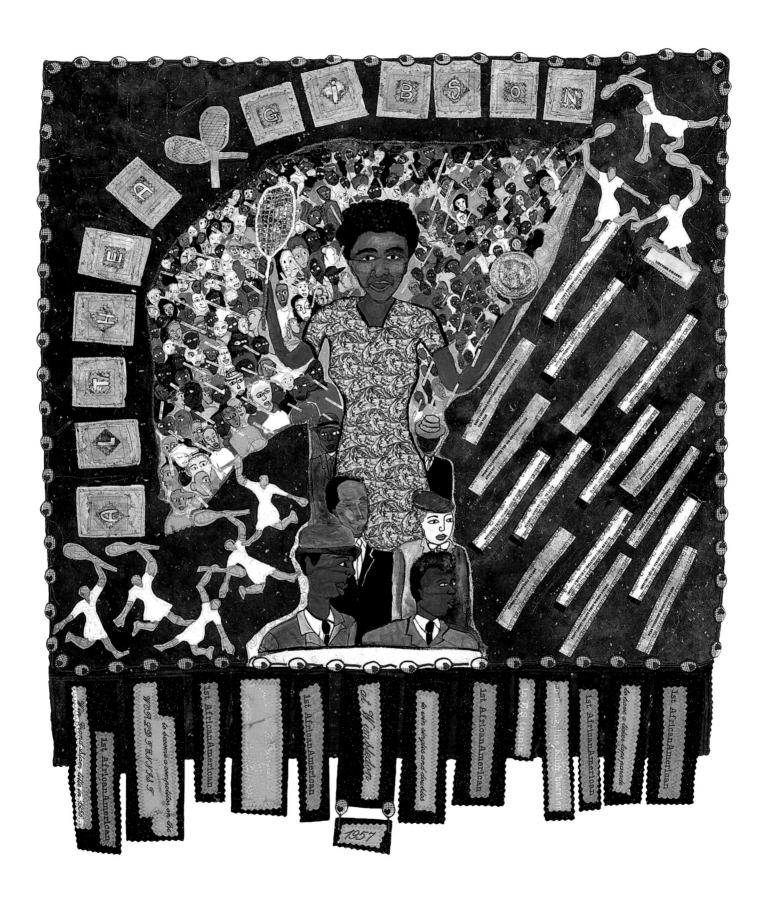

1957 | Althea Gibson

Dindga McCannon (New York, New York); 2012; 59 x 59 inches; hand dyed cottons, commercial cottons, paper, felt, glass beads, metal charms, and acrylic paint, cotton batting; painted, machine embroidery and quilted; photo by Chas. E. and Mary Martin.

This is the third art quilt I've made depicting the life of tennis great Althea Gibson. African-American women's history, especially Harlem women's history, has been portrayed in my art since the 1960s.

I choose to revisit Gibson because I feel she is important as a black woman who not only excelled in her field of choice, but also did it while being poor and despite the ugly racial realities of the day. I'm hoping by doing this ongoing series, her story will never be forgotten. I am also proud of the fact that she spent a lot of her life in Harlem, which is my hometown.

This quilt illustrates the events of July 6, 1957, when she became the first African-American woman to be given a ticker tape parade down Broadway in her native New York City.

This quilt makes more use of mixed media than my previous quilts. I am going through a phase in which I am pushing the limits of quilt making and expanding the boundaries of what can be used in making quilts, such as the use of paper. I continue to explore the use of new materials, such as Lutradur® and Tyrek®, and the combination of the new with traditional techniques.

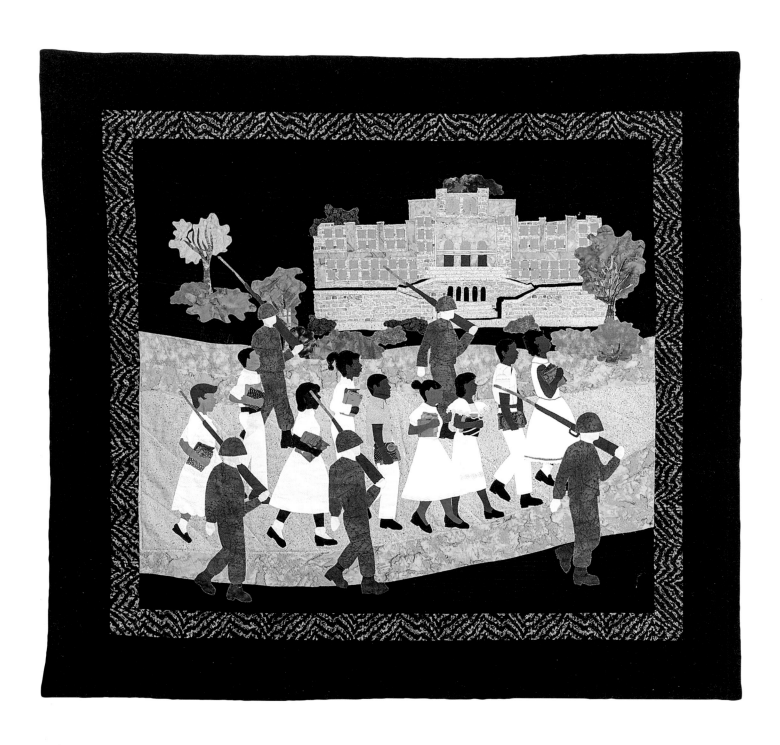

1957 | The Little Rock Nine

Sandra Noble (Shaker Heights, Ohio); 2012; 50 x 50 inches; cotton fabric and batting; machine free motion quilting and appliqué, fusing, and free motion quilting; photo by Chas. E. and Mary Martin.

In 1957, Arkansas Governor Orval Faubus forbade nine African-American teenagers to attend the all-white Little Rock Central High School. In 1954, the Supreme Court had ruled that segregated schools were unconstitutional, which Governor Faubus ignored. On September 4, 1957, Arkansas National Guard soldiers, dressed for war and armed with guns, and an angry mob of white people of all ages shouting violent threats and racial slurs greeted the three boys and six girls outside of Central High School.

The nine teens, nicknamed the "Little Rock Nine," finally entered Central High School on September 24 after President Dwight Eisenhower neutralized the Arkansas National Guard and sent federal troops to escort the nine into the school.

I specifically selected this event in black history as the focus for my quilt because I had a personal connection to the "Little Rock Nine." In the fall of 1958, Ernest Green, the first of the nine to graduate from Little Rock Central High School, entered Michigan State University. I entered Michigan State University that same fall, and Ernie and I were in the same freshman class. One year later, another member of the "Little Rock Nine," Carlotta Walls, entered Michigan State University.

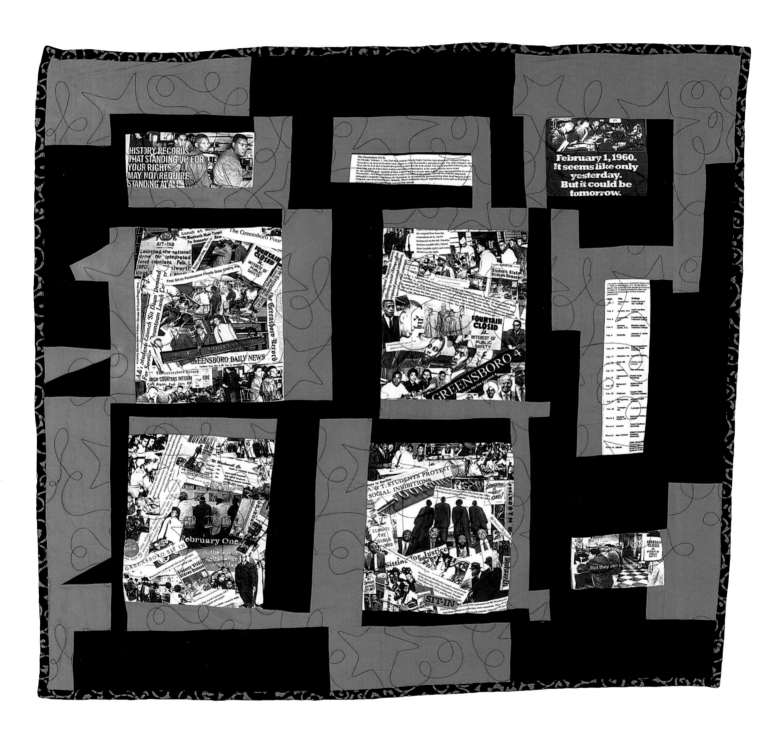

1960 | Student Sit-In

Ed Johnetta Miller (Hartford, Connecticut); 2012; 38 x 36 inches; cotton, photo transfer, cotton fabrics and batting; machine pieced and quilted; photo by Chas. E. and Mary Martin.

I was born in Greensboro, North Carolina, during segregation and recall the sit-ins at the local downtown stores. I vividly remember going to that segregated section of both Woolworth and Kress stores to buy goods. The entire African-American population of Greensboro knew big change was in the air when over twenty African-American college students sat in the white section of the Woolworth store and asked to be served. While many African-Americans, especially elders, were afraid to go downtown during the sit-ins, they appreciated the courage of the students who dared go against the racist policies of the South. In the end, the students accomplished what they started out to do. African-Americans stopped shopping at Woolworth and Kress. The stores were losing money, so they decided to change their policy of segregated counters. During the summer of 1960, Woolworth desegregated their lunch counters.

An elder woman in Greensboro gave me a box of old newspapers detailing the sit-in movement she collected during the winter of 1960. I used the headlines from the newspaper clippings to create my quilt. The clippings were digitally photo transferred onto cotton fabric, and strip pieced improvisationally. The quilt serves as a reminder of just how far my people have come. The quilt marks the end of an ugly era in American history I lived through and survived.

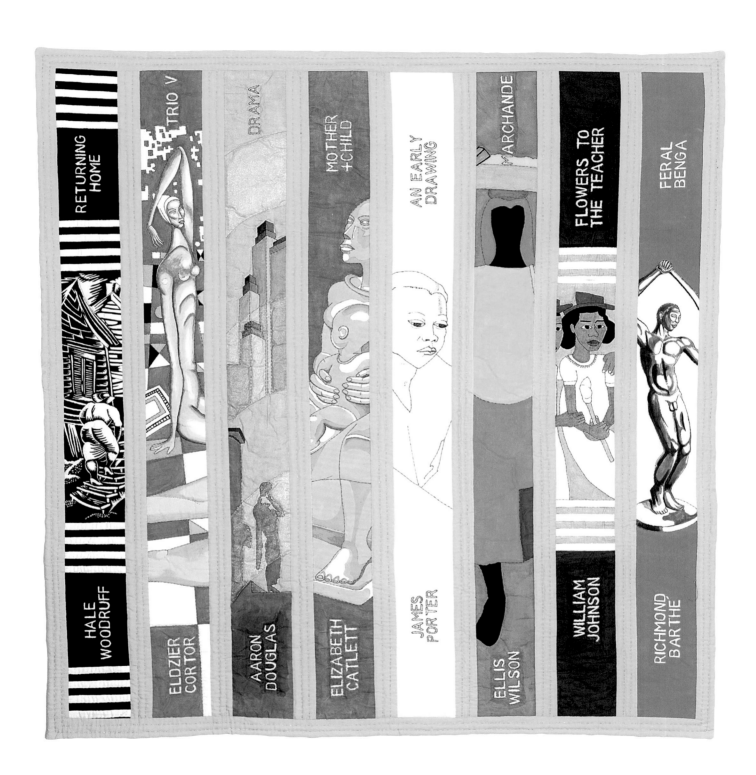

1960 | American Negro Art:
An Album

Jim Smoote (Chicago, Illinois); 2012; 44 x 47 inches; acrylic paint, cotton fabric, cotton batting; drawn, hand painted, machine pieced and hand quilted; photo by Chas. E. and Mary Martin.

American Negro Art: An Album is a strip-pieced quilt made with acrylic, painted on cotton. The work was inspired by the first comprehensive survey of African-American visual art. *Survey of African-American Art*, by Cedric Dover, was first published in 1960 by Studio Books, in London, and by the New York Graphic Society. The eight works I chose to depict are mid-twentieth century and highlight drawing, painting, printmaking, murals, and sculptures. The work shows a range of styles and artistic visions. The artists represented are Hale Woodruff, Eldrier Cortor, Aaron Douglas, Ellis Wilson, William Johnson, and Richmond Barthe.

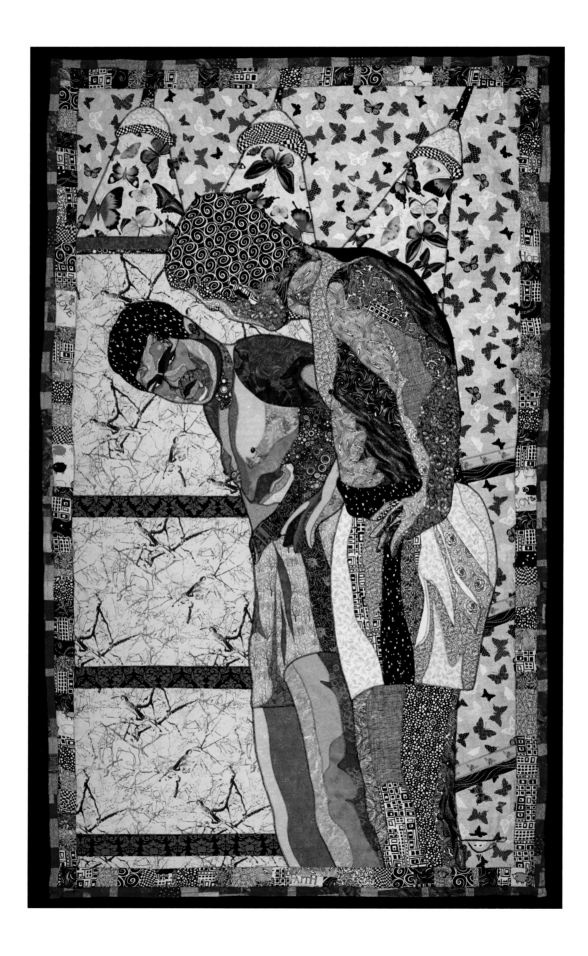

1960 | Muhammad Ali

Ramsess (Los Angeles, California); 2012; 60 x 96 inches; cotton fabric, thread and batting; appliqué; photo courtesy of artist.

Muhammad Ali was one of my earliest heroes and continues to be someone I respect and admire. I am inspired by his legacy as a boxer and his charming arrogance, which never let the constraints of racism get him down. The image in the quilt is of Ali looking at himself in a mirror. The black-and-white image represents how the public sees him and the color image represents the full depth in which he sees himself as he says, "Man ain't we pretty?"

Today, Ali is widely regarded for not only the skills he displayed in the boxing ring but also for the values he exemplified outside of it: religious freedom, racial justice, and the triumph of principle over expedience. He won the Light Heavyweight gold medal in the 1960 Summer Olympics in Rome when he was only 18 years old.

When Ali was 22, he fought Sonny Liston. The year was 1964. The fight was a brutal defeat for Liston, and Ali won the world heavyweight championship. After the bout, Ali became a Muslim and changed his name.

As one of the most recognized people in sports, Ali was crowned "Sportsman of the Century" by Sports Illustrated magazine. He revolutionized the sport of boxing by sheer power and the magnetism of his personality.

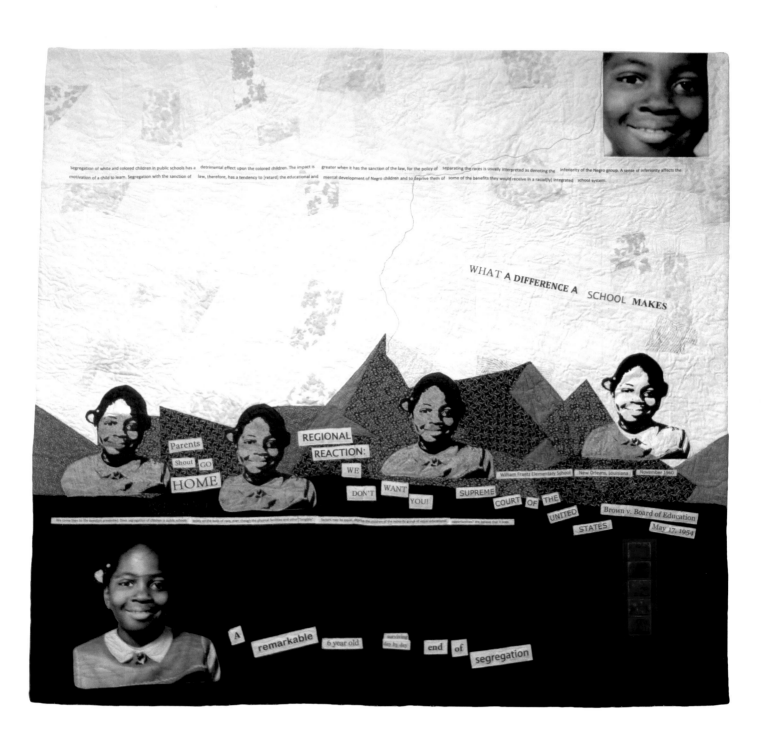

Segregation of white and colored children in public schools has a detrimental effect upon the colored children. The impact is greater when it has the sanction of the law, for the policy of separating the races is usually interpreted as denoting the inferiority of the Negro group. A sense of inferiority affects the motivation of a child to learn. Segregation with the sanction of law, therefore, has a tendency to [retard] the educational and mental development of Negro children and to deprive them of some of the benefits they would receive in a racial[ly] integrated school system.

WHAT **A** DIFFERENCE A SCHOOL MAKES

Parents Shout GO HOME

REGIONAL REACTION:

WE DON'T WANT YOU! SUPREME COURT OF THE UNITED STATES

William Frantz Elementary School New Orleans, Louisiana November 1960

Brown v. Board of Education

May 17, 1954

We come then to the question presented. Does segregation of children in public schools solely on the basis of race, even though the physical facilities and other "tangible" factors may be equal, deprive the children of the minority group of equal educational opportunities? We believe that it does.

A remarkable 6 year old surviving day by day end of segregation

1960 | Ruby Nell Bridges

Marion Coleman (Castro Valley, California); 2012; 50 x 50 inches; cotton fabric, photo-transfer on cotton; machine pieced and quilted; photo courtesy of artist.

In 1960, six-year-old Ruby Bridges Hall became one of the first African-American children to desegregate an elementary school. Ruby and her family moved to New Orleans in 1958. At that time in our country's history, segregation was law in the south. Blacks and whites used different drinking fountains, sat in different seats on buses, lived in separate neighborhoods, went to separate schools, and were even buried in separate cemeteries.

When Ruby was old enough to go to school, her father wanted her to go to an all-black school. That was because he was afraid that people would get angry if she went to to the all-white William Frantz School. Ruby's mother, on the other hand, knew that Ruby would get a better education at the all-white school and insisted on getting Ruby the best education possible.

In the spring of 1960, Ruby Bridges was one of six black children in New Orleans to pass the test that determined whether they would go to the all-white school. Two of the children decided to stay in their old schools, three were assigned to McDonogh Elementary School, and Ruby was assigned to William Frantz Elementary School by herself.

On her first day at the new school, Ruby was led into the building by U.S marshals, who protected her from an angry crowd of white people protesting outside. There were children and adults holding signs and yelling at Ruby for coming to their school. No white parents wanted Ruby in the same class as their children, and some even took their children out of school.

Because of this animosity, she was placed in a class by herself. She was the only student in the room with her teacher, Barbara Henry, and her classes even had to be held on a separate floor in the school, away from the white students. Ruby was Henry's only student and they worked alone in a classroom. Her teacher would allow her to eat only food brought from home because of daily threats of poisoning. At her mother's suggestion, Ruby began to pray on the way to school, which she found provided protection from the comments yelled at her on her daily walks.

Although difficult at times, Ruby Nell Bridges persevered and remained in school.

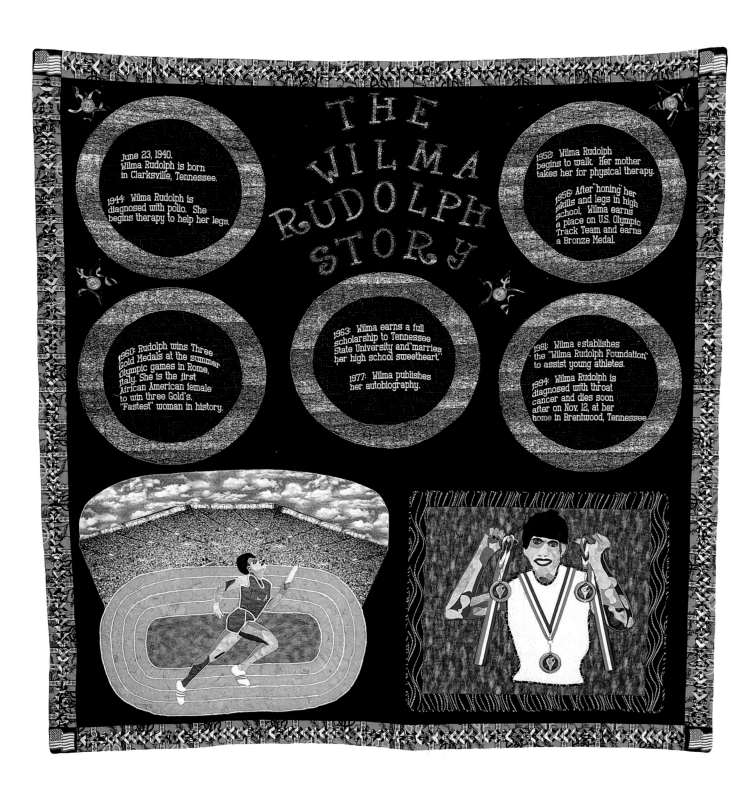

THE WILMA RUDOLPH STORY

June 23, 1940. Wilma Rudolph is born in Clarksville, Tennessee.

1944: Wilma Rudolph is diagnosed with polio. She begins therapy to help her legs.

1952: Wilma Rudolph begins to walk. Her mother takes her for physical therapy.

1956: After honing her skills and legs in high school, Wilma earns a place on U.S. Olympic Track Team and earns a Bronze Medal.

1960: Rudolph wins Three Gold Medals at the summer Olympic games in Rome, Italy. She is the first African American female to win three Gold's. "Fastest" woman in history.

1963: Wilma earns a full scholarship to Tennessee State University and marries her high school sweetheart.

1977: Wilma publishes her autobiography.

1981: Wilma establishes the "Wilma Rudolph Foundation" to assist young athletes.

1994: Wilma Rudolph is diagnosed with throat cancer and dies soon after on Nov. 12, at her home in Brentwood, Tennessee.

1960 | The Wilma Rudolph Story

Laura M. Croom (Warrensville Heights, Ohio); 2012; 80 x 80; cotton, silk dupioni, athletic nylon mesh, lame, fusible web, yard, vinyl, cotton batting; collage, appliqué, quilting, couching, and embroidery; photo by Chas. E. and Mary Martin.

Inspiring, persevering, and winning is what I think of when reading the *Wilma Rudolph Autobiography*. When the modern Olympic Games began in 1913, the symbol of the five interlocking rings represented the five continents from which the athletes participated. I thought this would be a perfect way to represent Wilma's story, but through unlocked circular rings.

Wilma inspired me; she overcame great odds to become an Olympian. At the age of five, Wilma was diagnosed with polio and had to wear leg braces to aid in walking. Wilma was able to persevere; with her mother's inspiration, she continued with rehabilitation and began to participate in sports. Wilma played basketball and was on the track team in high school. In 1956, Wilma participated in the Melbourne Olympics and won the bronze medal. Wilma continued her training and represented the United States in the 1960 Summer Olympics in Rome, Italy, where she won three gold medals!

Wilma was the first African-American woman to medal in the Olympics! She paved the way for other African-American athletes when she founded the Wilma Rudolph Foundation in 1981. Wilma Rudolph triumphed over adversity and was truly an inspiring African-American woman.

1960: Rudolph wins Three Gold Medals at the summer Olympic games in Rome, Italy. She is the first African American female to win three Gold's. "Fastest" woman in history.

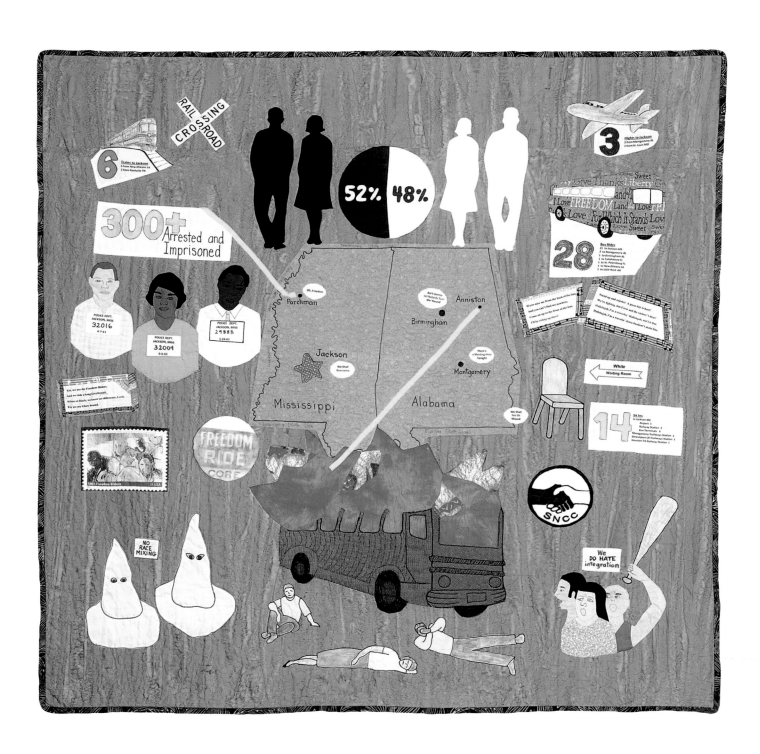

1961 | Freedom Riders:
Spring and Summer 1961

Marjorie Diggs Freeman (Durham, North Carolina); 2012; 50 x 50 inches; commercial cotton, African cotton, cotton batting, cotton cord, grosgrain ribbon; photo transfer on cotton, ink and pencil-colored drawing, hand and machine appliqué, machine quilted; photo by Chas. E. and Mary Martin.

During the spring and summer of 1961, volunteers from all over the United States converged in the South to test the new laws that prohibited segregation related to all aspects of interstate travel. After researching the events and people actively involved, I consolidated the information and created a quilt design to translate my findings, while telling the stories of the freedom riders with visual impact and few words.

The states of Alabama and Mississippi were the focus of the protests, which targetted all means of transportation—buses, trains, and airplanes—and included a number of sit-ins at terminals. The freedom riders crossed all social and economic lines, age groups, religious beliefs, and occupations, from homemakers to high school and college students to ministers and mayors, and even the unemployed. The participants were divided almost equally between races: 48% white and 52% African-American. Wherever they traveled or met, those of both races faced imprisonment and life-and-death situations at the hands of angry mobs and the Ku Klux Klan. The main sponsors of the program, the Congress of Racial Equality (CORE) and the Student Nonviolent Coordinating Committee (SNCC), were actively involved with other like-minded groups and organizations in carrying out planned trips and activities for over 1,000 volunteers.

My quilt illustrates and lists specific details and facts, with hymn titles next to major cities indicating an event that occurred there. The words to a few of the freedom songs sung by the riders appear in musical frames. The burning of the bus in Anniston, Alabama, centered at the quilt's base, is surrounded by examples of the horrors and injuries these Americans faced as they sought basic equality in public transportation. It is impossible, however, for me to show the emotional and psychological scars sustained by these courageous freedom riders, whose activities, shown to the world, forever changed federal and state laws and the lives of innumerable African-Americans, then and for years to come.

In the years that followed, the freedom riders continued the struggle for equality in the South by working on voter registration and other issues relating to housing and education.

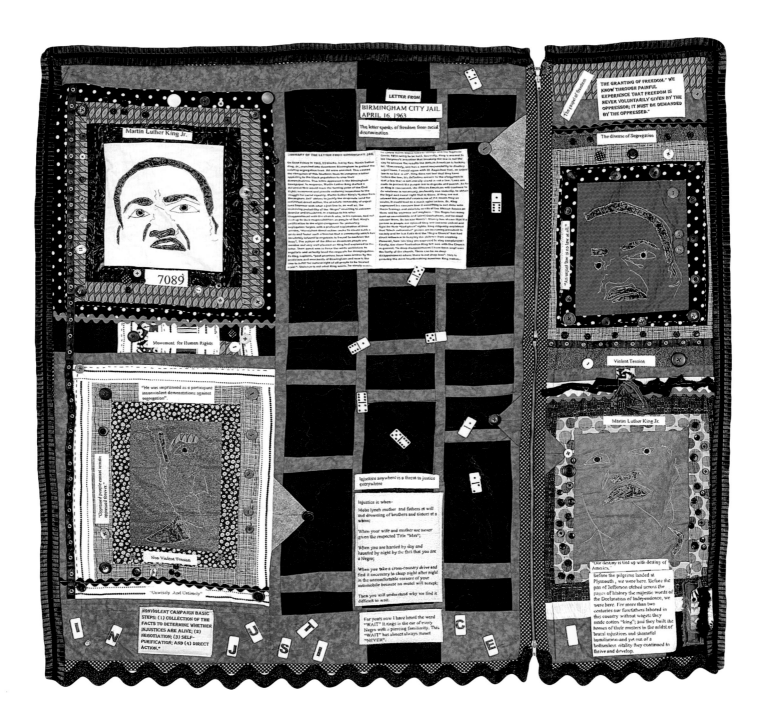

1963 | Letter from a Birmingham Jail

Latifah Shakir (Lawrenceville, Georgia); 2012; 50 x 50 inches; cotton, acrylic ink, found objects, beads, button, zippers, cotton batting; machine piecing, collage, hand drawing, machine quilted; photo by Chas. E. and Mary Martin.

Equality? Are we there yet? Ask yourself that question. What answer comes to mind?

I want viewers to feel the tension in my quilt. It is a simple geometric design with the architectural layout of a jail cell. There are fragmented pictures of Martin Luther King peeping through the closed squares. Layered netting and machine stitching round out the feel I'm trying to express.

Like the squares, the black units show tension and give depth to the piece. The squares are surrounded by red bars, which symbolize the blood shed by many during the Civil Rights Movement. The dominoes embellishing this piece are in a rhythmical direction, and represent Dr. King's eloquent language in the "Letter from a Birmingham Jail."

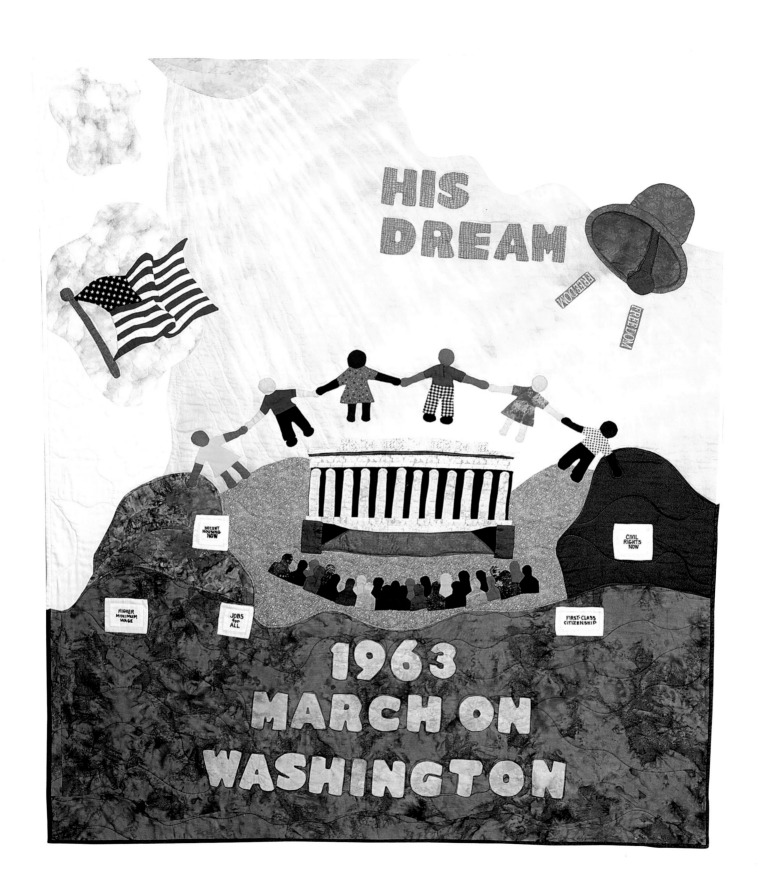

1963 | His Dream

Selena Sullivan (Mint Hill, North Carolina); 2012; 65 x 60 inches; cotton fabric and batting; appliquéd, machine quilted by Deborah Norris; photo by Chas. E. and Mary Martin.

Growing up and becoming an adult by the mid-sixties allowed me to experience life in the South both before and after the Civil Rights Act of 1964. The historic March on Washington and Martin Luther King's famous "I Have A Dream" speech, delivered to over 250,000 supporters on August 28, 1963, really did set the stage for passage of this important legislation prohibiting segregation and discrimination in education and employment.

In this quilt, I decided to focus on some of the symbolism and elements that resonated within me when I read and re-read the speech. Children of various races holding hands, in my mind, symbolize the innocence, hope, and optimism of the future. They are joined by our American Flag proudly blowing in the wind, a bell ringing freedom, the sun streaming down from above and symbolizing the dawn of a "new day," and, of course, the Lincoln Memorial, where the historic speech was delivered to eager supporters. I placed signs and placards nearby to emphasize the sentiments and purpose of this important event. Even today, much still needs to be done to enable "His Dream" to be fully realized.

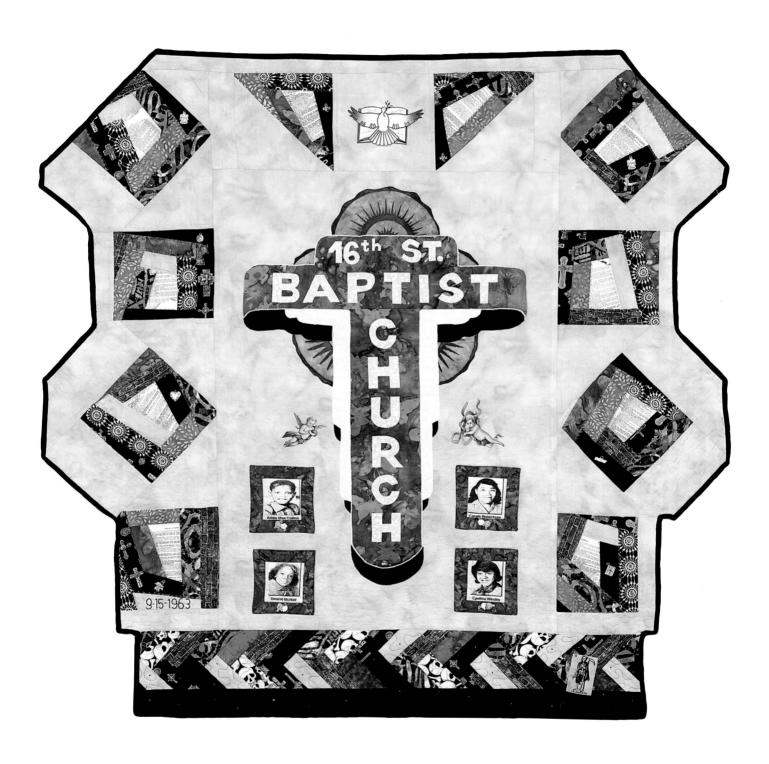

1963 | Birmingham Bombing

Sylvia Hernandez (Brooklyn, New York); 2012; 49 x 50 inches; cotton, photo transfer fabric, beads, buttons, silk flowers, cotton batting; machine pieced, appliqué and quilted; photo by Chas. E. and Mary Martin.

This quilt was inspired by the bombing tragedy that took place September 15, 1963, at the 16th Street Baptist Church in Birmingham, Alabama. The research I did to prepare for this piece was very difficult, because, as I read the articles and saw the photos, I felt the horror of it all in my very soul. Midway through making the quilt, there was the shooting tragedy in Aurora, Colorado, and then the killings in Wisconsin, yet again in a house of worship. It is fifty years later and people are still dying because of the color of their skin or because of who others think they are.

I needed to show beauty in this quilt, and what better beauty than the love of God and our churches? Faith has always been at the center of the lives of so many families. Without our faith, we all would have perished. Faith, not only in God, but in each other's ability to succeed, is the essence of who we are as a people. The young girls killed in the bombing did not die in vain. They died for the Oprahs, the Sonia Sotomayors, and all the other young girls who grew up to make a huge difference in the world—and for so many yet to come. The quilt depicts the shattering of the church. The red beads represent the blood lost. It would have been impossible for me to make this quilt without my faith guiding me through.

1964 | Ironic

Sandra Hankins (Lake Elsinore, California); 2012; 22 x 44 inches; whole cotton cloth, tulle, Tsenkineko® inks, various threads, cotton batting; hand painted, machine quilted; photo by Chas. E. and Mary Martin.

In June 1964, near Philadelphia, Mississippi, the murders three young men demonstrated the dangers faced by civil rights workers in the South in that era. During what became known as "Freedom Summer," dedicated to voter education and registration, James Chaney, a 21-year-old black man from nearby Meridian, Mississippi, Andrew Goodman, a 20-year-old, white, Jewish anthropology student from New York, and Michael Schwerner, a 24-year-old, white, Jewish Congress of Racial Equality organizer and former social worker also from New York, were murdered by the Ku Klux Klan.

The hate-filled murders of these three, heroic young men were vile, and profoundly illustrated the extent that racist cowards would go to marginalize African-Americans at that time. In the summer of 1964, Chaney, Goodman, and Schwerner paid the ultimate sacrifice to help others exercise their right to vote. I find it ironic that, almost fifty years later, we are facing a new phenomenon, with our civil liberties now being threatened again by the voter suppression movement of minority voters in several states. When will this hatred ever end?

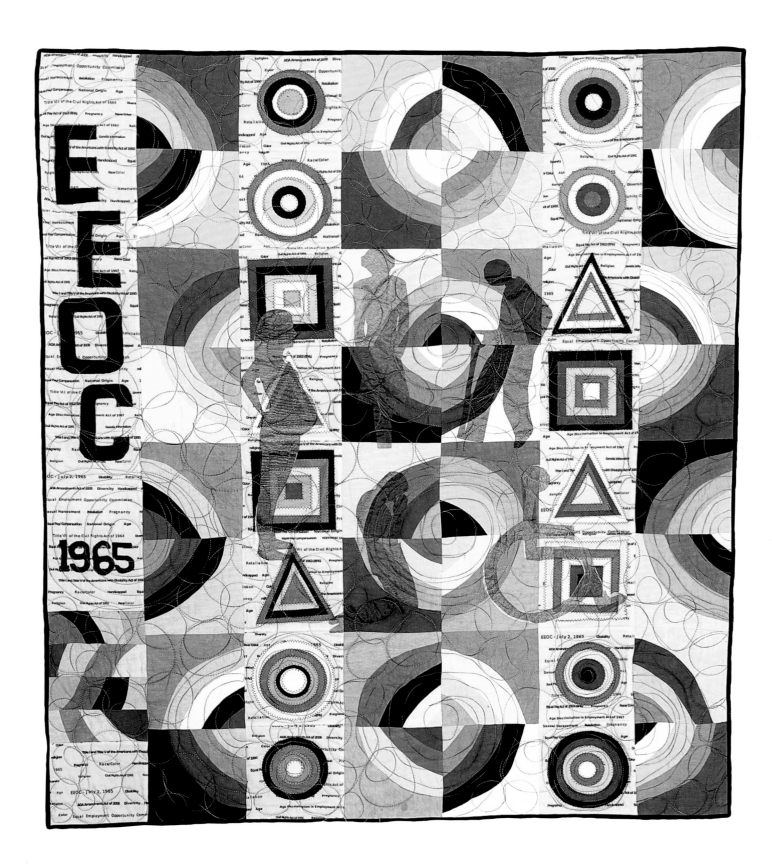

1965 | We Are Not There Yet

Gwen Maxwell-Williams (Redmond, Washington); 2012; 42 x 48 inches; commercial sueded cotton and organza, cotton batting, cotton batting; machine appliqué and quilted; photo by Chas. E. and Mary Martin.

Created in 1965, the U.S. Equal Employment Opportunity Commission (EEOC) is a federal law enforcement agency that enforces laws against workplace discrimination. Have we arrived? Are the issues gone? Have we truly become a nation where race, the color of one's skin, religion, sex, disabilities, sexual orientation, and other factors are no longer divisive, no longer define or limit us? Is discrimination a thing of the past? My answer is NO! Over forty years have passed since the creation of the EEOC, and we still see evidence that discrimination continues to exist, although at times it is covert. Will we as a nation ever get there? The pessimistic side of me continues to say, "No." America, prove me wrong!

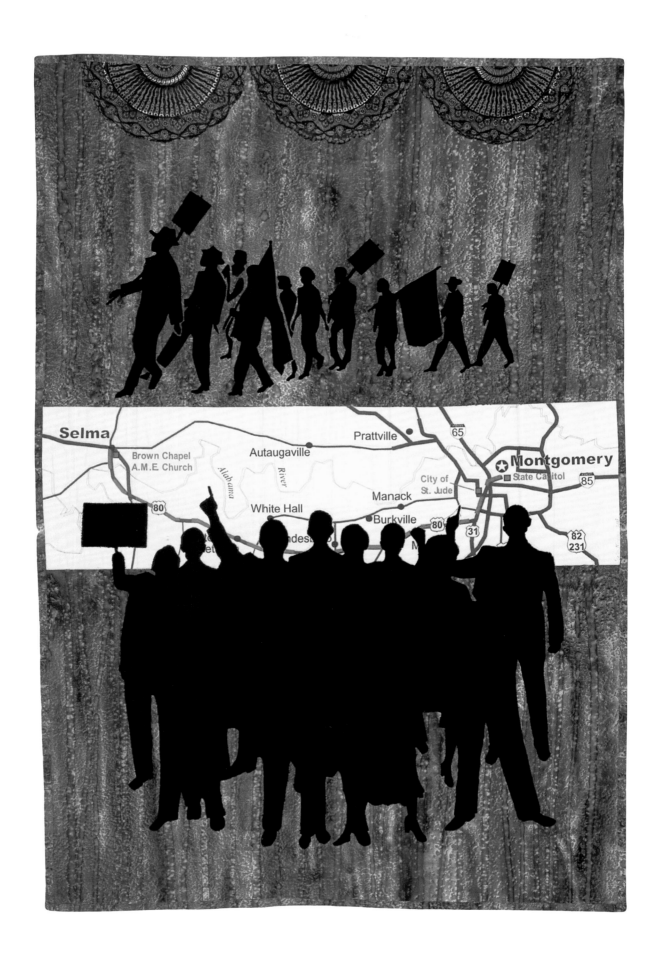

1965 | Ain't Gonna Let Nobody Turn Me Around

Carolyn L. Mazloomi (West Chester, Ohio); 2009; 62 x 44 inches; cotton fabric, photo transfer, cotton batting; machine appliqué and quilting; photo by Chas. E. and Mary Martin.

As a young person growing up in Louisiana, I vividly remember watching the television news report of 600 peaceful, unarmed demonstrators in Selma, Alabama, being violently attacked. Civil rights leaders had sought and received court protection for a full-scale march from Selma to the state capitol in Montgomery, but state troopers and local police used tear gas, whips, and clubs to drive the marchers back. The demonstrators, led by Rev. Martin Luther King, Jr., were trying to cross the Pettus Bridge in Selma, to march to Montgomery. All this brutality happened in plain sight of photographers and journalists. The marchers were demonstrating for African-American voting rights and to commemorate the death of Jimmie Lee Jackson, shot three weeks earlier by a state trooper while trying to protect his mother at a civil rights demonstration. Fifty marchers were hospitalized. That day, March 7, 1965, became known as "Bloody Sunday."

The television coverage of the violence shocked the nation. It provoked an outpouring of support for the voting rights movement from whites throughout the country. Religious leaders from numerous faiths, labor leaders, students, and ordinary citizens poured into Selma to stand with the marchers. An estimated 800 volunteers from 22 states arrived in Selma in the days after Bloody Sunday. On Sunday, March 21, 1965, about 3,200 marchers again set out for Montgomery, walking twelve miles a day and sleeping in fields. By the time they reached the capitol on Thursday, March 25, 1965, they were 25,000-strong.

The march is considered a catalyst for the Civil Rights Movement. President Lyndon Johnson and key members of Congress, who had been dubious about the need for a voting rights bill, now committed themselves to its passage. Less than five months after the last of the marches, President Lyndon Johnson signed the Voting Rights Act of 1965, guaranteeing every American age twenty-one and over the right to register to vote.

1966 | Kwanzaa

Carolyn Crump (Houston, Texas); 2009; 34 x 26 inches; cotton fabric, cotton thread, ribbon, beads, metal, felt, cowrie shells, plastic, cotton batting; appliqué, fabric manipulation, hand painted, printed, machine quilted; photo by Chas E. and Mary Martin.

Kwanzaa was started in 1966 by Maulana Karenga created the holiday in 1966. Celebrated from December 26 to January 1 to honor African-American heritage, each of the seven days of Kwanzaa is dedicated to one of its seven principles: unity, self-determination, collective work and responsibility, collective economics, purpose, creativity, and faith.

In the home a decorative mat is placed in a prominent location. It features the symbols of Kwanzaa: a candleholder for seven candles, fruits and vegetables, a black, red, and green flag, and a libation cup. Celebrations take place throughout the week and include the lighting of candles, music, drumming, dancing, and a reflections on and remembrances of African-American history. On the seventh day a feast is held and gifts are given.

The inspirations behind this art quilt were family, community, and culture. I wanted the art to reflect the week-long celebration honoring the African heritage. The circular shape with the blue and green colors shows that Kwanzaa is recognized by millions throughout America and the world. I wanted to show that the father is the bond that holds the family together as he circles them with love, security, and a sense of wholeness. Kwanzaa is a festive and joyous celebration, birthed out of the African heritage, showing unity and purity of its people.

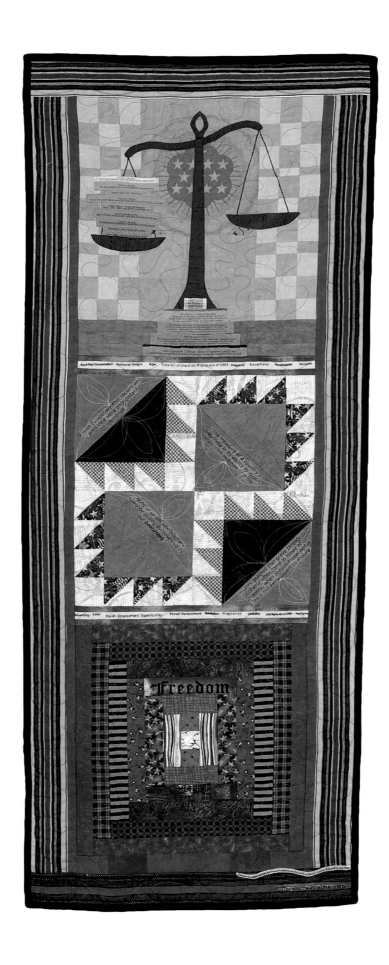

1967 | The Advocate

Rachel D. K. Clark (Watsonville, California); 2012; 22.5 x 58 inches; cotton fabric and batting; machine pieced and quilted; photo by Chas E. and Mary Martin.

When President Johnson appointed Thurgood Marshall to the Supreme Court in 1967, he became the first black Supreme Court Justice. He was an advocate for equal justice for all Americans. Because I am a quilter, I enjoy using quilt blocks to help put meat on the bones of the story. Therefore, I chose the traditional quilt blocks of Courthouse Steps, the Barrister's block, and I designed a Scale of Justice block for the body of the quilt. I thought this image was an excellent representation for him, as he spent most of his life attempting to balance that scale so that all people are able to participate in the full measure of the constitution.

The measure of a country's greatness is its ability to retain compassion in times of crisis.
— Thurgood Marshall

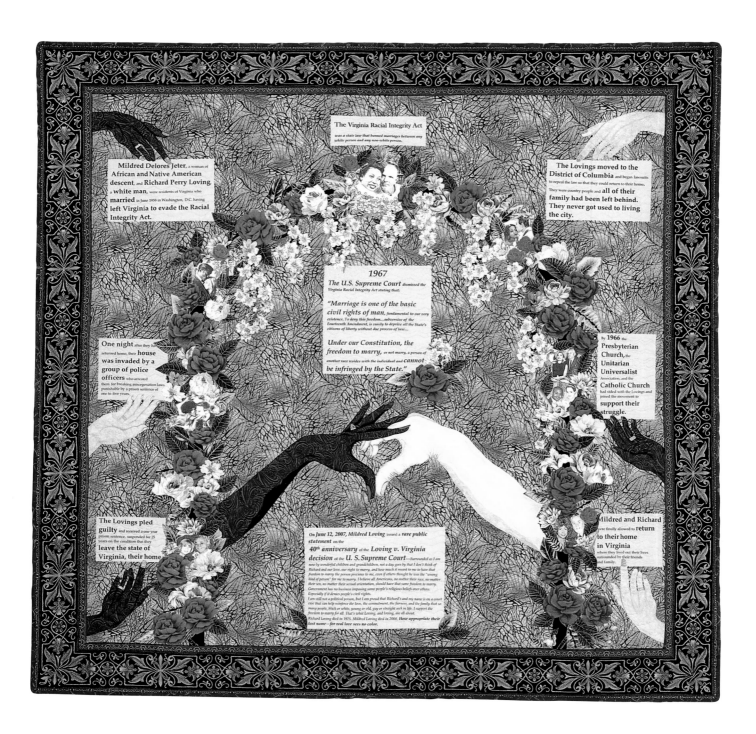

The Virginia Racial Integrity Act

was a state law that banned marriages between any
white person and any non-white person.

Mildred Delores Jeter, a woman of
African and Native American
descent, and Richard Perry Loving,
a white man, were residents of Virginia who
married in June 1958 in Washington, D.C. having
left Virginia to evade the Racial
Integrity Act.

The Lovings moved to the
District of Columbia and began lawsuits
to repeal the law so that they could return to their home.
They were country people and all of their
family had been left behind.
They never got used to living
the city.

1967
The U.S. Supreme Court dismissed the
Virginia Racial Integrity Act stating that:

"Marriage is one of the basic
civil rights of man, fundamental to our very
existence. To deny this freedom...subversive of the
Fourteenth Amendment, is surely to deprive all the State's
citizens of liberty without due process of law...

Under our Constitution, the
freedom to marry, or not marry, a person of
another race resides with the individual and cannot
be infringed by the State."

One night after they had
returned home, their house
was invaded by a
group of police
officers who arrested
them for breaking miscegenation laws,
punishable by a prison sentence of
one to five years.

By 1966 the
Presbyterian
Church, the
Unitarian
Universalist
Association, and the
Catholic Church
had sided with the Lovings and
joined the movement to
support their
struggle.

The Lovings pled
guilty and received a one year
prison sentence, suspended for 25
years on the condition that they
leave the state of
Virginia, their home.

On June 12, 2007, Mildred Loving issued a rare public
statement on the
40th anniversary of the Loving v. Virginia
decision of the U. S. Supreme Court—Surrounded as I am
now by wonderful children and grandchildren, not a day goes by that I don't think of
Richard and our love, our right to marry, and how much it meant to me to have that
freedom to marry the person precious to me, even if others thought he was the "wrong
kind of person" for me to marry. I believe all Americans, no matter their race, no matter
their sex, no matter their sexual orientation, should have that same freedom to marry.
Government has no business imposing some people's religious beliefs over others.
Especially if it denies people's civil rights.
I am still not a political person, but I am proud that Richard's and my name is on a court
case that can help reinforce the love, the commitment, the fairness, and the family that so
many people, black or white, young or old, gay or straight seek in life. I support the
freedom to marry for all. That's what Loving, and loving, are all about.
Richard Loving died in 1975. Mildred Loving died in 2008. How appropriate their
last name—for real love sees no color.

Mildred and Richard
were finally allowed to return
to their home
in Virginia
where they lived out their lives
surrounded by their friends
and family.

The Lovings Quilt

Barbara Ann McCraw (Denton, Texas); 2012; 75 x 75 inches; cotton fabrics, 60 weight decorative threads, 80/20 Hobbs batting; machine pieced and appliqué, Broderie Perse and hand appliqué; photo by Chas. E. and Mary Martin.

The subject of my quilt is the 1967 Supreme Court ruling that declared Virginia's Racial Integrity Act of 1924 unconstitutional. The Racial Integrity Act stated that marriages between white and non-white people were against the law. This 1967 Supreme Court ruling was the result of the legal fight by Richard and Mildred Loving, an interracial couple, who lived in rural Virginia. The state did not recognize their marriage, and indeed, considered them criminals.

I knew the story of the Lovings. I had read stories and had even watched video documentaries of their lives—I compared their story to ours. You see, my husband is a white man. We have been married for thirty-three years and throughout that time, there has been joy and laughter, sadness and despair. This is the way of life and marriage. Nevertheless, unlike same-race marriages, some of the sadness and hurt was brought about by people who hated us because the color of our skin was different and we happened to be in love with each other.

I was honored to have the opportunity to express my feelings in *The Lovings Quilt*.

In my usual way, I try to find beauty in every quilt subject I undertake. Even when the subject matter is difficult, I want my quilts to be as beautiful as I can make them. For this piece, I envisioned a wedding bower of flowers with two simple hands in the center. Mildred and Richard Loving were very simple people. As I worked, I decided to use more hands of varying colors to signify the strength and unity of interracial relationships. There are small photos of couples—some famous, some not—among the flowers, and the story of the Lovings is told in chronological statements featured around the quilt.

Richard and Mildred Loving and their family had to endure so much—so much more than Ernie and I did, or other interracial couples that came after them. They held each other's hand, stood out in the sunlight on the steps of the Supreme Court, and announced their love to the world. They had been arrested, called names, frightened for themselves and their children, and even had to move away from all they knew, just because they loved.

We are grateful to Mildred and Richard Loving for the inspiration of their love. They inspired us with the strength of their conviction and bravery. Their unwavering struggle to successfully overturn the law, which prohibited them from legal marriage, provided a significant strike against racism in this country.

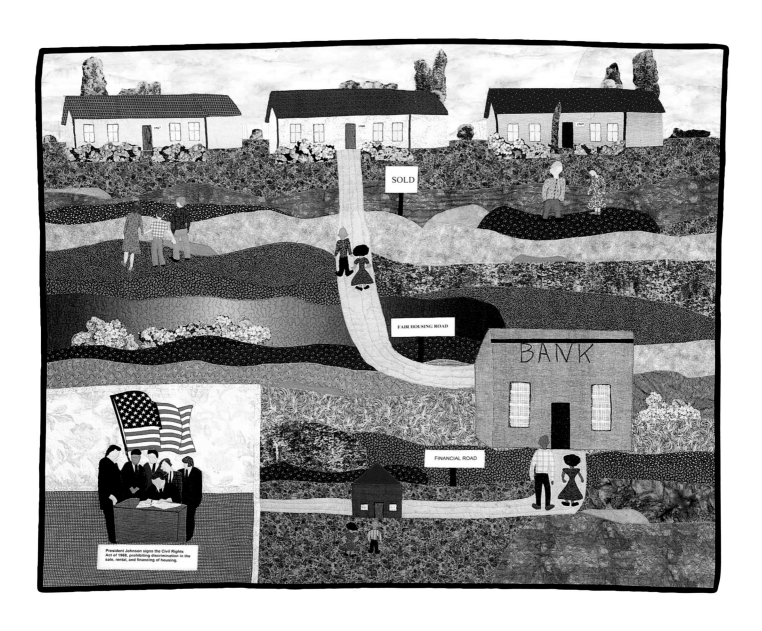

1968 | President Lyndon Johnson Signs the Civil Rights Act

Connie Horne (Elk Grove, California); 2012; 50 x 50 inches; commercial cottons, fusible web and fabric paint, cotton batting; fusing, machine raw-edge appliqué and quilted; photo by Chas. E. and Mary Martin.

I was born in El Paso, Texas, and my family moved to California when I was five years old. I remember my parents looking for a place for us to live. The first place was a small apartment they rented down the street from a school. We lived in that apartment for four years. My father and mother wanted a bigger place and, later, they were able to rent a house. I always wondered why we were renting from someone else and not buying our own home, but my parents were in charge. We rented that house for three years. The most exciting day came when my parents said they were going to be able to buy a home. My dad and mom were proud to be homeowners due to the signing of the Civil Rights Act Bill 1968, by President Lyndon B. Johnson. This helped pave the way for many more opportunities for blacks and other minorities to move ahead in finance and housing.

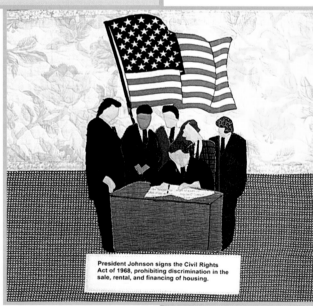

President Johnson signs the Civil Rights Act of 1968, prohibiting discrimination in the sale, rental, and financing of housing.

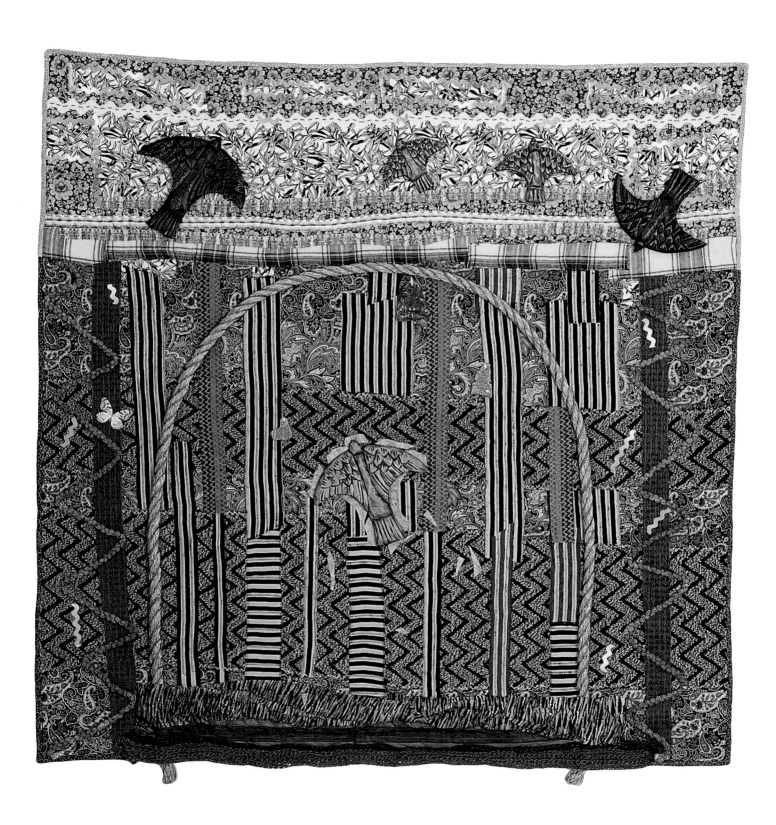

1969 | I Know Why the Caged Bird Sings

Mayota Willette Hill (Pittsburgh, Pennsylvania); 2012; 55 x 55; cotton, wood, acrylic paint, twine, found objects, cotton, cotton batting; painting, appliqué, machine quilted; photo by Chas. E. and Mary Martin.

In 1969, renowned African-American poet and storywriter Maya Angelou's childhood autobiography, *I Know Why the Caged Bird Sings*, was published. The story portrays her early encounters of racism and other damaging experiences. The scathing events induced a mind state of self-imprisonment whose bars of captivity and limitations were reminiscent of that of a bird housed within the bars of a cage.

The book was named by Abby Lincoln Roach, deceased jazz songstress and former wife of deceased jazz drummer Max Roach. She chose the title from the poem "Sympathy" by Paul Lawrence Dunbar.

"Sympathy" depicts how the uncaged bird has free range to explore the various beauties of nature, but having to live behind the bars of a cage prevents this joyous experience. As Dunbar states in the poem, its song is "not a carol of joy or glee, but a prayer that it sends from its heart's deep core, a plea that upward to heaven it flings. I know why the caged bird sings."

1971 | Satchel Paige

Edward Bostick (Brooklyn, New York); 2008; 36 x 41 inches; cotton sheeting, cotton batting, cotton thread, acrylic paint; painted, machine quilted; photo by Chas E. and Mary Martin.

Satchel Paige was born Leroy Robert Paige on July 7, 1906, in Mobile, Alabama, at a time when racial unrest was just beginning to rear its ugly head. He was the seventh of twelve children born to father John Paige, a gardener, and mother Lula, a washerwoman. He honed his pitching talents in reform school and made his professional baseball debut in 1926, moving up through various teams in the Negro Southern League and amassing a reputation as an ace pitcher. He made his major league debut with the Cleveland Indians in July 1948, at the age of forty-two, and continued playing for nearly another twenty years.

A run-in with law, for petty theft and truancy, got him enrolled in a reform school at age twelve. The Industrial School for Negro Children in Mount Meigs, Alabama, may have been a blessing in disguise. His baseball talent was coupled with big hands and feet on his long, lanky frame—he grew to 6'4". His coach at the reform school, Edward Byrd, taught him to pull back, then kick his foot high in the air and, as he came down, bring his arm from way behind and thrust his hand forward as he released the ball, giving the ball maximum power as it hurled forward. Some years later Satchel said, "You might say I traded five years of freedom to learn how to pitch."

Satchel Paige was elected to the Baseball Hall of Fame in 1971, the first player to be inducted based upon his play in the Negro leagues.

Work like you don't need the money. Love like you've never been hurt. Dance like nobody's watching.
—Satchel Paige

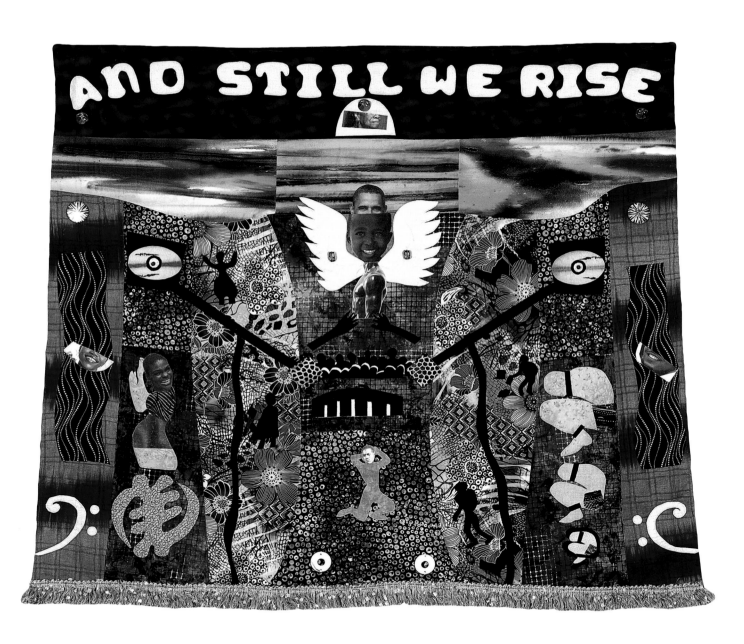

1971 | And Still We Rise:
Homage to Romare Bearden

Iris Simmons (Wilmington, North Carolina); 2012; 52 x 46 inches; commercial cotton, photo transfer cotton batting, charms, cotton thread, cotton batting; machine pieced, appliquéd and quilted; photo by Chas. E. and Mary Martin.

Romare Bearden (1911–1988) was one of America's great artistic innovators. His work reflects a unique view of the African-American experience and occupies a prominent place in American art at large. Bearden is best known for his work with collages and black figural abstractions. His images were colorful, complex, and imaginative. In 1971, Bearden opened *Prevalence of Ritual,* a solo exhibition of fifty-six of his artworks at the Museum of Modern Art in New York City. He made the African-American experience visible in modern art.

This piece, *And Still We Rise*, is a collage assemblage that visually references the history and struggle of African-Americans and celebrates their hard-won accomplishments and achievements. My quilt is meant to reflect both pain and joy—from the depths of inhumanity to the reality of becoming the leader of the free world, and everything in between. Metaphorically and symbolically, this piece represents a panoramic view of the "Face of Omnipotence" and grace. Even the bass clef symbols that anchor the work serve their purpose by keeping the rhythm to "stay in step" and survive. Rhythm is a language, and we, as a people, have created a powerful and effective language for survival as well as enjoyment.

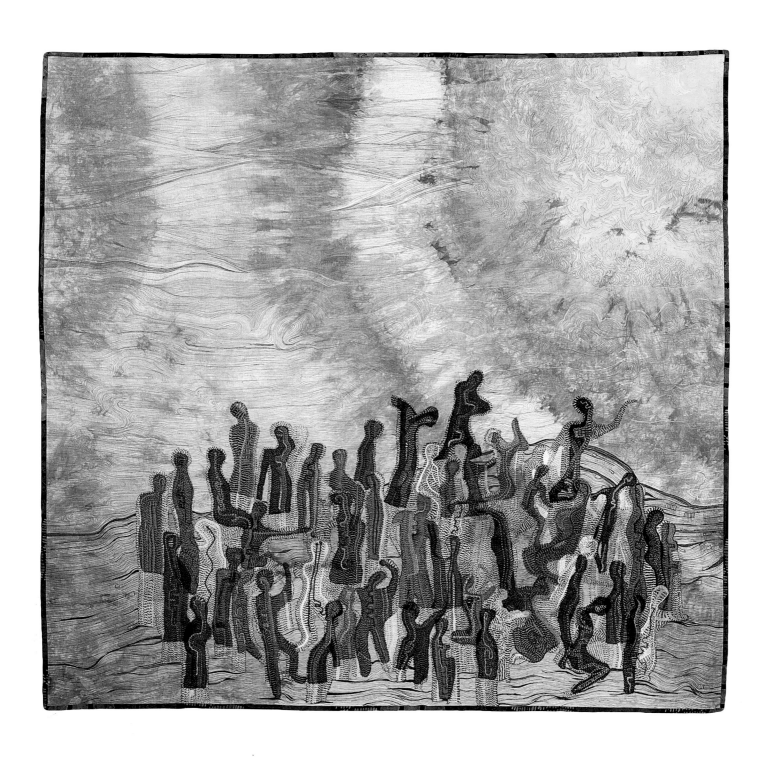

1972 | We Are All Warmed by the Same Sun

Helen Murrell (Cleveland Heights, Ohio); 2012; 54.5 x 54 inches; dyed linen front and back lined with cotton scrim, cotton batting, cotton, linen, polyester and silk threads, cotton batting; embroidery, thread painting, free motion machine quilting; photo by Chas. E. and Mary Martin.

For 40 years (1932-1972), the U.S. Public Health Service working with the Tuskegee Institute conducted a study on nearly 400 poor African-American men with syphilis from Macon County, Alabama. The men were never told they had syphilis, nor were they ever treated for it. For participating in the study, the men were given free medical exams, free meals and free burial insurance. The study was conducted to determine from autopsies what the disease does to the human body.

In 1997, the U.S. government under President Bill Clinton apologized to the families of the men, saying, "What was done cannot be undone. But we can end the silence. We can stop turning our heads away. We can look at you in the eye and finally say, on behalf of the American people: what the United States government did was shameful."

—Alex Chadwick, "Remembering Tuskegee: Syphilis Study Still Provokes Disbelief, Sadness," National Public Radio, July 25, 2002

Reflecting on Ghandi's view of war, William Stuart Nelson wrote: "all mankind is supported by one universe—the same earth feeds us, the same sun warms us, and the same stars shine upon us." (*Gandhi: His Relevance for Our Times*, edited by G. Ramachandran and T. K. Mahadevan, 1967)

I believe there is a common quality in all humans that should not give any person dominance over any other- especially when it comes to life and death. We should never forget that the tragedies of the past might occur again.

I made this quilt in the hope that it will remind us all that we are ultimately one family. If we are to give justice to the men who were the subjects of the Tuskegee syphilis study, we should not ever forget our own humanity, nor let others forget theirs.

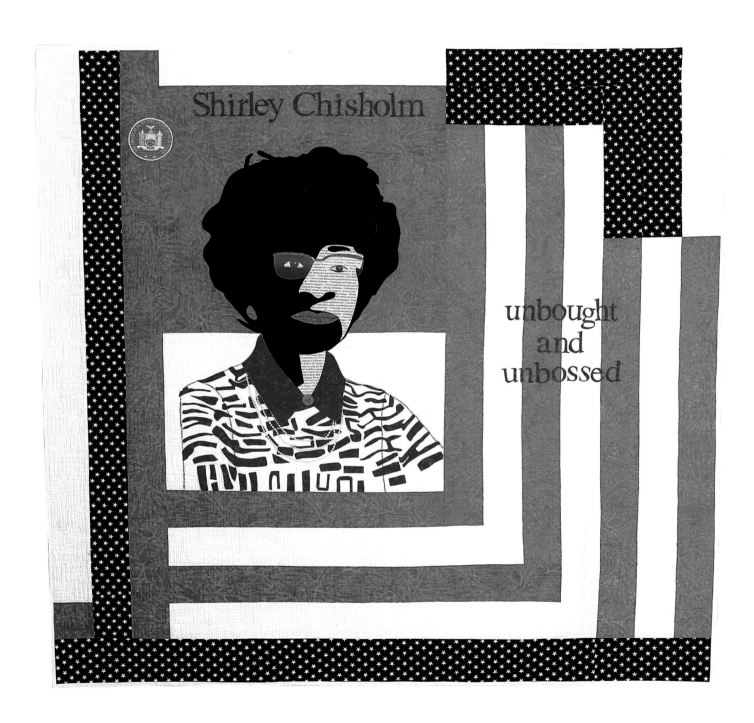

| # Shirley Chisholm:
Unbought and Unbossed

Ife Felix (New York, New York); 2012; 50 x 50 inches; cotton fabric, plastic, cotton string, cotton batting; machine piecing and quilting; photo by Chas. E. and Mary Martin.

Politician Shirley Chisholm was my inspiration for this piece. In 1968, she made history as the first African-American woman ever elected to Congress. In my community, there was a lot of buzz about this handsome, dark-skinned woman who was just seated in the House of Representatives. At the time, I didn't understand what all this meant, but I got the feeling that I, too, should be proud. Passing a barbershop on my way to the corner store, I overheard the men talking about this woman who was opening doors for her people. I was intrigued with their conversation and stood where I thought I would be unnoticed. "This woman is going to do big things. I've been following her since she began politicking," one man said. "Sitting in that seat she'll be able to grab a few of us up," another said. "She got more brains than beauty," to which there was a collective, "Amen" and then chuckles. "Listening to her talk I have to pull my dictionary off the shelf. I bet them boys in Congress scratch their heads when she speaks," commented another.

The man sitting closest to the door startled me with a clap of his hands. Laughter followed me as I ran away. After that day, I followed her on the news and I felt proud of her accomplishments. In 1972, she ran for the Democratic nomination for president of the United States, another first for a black woman. "How could this be? Only white men were presidents of these United States," were my initial thoughts when this announcement was made; but I grinned with pride at the possibilities. Her slogan, "Unbought and Unbossed," referred to her being her own person, free to do as her conscience dictated. Shirley Chisholm was a woman for the people.

I began college in 1973 and majored in political science hoping to go to law school after undergraduate studies. I leaned towards politics, wanting to idealistically follow Chisholm's example. By graduation, I realized politics was not for me; however, my admiration for Shirley Chisholm continues to this day. She is my "she" hero.

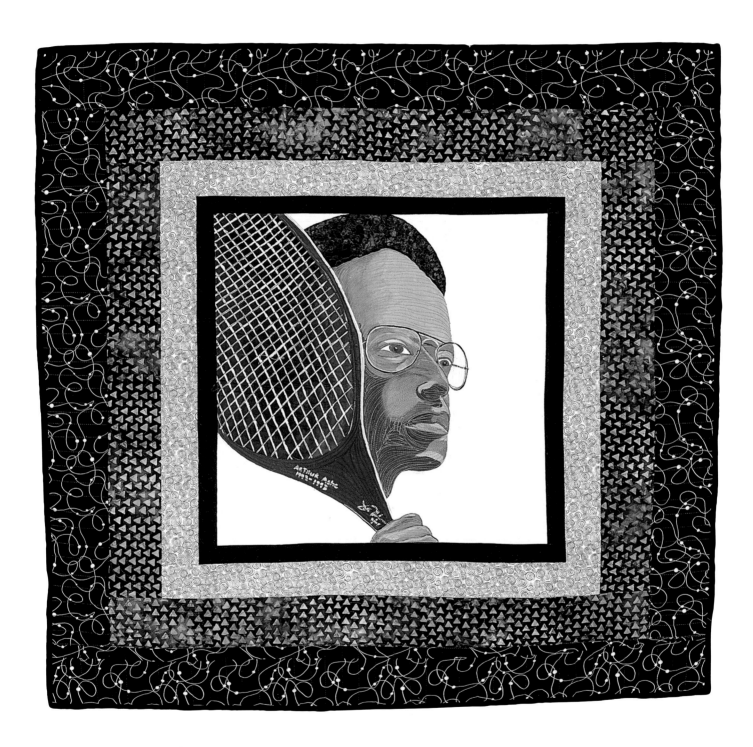

1975 | Arthur Ashe

Edward Bostick (Brooklyn, New York) 2009; 36 x 36 inches; cotton sheeting, cotton batting, cotton thread, acrylic paint, cotton batting; painted, machine quilted; photo by Chas. E. and Mary Martin.

Arthur Ashe, Jr., was born in Richmond, Virginia, in 1943, to parents Arthur Ashe, Sr., and Mattie Cordell Cunningham Ashe. His father was a strict disciplinarian who would not allow him to play football due to his slight body size. The Ashes' home was located on the grounds of Brookfield Playgrounds, which had a tennis court. There he learned a few basic strokes from another young tennis player, Ron Charity.

Ashe was ranked among the most elite professional tennis players. He won three Grand Slam titles, ranking him among the best tennis players from the United States. He was the first African-American ever selected to the United States Davis Cup team. In 1975, Ashe won Wimbledon, defeating Jimmy Connors in the final. He retired in 1980.

Ashe was certainly a world hero to people of all ages and races, and his legacy continues to touch the lives of many people today. To him, tennis was a means to an end. Although he had a lucrative tennis career, it was always more than a personal glory or individual accolades. He used his status as an elite tennis player to speak out against the moral inequalities that existed both in and out of the tennis world. He sincerely wanted to bring about change in the world. What made him stand out was that he became a world champion along the way.

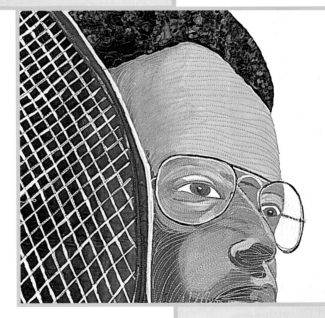

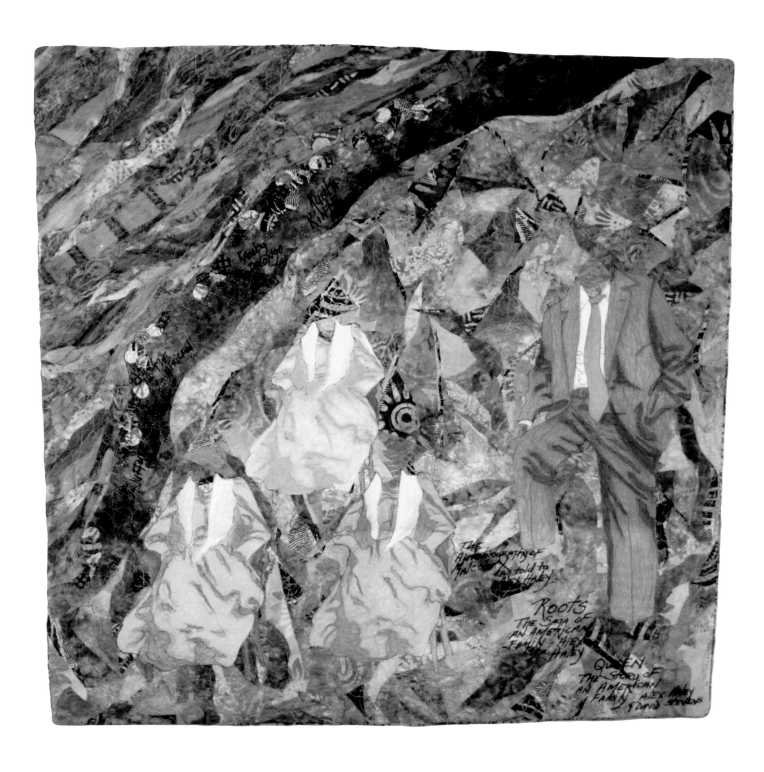

1976 | A Tribute to the Storyteller Alex Haley

Patricia Montgomery (Oakland, California); 2012; 42 x 42 inches; oil pastel drawing; African and batik fabric, cotton batting; written text; machine free motion quilting; photo by Chas. E. and Mary Martin.

As a young boy, Alex Haley heard the stories about "the African" named Kunta Kinte, who lived across the great ocean near "Kamby Bolongo." One day, Kunta Kinte went into the forest to cut down a tree so he could make a drum for his brother. He was captured, brought to Colonial America, and sold into slavery.

These stories, told by his grandmother and aunts, inspired Alex Haley to write *Roots, the Saga of an American Family* that traced his family origin back to Africa. He shared with millions, especially African-Americans, the rich African culture that slavery could never take away.

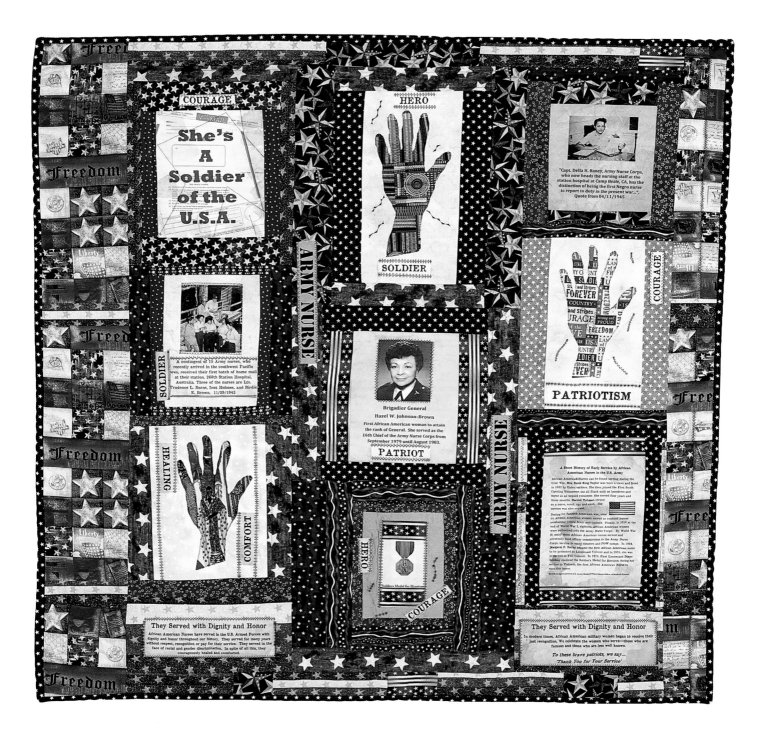

1979 | She's a Soldier of the USA:

Tribute to Brigadier General Hazel W. Johnson-Brown

Carole Lyles Shaw (Sarasota, Florida); 2012; 70 x 70 inches; commercial cotton, photo transfers; cotton batting; machine pieced and quilted; photo by Chas. E. and Mary Martin.

This art quilt honors the service of African-American nurses who have served in the U.S. Armed Forces since the Civil War, in paid and unpaid positions, despite tremendous racial barriers to their service. The center portrait is of Brigadier General Hazel W. Johnson-Brown (October 10, 1927–August 5, 2011) who served with the U.S. Army from 1955 to 1983. In 1979, she became the first black female general in the United States Army and the first black chief of the Army Nurse Corps. Johnson-Brown joined the Army in 1955, shortly after President Harry Truman banned segregation and discrimination in the armed services. She served in Korea and Japan and held prestigious posts at Walter Reed Nursing Institute and the University of Maryland.

This piece is part of my *War, Honor and Freedom* series. In 2006, I began a series of mixed media collages, assemblages, and art quilts that document the lives of ordinary African-American men and women who served in the U.S. military, with a particular focus on the early 20th century. I have collected photos, documents, and other memorabilia from the public domain and private sources that I use in these works. This series will be the subject of a forthcoming book.

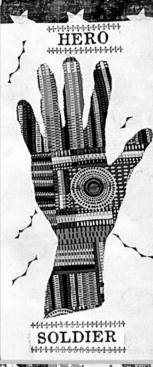

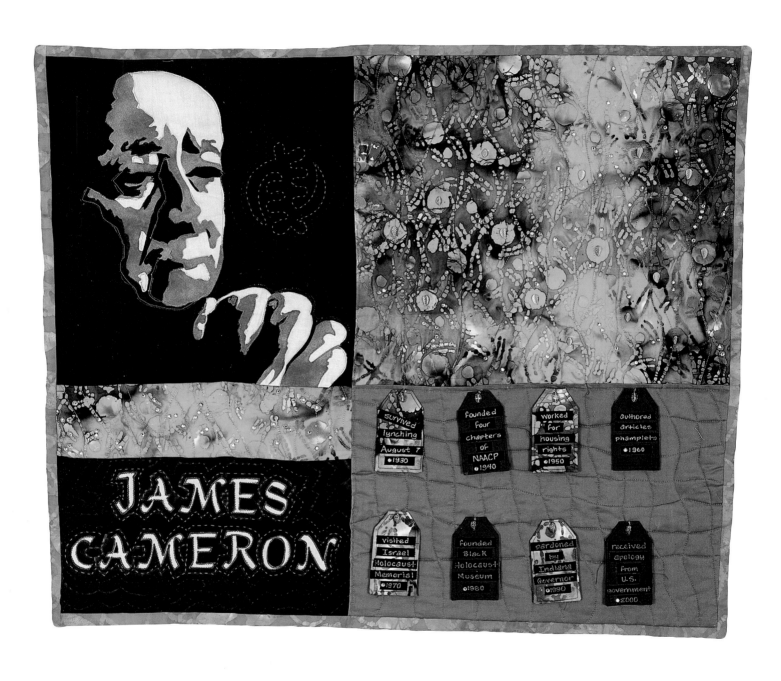

1988 | Lest We Forget:
Tribute to James Cameron

Dorothy Burge (Chicago, Illinois); 2010; 34 x 31 inches; commercial cotton, cotton batting, rayon threads, fabric markers, batiks, beads, button, crystals; raw edge machine appliqué and hand and machine quilted, photo by Chas. E. and Mary Martin.

This quilt is a tribute to James Cameron, a witness to and a survivor of a lynching in Marion, Indiana. Cameron was an author and civil rights activist, who founded the Black Holocaust Museum in 1988. The museum was known as a place for racial education and reconciliation. Key events in Cameron's life are noted on fabric tags, and crystals represent the nearly 3,500 African-Americans who were lynched in this country between 1882 and 1968. I hand-embroidered the Gye Nyame, the Adinkra symbol from west Africa, because I felt that its meaning, "fear no-one except God," was indicative of his life.

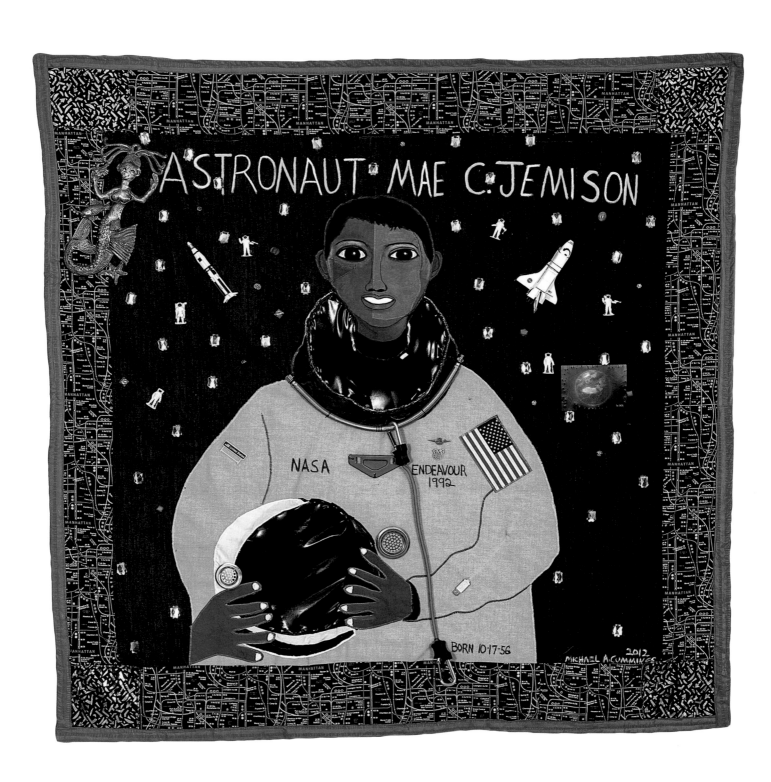

190

Astronaut Mae C. Jemison

Michael Cummings (New York, New York); 2012; 60 x 60 inches; cotton, assorted found objects, beads, metal tubing, plastic, cotton batting; machine appliqué, fusing, machine quilted; photo by Chas. E. and Mary Martin.

My journey in creating this quilt had several bumps before I realized how remarkable a discovery I had made. I first thought I would simply select a person from a list of events and famous people provided by Dr. Carolyn Mazloomi, the exhibition curator. By the time I chose a name, it had been taken. At some point, all the names were taken and I was left with no subject for my quilt. I talked to my mother about my situation, and, like always, she did not miss a beat in our conversation and quickly introduced me to the idea of creating this quilt on the first female African-American astronaut.

Mae Carol Jemison is a physician and NASA astronaut, who became the first female African-American to travel into space when she went into orbit aboard the space shuttle Endeavor on September 12, 1992. Dr. Jemison says she was inspired by the "I Have a dream" speech by Dr. Martin Luther King, Jr. Dr. King's speech was not an elusive dream, but a call to action for Jemison. She says, "too often people paint him like Santa-smiley and inoffensive, but when I think of Martin Luther King, Jr., I think of attitude, audacity, and bravery." She thought the Civil Rights Movement was all about breaking down barriers to human potential. "The best way to make dreams come true is to wake."

In 1993, Jemison founded her own company, The Jemison Group, which researches, markets, and develops technology for daily life. She continues to advocate strongly in favor of science education and getting minority students interested in science.

Constructing this narrative quilt was a fun process. I wanted to provide my impression of a well-known photo of her in a spacesuit. I embellished the quilt surface with miniature space ships and astronauts floating in space. To create the "stars," I used glass ornaments. I wanted to connect the present to the past and those ancient, dusty rivers of Africa, so I included the African goddess Yemaya. Yemaya is represented by a metal cutout made in Haiti. She is the spirit that connects sea and sky. I also use textile paint and found objects on the quilt.

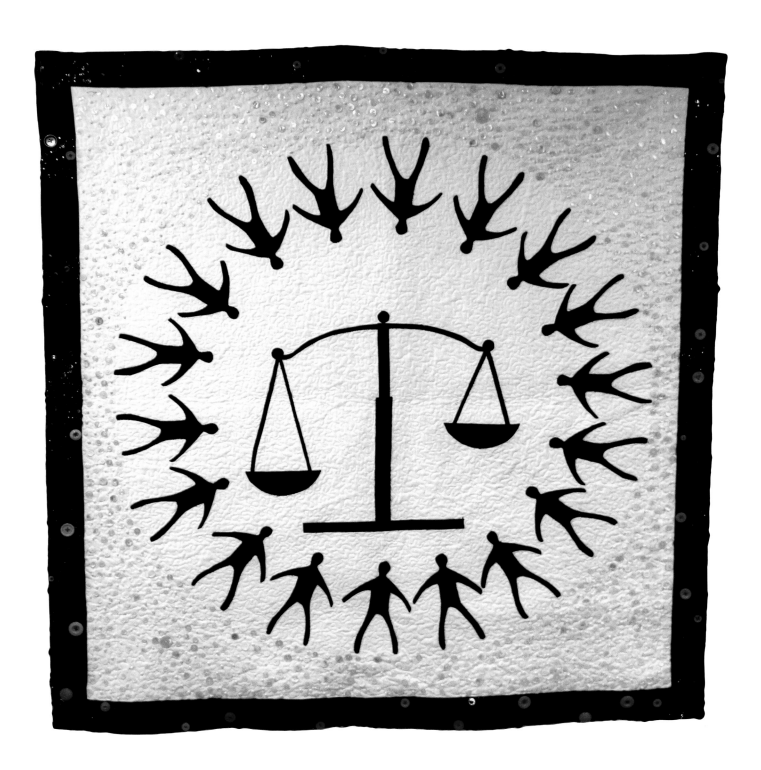

1994 | The Unbalanced Scales of Justice

Cleota Proctor Wilbekin (Cincinnati, Ohio); 2012; 50 x 50 inches; cotton fabric, cotton, antique buttons; machine appliqué and quilted; photo by Chas. E. and Mary Martin.

A balanced scale of justice, encircled by people, is the logo of the National Association of Bench and Bar Spouses Foundation. The Foundation is composed of spouses of lawyers and judges. and provides grants to college students, law school students, world needs, and health concerns.

The scale of justice is always depicted as a balanced scale held by a blindfolded goddess. The scale symbolizes fairness and justice, defense of one's rights to offset tyranny, fear, hopelessness, and heartbreak, and for justice for all. The symbol stands for fair conduct in and out of a court of law. In reality, minorities in this country have experienced limited justice or, in some cases, no justice at all. In my quilt, I chose to show the scale of justice as unbalanced to express the fact that the United States still has a long way to go in providing justice for all its citizens. Hundreds of antique buttons surround the quilt. The white buttons symbolize our tears, the red buttons symbolize our blood and fears, and the black buttons represent our strengths.

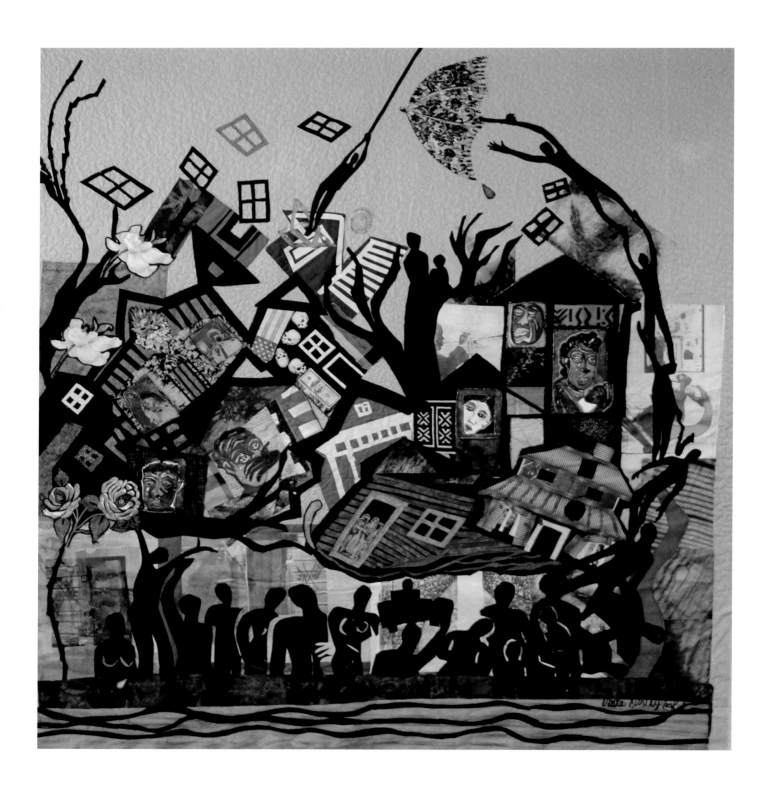

2005 | Katrina Wreckage and Tears

...And Still We Rise

Viola Burley Leak (Washington, DC); 2012; 76 x 69 inches; cotton, metallic lame; metallic threads; cotton batting, acrylic paint; silk screen; hand painted; machine quilted; photo by Chas. E. and Mary Martin.

The devastation surrounding Hurricane Katrina was almost too much for me to handle. I was overwhelmed as I watched the newscasts showing the suffering of the people of New Orleans, one of my favorite cities to visit. It saddened me to see the suffering of those trapped in the city. Dead bodies floating in the water and left in the streets for days, people stranded on rooftops, the mass humanity stuck inside the Super Dome with no food or water. I stared at the images in disbelief, wondering, "Is this really happening in America?" The African-Americans, who were a large share of the population and among the poorest, were hit hardest.

The black silhouettes in the quilt represent African-Americans living in New Orleans at the time the hurricane struck. The houses in the quilt are those washed away by the high flood waters. Many of the homes have images of occupants still inside, washed away and drowned in their homes. Skeletons symbolize the loss of life. I placed an American flag amidst the chaos to indicate the neglect by the Federal government to act quickly to the plight of the citizens of New Orleans. They were slow to come to the aid of the people and I feel they let the public down. Images of flowers are scattered over the quilt to honor the dead. On the right side of the quilt there's a line of connected black bodies rising above the chaos toward the sky. African-American people are strong and have endured much adversity in this country, and "still we rise."

2005 | From Sugar and Spice to Neo-Condi-Rice

Riché Richardson (Ithaca, New York); 2012; 30 x 36 inches; cotton and felt, mixed-media design elements incorporating patent leather, cotton, ribbon, plastic, beading, cotton batting; quilting, embroidery and appliqué; photo courtesy of artist.

Condoleezza Rice made history by becoming the first African-American woman National Security Advisor, and later Secretary of State, under George W. Bush's presidential administration. She was named by *Forbes* as the most powerful woman in the world in both 2004 and 2005. Even as Rice has been celebrated for her accomplishments, she has also been criticized for the foreign policy agendas that she helped to advance in nations such as Iraq and Afghanistan. Similarly, she was saliently associated with the government's neglect of New Orleans during Hurricane Katrina. Rice has frequently invoked the tragic bombing at Sixteenth Street Baptist Church in her hometown, Birmingham, Alabama, in which Addie Mae Collins, Carole Robertson, Cynthia Wesley, and Denise McNair lost their lives, to help advance neo-conservative agendas, including the War on Terror.

This quilt reflects on Rice's journey from segregated Birmingham to her emergence as the face of neo-conservative foreign policy agendas during the 2000s. It recreates key scenes from her childhood and iconic moments from her years working in Bush's administration. It begins with her visit to see Santa Claus in a segregated department store as a child, where she sits on his lap, which is a powerful and subversive image within a segregated social order. The next block focuses on the tragic loss of the four girls at Sixteenth Street Baptist Church and inserts ribbons in a church window to symbolize their iconic photographs and tragic losses. McNair was Rice's playmate and this incident scarred her consciousness. It was one of the incidents that epitomized the terror that earned Birmingham the nickname "Bombingham."

The quilt follows this sad story with a block that depicts Rice's visit to the White House in Washington, DC, with her parents, a pilgrimage that has sometimes been linked to her emergence as a national leader and work in the White House later in life. The next image depicts Rice's speech at the 2000 Republican National Convention, where she became widely known to national audiences and intimately linked to neo-conservative political agendas. The quilt's story goes on to visualize Rice's ubiquity in television media through her frequent interviews and speeches. Her famous flip hairstyle was closely linked to her visual iconicity during this period. The final image captures her famous visit to Wiesbaden Army Airfield in Germany, where her black attire and tall boots reinforced her iconicity and evoked the dominatrix.

This final image epitomizes Rice's power on the world's stage at the peak of her career in Washington as an advocate and symbol for neo-conservatism. Santa Claus is invoked here in relation to the sweetness and innocence of Rice's childhood, which was also shadowed by the loss of the girls at Sixteenth Street. Indeed, Rice's name, Condoleezza, means "with sweetness." Santa is fabled to check off a list of who's been naughty and who's been nice. In this sense, he is perhaps also a fitting metaphor for weighing the controversial neo-conservative policy agendas linked to the adult "neo-Condi Rice."

2008 | The Ascension

Linda Gray (Indianapolis, Indiana); 2008; 40 x 40 inches; and-dyed cotton, embroidered lettering, paint, cotton batting, metallic and polyester threads; hand painted, appliqué and machine quilted; photo by Chas. E. and Mary Martin.

My quilt commemorates the election of Barack Obama as President of the United States. The ascension of the Phoenix in the center of the quilt symbolizes the rise of African-Americans from their beginnings as enslaved people in America, to the stakeholders and contributors to American history they are today. The ascent of the Phoenix is buoyed by historic African-American leaders who broke down racial barriers to make it possible for an African-American to run for the country's highest elected office.

Barack Obama is a graduate of Columbia University and Harvard Law School. While at Harvard, he served as president of the Law Review. Obama worked as a civil rights attorney in Chicago and taught constitutional law at the University of Chicago Law School. Several events brought Obama to national attention during his 2004 campaign to represent the state of Illinois in the United States Senate, including his victory in the March Illinois Democratic primary and his keynote address at the Democratic National Convention in July 2004. On November 4, 2008, Obama won the presidency with 365 electoral votes to 173 received by Republican candidate John McCain, while the world stayed up to watch and be a part of this history-making event. On January 20, 2009, he took the oath of office administered by Chief Justice John G. Roberts Jr. His victory was celebrated in major cities around the world. Never before had so many Americans, as well as foreign visitors gathered, in unfavorable weather, to watch a swearing-in ceremony. Nine months later, Obama was named the 2009 Nobel Peace Prize laureate.

Dindga McCannon (New York, New York); 2012; 59 x 59 inches; hand dyed cottons, commercial cottons, paper, felt, glass beads, metal charms, and acrylic paint, cotton batting; hand painted, machine embroidery and quilted; photo by Chas. E. and Mary Martin.

The United States put a man on the moon when I was a young girl. Why did it take so long for an all-African-American flight crew to fly a plane? On February 12, 2009, Atlantic Southeast Airlines Flight 5202 flew from Atlanta to Nashville. The crew of four, made up of a captain, co-captain, and two flight attendants, made history by becoming the first all- African-American female crew to fly together in the United States. The names of the four women have been machine-embroidered and placed next to my image of them. I never try to get a photographic image of a person; I try instead for my interpretation of the spirit of the person. The "hang tags" were made from brown paper pages and list some of the other African-American aviators whose accomplishments made it possible for these four women to make history.

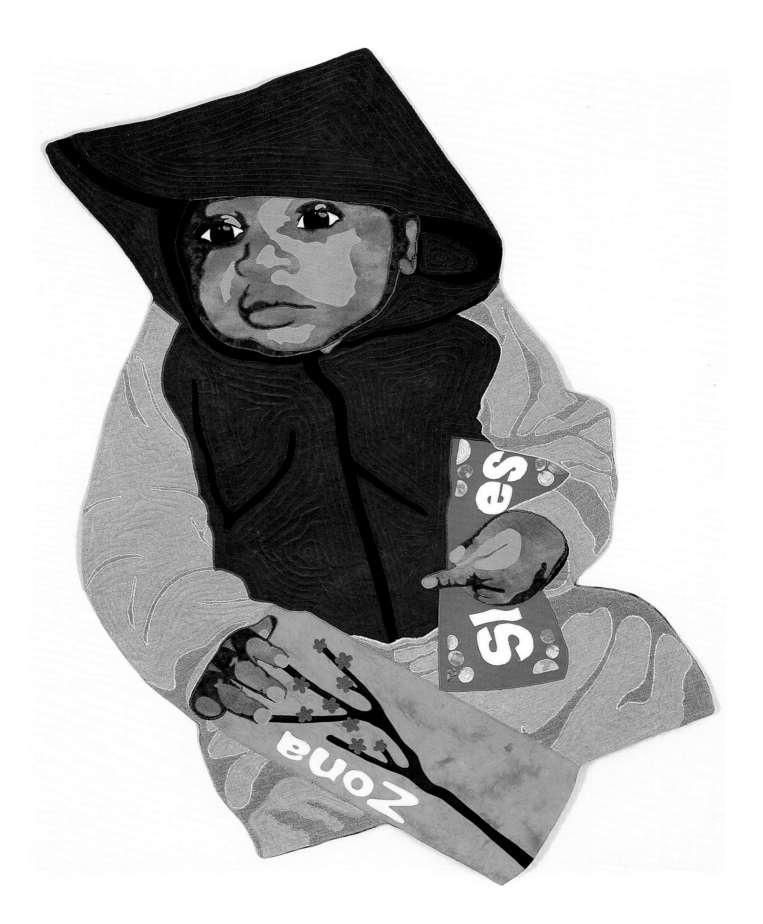

2012 | Trayvon Could Be My Son

Dorothy Burge (Chicago, Illinois); 2012; 30 x 48 inches; commercial cotton, cotton batting, cotton and rayon threads; machine appliqué and quilted; photo by Chas. E. and Mary Martin.

This fiber art wall hanging is dedicated to all of the mothers who fear for the safety of their children and seek to protect them from violence. The murder of Trayvon Martin was the inspiration for this quilt. This African-American teen was killed as he returned from a neighborhood convenience store. To raise awareness about this incident, people from around the country participated in a "We are all Trayvon" campaign. As a mother, I designed this quilt to show my support and concern and to illustrate that Trayvon could be my son. The quilt was created from a photo of my great nephew, who was the youngest member of my family at the time. He was dressed in a hooded sweatshirt and carrying an ice tea and a bag of candy, mirroring Trayvon Martin, the day he was killed.

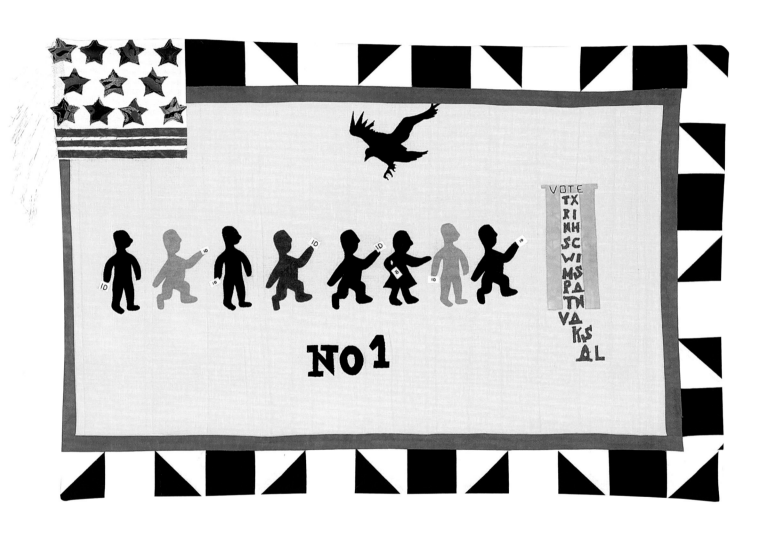

2012 | New Century Poll Tax

Michelle Flamer (Philadelphia, Pennsylvania); 2012; 39 x 27 inches; commercial and hand dyed fabrics, linen, cotton batting, metallic thread; machine appliqué and quilted, hand quilted; photo by Chas. E. and Mary Martin.

It was not until 1964 that the 24th Amendment to the United States Constitution prohibited poll taxes. Poll taxes were payments required in order to vote; and when assessed upon African-American voters, who were often too poor to pay the tax, the poll tax prevented them from voting in federal elections.

The eleven states featured in my quilt enacted Voter ID laws right before the 2012 Presidential election. My home state of Pennsylvania has the most restrictive, cumbersome ID law, potentially disenfranchising 100,000 voters just in my city of Philadelphia. Like the poll taxes and literacy tests following Reconstruction, voter ID is intentional in its design to inhibit and discourage African-Americans and other minorities from casting their votes at the ballot box.

I use Ghana's Asafo flag imagery for my quilt because Asafo means "war people," and that is how we must be, as warriors fighting to maintain our hard fought freedoms.

1619–2019 | Visionaries of Our Freedom

Quadricentennial: The First Four Hundred Years of African Presence in America

Sherry E. Whetstone-McCall (Kansas City, Missouri); 2012; cotton fabric, beads, buttons, found objects, photo transfers, dried sage and lavender, cotton batting; hand and machine quilting, appliqué, embroidery; photo by Chas. E. and Mary Martin.

In less than a decade, America will reach the Quadricentennial, or 400-year anniversary, of first arrival of Africans at Jamestown in 1619. Africa has always held my heart and spirit captive. My breathtaking homeland consistently shows up in my meditations, works of art, and poetry.

Black folks were free in Africa, so I thought it appropriate that this beautiful continent is visually prominent in a quilt that represents "freedom." Usually, I do not leave my edges raw or exposed; however, this technique is what called to my spirit. After all, our freedom has not been a smooth and finished process, has it? I also sewed a small pouch of sage and lavender on the back to honor our beloved ancestors.

The images portrayed in this piece in no way complete the volume of images that are equally deserving of a special place on this quilt. I only have room for a few; so I may need to create another artwork called *The Journey Continues*.

I chose African images and black icons to which I can personally relate for this work of art. These are images and people that have traveled the road to freedom and also assisted many of our brothers and sisters in the process, by any means necessary. These are warriors, each with their own talents, skills, and voices.

Freedom is mental, emotional, and physical. I want the observer of *Visionaries of Our Freedom* to connect with one or more of the images—whether it be a certain color that strikes a chord in the music of your mind, the cowrie shells that represent culture and prosperity, the Ankh, key of life, the anchor buttons along the bottom that represent the ships that took us on that long voyage called the "Middle Passage," or perhaps some of the brave mavericks that gave us hope, faith, life, courage, and strength. Hopefully, while viewing *Visionaries of Our Freedom*, you will feel what our ancestors felt—then and still.

This quilt has been cleansed with sage from my garden and a prayer from my spirit and soul. Let that anniversary be marked by the telling of stories that recognize and celebrate the perseverance and triumph of the African-American people. Let the stories inspire the world to take courageous steps for freedom today and for generations to come.

THE ARTISTS

Bibliography

Arnett, William. *The Quilts of Gee's Bend: Masterpieces from A Lost Place*. Atlanta, GA: Tinwood Books, 2002.

Benberry, Cuesta. *Always There: The African-American Presence in American Quilts*. Louisville, KY: The Kentucky Quilt Project Inc., 1992.

_____. *Piece of My Soul: Quilts by Black Arkansans*. Fayetteville, AK: University of Arkansas Press, 2000.

Brackman, Barbara. *Facts and Fabrications: Unraveling the History of Quilts and Slavery*. C & T publications, 2006.

Callahan, Nancy. *The Freedom Quilting Bee*. Tuscaloosa, AL: University of Alabama Press, 1987.

Cameron, Dan. *Dancing at the Louvre: Faith Ringgold's French Collection and Other Story Quilts*. Oakland: University of California Press, 1998.

Cubbs, Joanne. *Mary Lee Bendolph: Gee's Bend Quilts and Beyond*. Atlanta, GA: Tinwood Books, 2006.

Ezell, Nora. *My Quilts and Me: The Diary of an American Quilter*. Montgomery, AL: Black Belt Press, 1999.

Freeman, Roland. *A Communion of the Spirits*. Nashville, TN: Rutledge Hill Press, 1997.

_____. *Something to Keep You Warm: Quilts from the Mississippi Heartland*. Jackson, MS: Mississippi Historical Museum, 1981.

Fry, Gladys-Marie. *Stitched from the Soul: Slave Quilts from the Ante-Bellum South*. Chapel Hill, NC: University of North Carolina Press, 2001.

Grudin, Eva Unger. *Stitching Memories: African-American Story Quilts*. Williamstown, MA: Williams College Museum of Art, 1990.

Heffley, Scott. *Bold Improvisation: Searching for African-American Quilts – The Heffley Collection*. Kansas City: Kansas City Star Books, 2007

Hicks, Kyra. *Martha Ann's Quilt for Queen Victoria*. Plano, TX: Brown Books Publishing Group, 2006.

_____. *Black Threads: An African-American Sourcebook*. MacFarland and Company, 2002.

Huff, Mary E. Johnson. *Just How I Picture It in My Mind: Contemporary African-American Quilts from the Montgomery Museum of Fine Art*. Montgomery, AL: River City Publishing, 2007.

Leon, Eli. *Who'd Thought It: Improvisation in African-American Quiltmaking*. San Francisco: San Francisco Craft and Folk Art Museum, 1987.

Lyons, Mary E. *Stitching Stars: The Story Quilts of Harriet Powers*. New York: Charles Scribner's Sons, 1993.

MacDowell, Marsha. *African-American Quiltmaking in Michigan*. East Lansing, MI: Michigan State University Press, 1997.

Mazloomi, Carolyn. *Spirits of the Cloth: Contemporary African-American Quilts*. New York: Clarkson N. Potter, Inc., 1998.

_____. *Threads of Faith: Quilts from the Women of Color Quilters Network*. New York: Museum of Biblical Art, 2003.

_____. *Textural Rhythms: Quilting the Jazz Tradition*. West Chester, OH: Paper Moon Publications, 2007.

_____. *Quilting African-American Women's History: Our Challenges, Champions and Creativity*. Columbus, OH: Ohio Historical Society. 2008.

_____. *Journey of Hope: Quilts Inspired by President Barak Obama*. St. Paul, MN: Voyageur Press, 2010.

Perry, Regenia A. *Harriet Powers's Bible Quilts*. New York: Rizzoli International Publications, Inc., 1994.

Ringgold, Faith. *The French Collection: Part I*. New York: Being My Own Woman Press, 1992.

_____. *We Flew Over the Bridge: The Memoirs of Faith Ringgold*. New York: Bulfinch Press, 1995.

Thompson, Robert Farris. *Accidentally on Purpose: The Aesthetic Management of Irregularities in African Textiles and African-American Quilts*. Davenport, IA: Figge Art Museum, 2007.

Tobin, Jacqueline L. and Raymond G. Dobard. *Hidden in Plain View: A Secret Story of Quilts and the Underground Railroad*. New York: Doubleday, 1999.

Wahlman, Maude Southwell. *Signs and Symbols: African Images in African-American Quilts*. New York: Studio Books, 1993.